Desert Wetlands

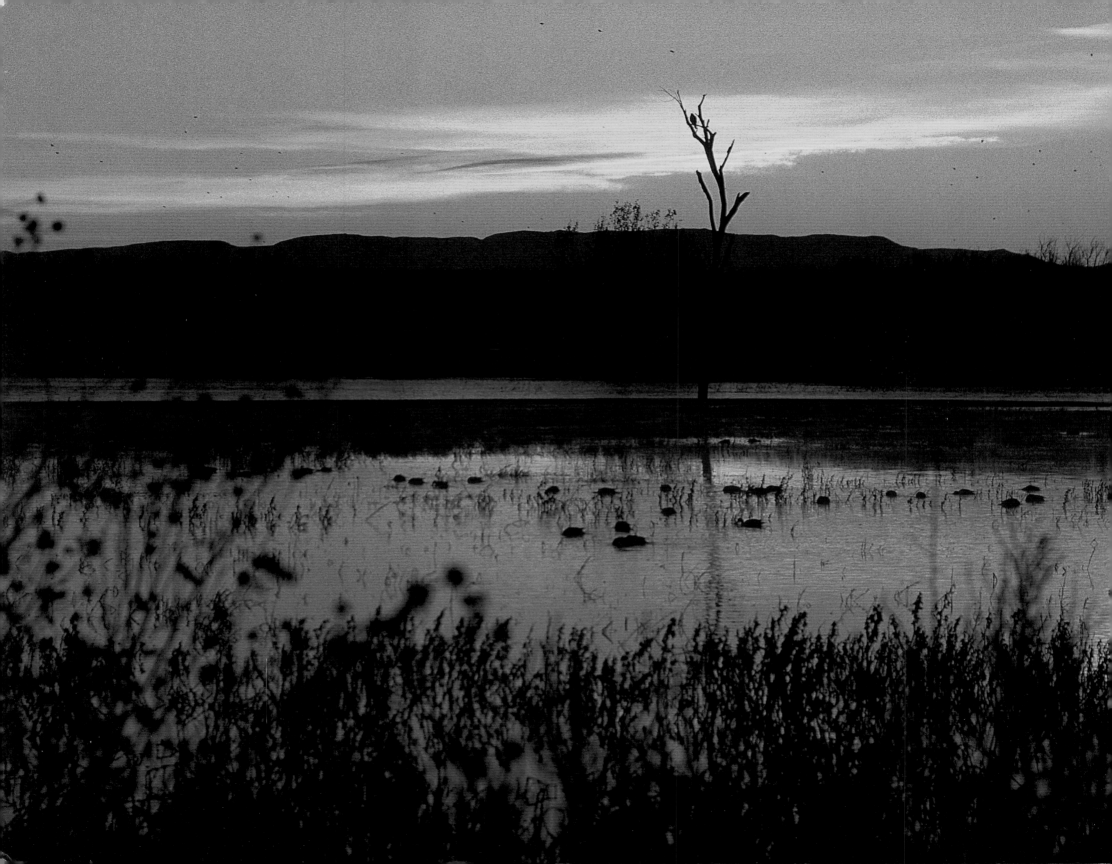

Desert Wetlands

Lucian Niemeyer

Text by **Thomas Lowe Fleischner**

UNIVERSITY OF NEW MEXICO PRESS ■ ALBUQUERQUE

Dedicated to my wife and partner,
Joan who loves the wetlands and finds peace in them.
—Lucian Niemeyer

For my children, River and Kestrel,
precious as water in the desert
—Thomas Lowe Fleischner

Photographs ©2005 by Lucian Niemeyer
Text ©2005 by Thomas Lowe Fleischner
All rights reserved. Published 2005

10 09 08 07 06 05 1 2 3 4 5 6

Printed in China by Everbest Printing Company Ltd.
through Four Colour Imports, Ltd.
Design and Composition by Melissa Tandysh
Map courtesy Charlotte Cobb, ©2005

Library of Congress Cataloging-in-Publication Data

Niemeyer, Lucian.
Desert wetlands / Lucian Niemeyer and
Thomas Lowe Fleischner.— 1st ed.
p. cm.
Includes bibliographical references.
ISBN 0-8263-3260-9 (cloth : alk. paper) —
ISBN 0-8263-3261-7 (pbk. : alk. paper)
1. Desert ecology—Southwest, New—Pictorial works.
2. Deserts—Southwest, New—Pictorial works.
3. Wetland ecology—Southwest, New—Pictorial works.
4. Wetlands—Southwest, New—Pictorial works.
I. Fleischner, Thomas Lowe, 1954— II. Title.
QH104.5.S6N54 2005
578.754′0979—dc22
2004023661

Frontispiece: Sunrise at the Bosque del Apache
National Wildlife Refuge, New Mexico.

Contents

Preface

The term "desert wetlands" seems like an oxymoron. It stands to reason that desert and water are at opposite ends of the environmental spectrum. Yet if the desert had no water, there would be no life. So in the North American southwest, "desert" is not an absolute. The wetlands in our main four desert areas play a more important role in sustaining life in a very hostile environment than do the areas in their Eastern counterparts. The migration corridor from north to south for birds and the path from high mountains to low desert for the animals are not for recreation. Birds and animals migrate to find adequate water, food, and a safe place for reproduction. It is an age old ritual that wildlife and man have found successful. Seven hundred years ago a slight shift of rainfall created a situation in which the forests and crops died, and people living in the region relocated to the steady water flow of the Rio Grande. This is being repeated on this critical edge of life and death, wetlands versus desert, in the early 2000s. Thus, when human progress eliminates wetlands in desert areas, the whole food chain suffers. There are no marginal solutions.

From middle Texas to California and Mexico to Nebraska, fresh water plays a critical role for life, human as well as bird, animal, and plant. Court battles over water are a constant in human society because of the need to provide sustainable water sources reaching ever farther for supplies. Yet there is never enough water. Now take this situation one step lower in the hierarchy and the battle becomes more fierce. Now the shortage of water creates death and destruction—whole forests of piñons die, whole populations of animals die. Fewer birds are born because they recognize that food is not available. Migrations cease. The desert becomes more deserted and spreads. The food chain breaks. We have seen this effect in Africa. Humans would face living alone for a while, then they too would leave. Humans are quite resourceful. They can desalinate the Gulf and run pipelines

from Canada and the great rivers even reaching to the Mississippi River, but nature cannot partake in this water. The Sonoran, Great Basin, Mohave, and Chihuahuan Deserts would continue to make up an area similar to the inhospitable Saharan Desert.

Thus, we humans as stewards of this planet earth must provide for an even balance of life for all creatures: humans, animals and plants. We must conserve enough water from its historical sources to maintain a migratory pattern for birds and animals. We must preserve plant life in its ever changing mode. The natural system of water replenishment is quite a sensitive mechanism that has historically provided for quality living in this four-desert area. Snow from the mountains melts in the spring, releasing great amounts of clear water that fills the immediate spring growth needs. This is the time that nature reproduces, finding enough food and water to sustain the accelerated needs for growth. Much of the snow cap is kept in the high altitude bogs, pristine lakes, and beaver-created damned ponds, which release the water slowly, providing for a sustained if meager ration for the dry summer months. Then in the fall, nature slows down until the early snow in the mountains again brings needed water. Rains can not provide enough water in the four-desert region to meet demand, so the rivers become corridors for migration and life. This is the way it has been for eons. If we humans use the water from these corridors, drying up the rivers and lakes, we break the migration pattern. If we dry up the overflow wetlands, mountain bogs, and lakes, the food chain will be broken. If we use up the aquifer via wells without letting them replenish, human life will not be sustainable. If we do not pay attention to nature's need, we will end up alone. The health of desert wetlands is far more important to humans than is commonly understood. Observe the rhythms of nature; they are giving us the temperature gauge of our environment. Listen to the warnings. Only human beings can reason and act enough to allow for a balance of nature and human development in a sustainable future. Human beings have the distinction and the responsibility to be stewards of our planet. It is our

legacy. How we handle this steward-ship will determine our destiny.

In doing this study I used Leica SLR 35mm cameras and lenses. No filters or flash were used. No manipulation of images was done other then using a longer lens to place me closer to nature without infringement. I used neutral color slide film, Agfachrome 100asa, mostly. This is the fourth study of wetlands that has consumed a large part of my photographic career. This work has ranged from a basic under-standing of the wetlands, *Long Legged Wading Birds of the North American Wetlands,* with an essay by Mark Riegner, to a broad, beautiful look at the range of wetlands in the United States, *Where Water Meets Land.* A complex study of one of the world's great wetlands, *Okefenokee,*

with an essay by George Folkerts, is fol-lowed by this study of our *Desert Wetlands.*

I would like to thank the staff of Bosque del Apache National Wildlife Refuge, where the majority of this study was photographed, as it represents the desert wetland well. Other areas such as Ramsey Canyon, Maxwell National Wildlife Refuge, Laguna Atacosa Wildlife Refuge, and Big Bend National Park played a large role in the study, and I thank the park personnel that helped to reveal the story. Eliot Porter, always a guru but not my contemporary, was my guide, as were John James Audubon, Roger Tory Peterson, and Russell Peterson, whose talents, standards, and knowledge helped me immensely.

I thank Tom Fleischner for his essay, as it is so clear and concise.

Luther Wilson of the University of New Mexico Press was so important as he embraced this study with fervor and produced it well. Melissa Tandysh did a wonderful design, which brought life to the story.

I thank my wife and partner, Joan, as she has gone the whole mile with me including dealing with mosquitoes; yellow, black, and green flies; insuffer-able heat; penetrating rain; and cold and rough tenting. She is always my most important critic and supporter on this journey. I thank my maker for the beauty and order that we have encoun-tered. He has allowed me to show you this work of his, hopefully well.

Lucian Niemeyer
Santa Fe, 2005

Acknowledgments

My thanks to Lucian Niemeyer for his good-spirited collaboration; to Ed Grumbine for shared time in the field, to Mark Riegner for helping initiate this project, and to Lyn Chenier for assistance in gathering literature. Special gratitude to my wife, Edie Dillon, for her support and for believing so completely in the creative life, and to my children, River and Kestrel, for daily renewing my faith in the future.

Thomas Lowe Fleischner
Manzanita Creek, Arizona, 2005

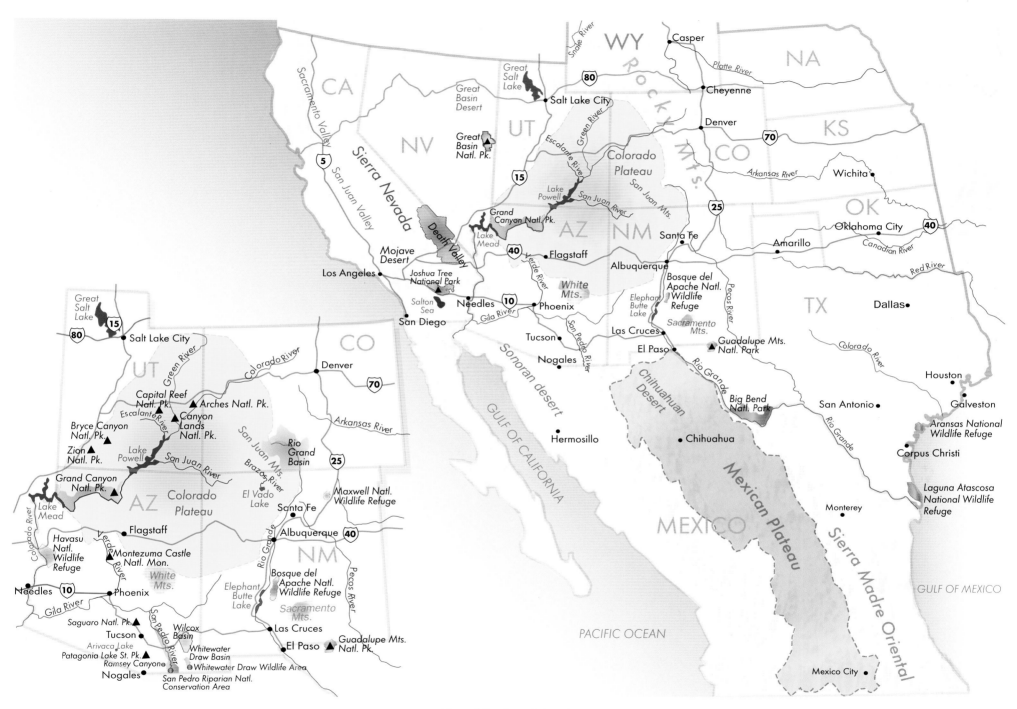

Map of Southwest deserts.

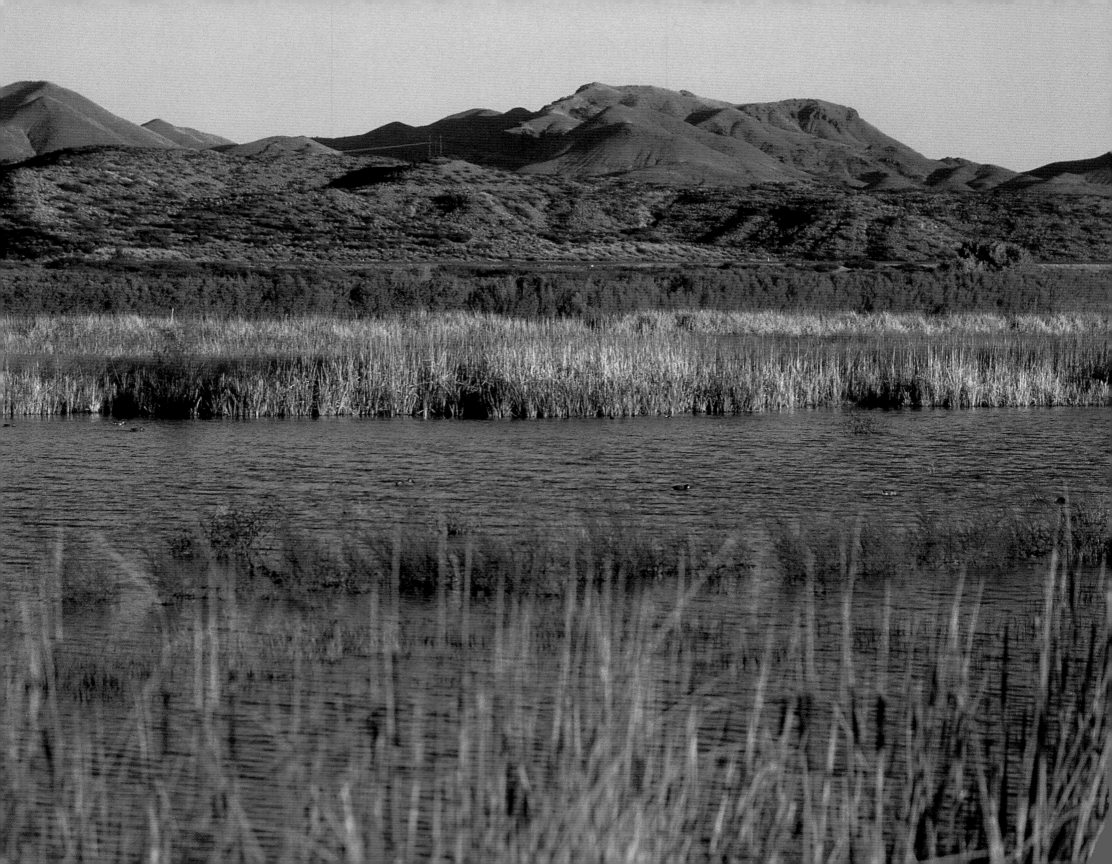

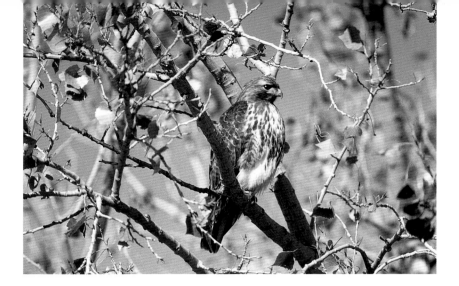

Above: Red-tailed hawk (*Buteo jamaicensis*) in the Bosque del Apache National Wildlife Refuge, New Mexico.

Opposite: Late summer on Pond Loop in the Bosque del Apache National Wildlife Refuge against the Chupadera Mountains, New Mexico.

I. The Greatest Alchemy

The first time I ever visited the slickrock canyon country of southern Utah I almost perished from thirst. I had traveled from the Pacific Northwest, an opposite kind of land—intensely green, drab gray skies, and most fundamentally, *wet* everywhere. Now I found myself walking through a russet-brown land, under shimmering blue sky, with water only in my imagination. I was so accustomed to the omnipresence of water that when I began hiking I only briefly considered where I would find my next drink. It seemed clear enough: there on the topographic map, right on my route, I could see a spring indicated, plain as day. I'd refill my bottles there at midday, then continue on my way.

Today, two and a half decades later, I know to be wary of taking water for granted in the desert. But that sunny March day yielded a harsh lesson: the contradiction between the map's blue dot and the parched brown ground I found in its place. As the afternoon wore on, hiking across a vast, shadowless, sagebrush basin, surprise turned toward something crueler as my mouth began to swell shut from dehydration. All I could do was keep hiking toward the next spring noted on the map—and desperately hope this one would exist for real. After several hours of this zero-sum game—working harder so I could arrive sooner, but dehydrating further with each step—I finally crested a slight hill and, with a sense of relief greater than I'd ever experienced, saw water. Sunset colors were reflected in this precious liquid, contained in a rusty, sawed-in-half barrel. Though that catchment was devised for cows, not people, I plunked my entire head into the scummy

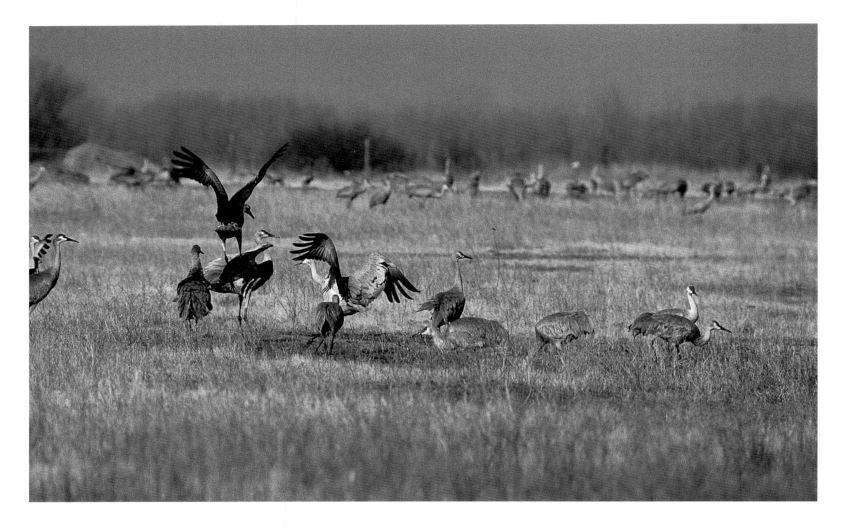

Left: Sandhill cranes (*Grus canadensis*) performing their mating ritual at the Platte River near Grand Junction, Nebraska.

Opposite: A mountain lake north of Chama, New Mexico, provides for the gradual release of water in the mountains during dry times.

tank and guzzled deeply. No drink has ever been so gratefully consumed. I suspect I hold this in common with many desert wanderers: never will I fully forget the haunting sensation of thirst.

Another canyon trip, many years later. We have driven two hours through monotonous desert with nothing alive higher than our knees and with nothing greener than the dust cloud trailing our van. We finally begin our descent from a sandstone rim into a canyon renowned for the images left behind by ancient peoples. I'm leading a group of college students and am accompanied by my wife and our son, who celebrates his second birthday by riding in the best seat available, a pack on his mother's back.

When we reach the canyon floor we find only more dry sand. We turn downcanyon, toward the river fifteen miles distant, knowing we *must* reach water long before that. After an hour

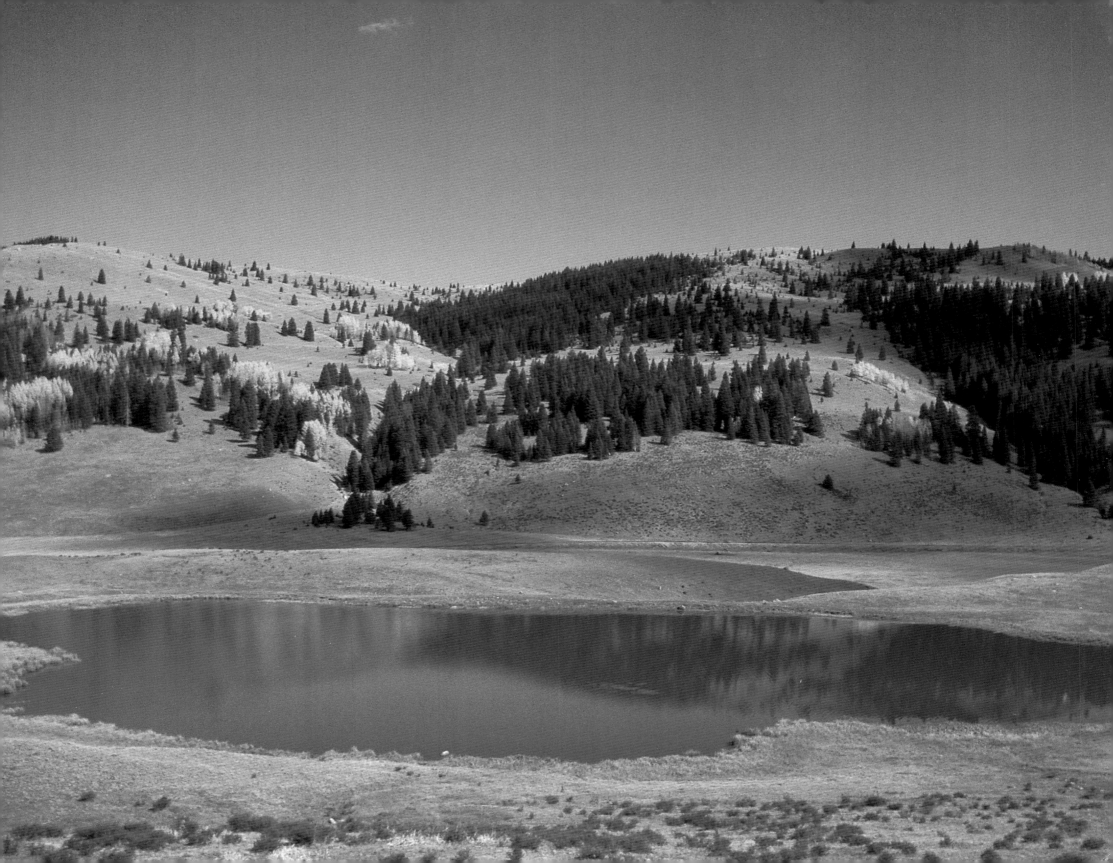

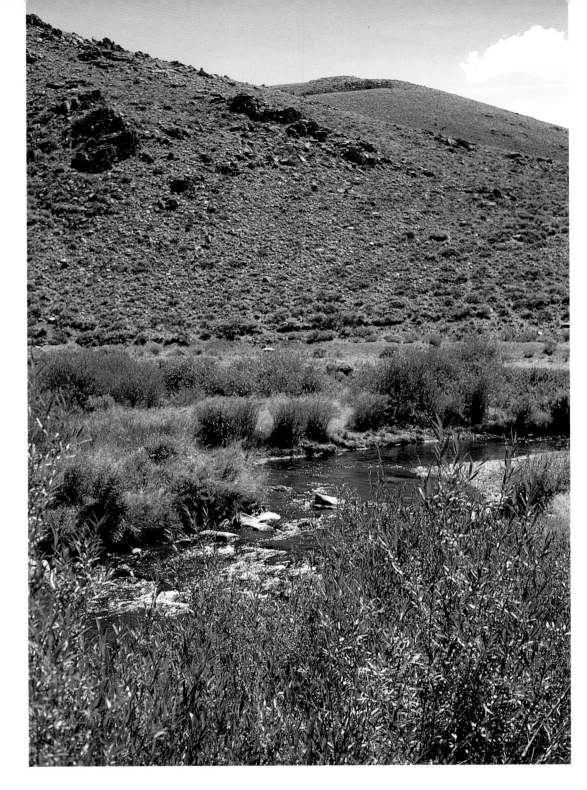

Mountain creek and bog near Cimarron, Colorado.

has passed and the canyon remained bone dry, my worry engine engages full throttle. The memory of that earlier, desiccated hike teases my tongue. But if anything, this is worse: this time I'm responsible for several other lives, including that of my own offspring. Bad enough to suffer from thirst in the desert—even worse to lead others toward that unpleasant fate. I try to will green cottonwoods and a babbling stream into being, but my attempts at conjuring fail.

Finally, there it is. Cottonwoods and willows radiate green. The canyon's eerie silence is broken by the sudden arrival of sounds: leaves rustling in an evening breeze, water sloshing across a stone ledge. We sag into the shade on the damp, copper sand and pour water

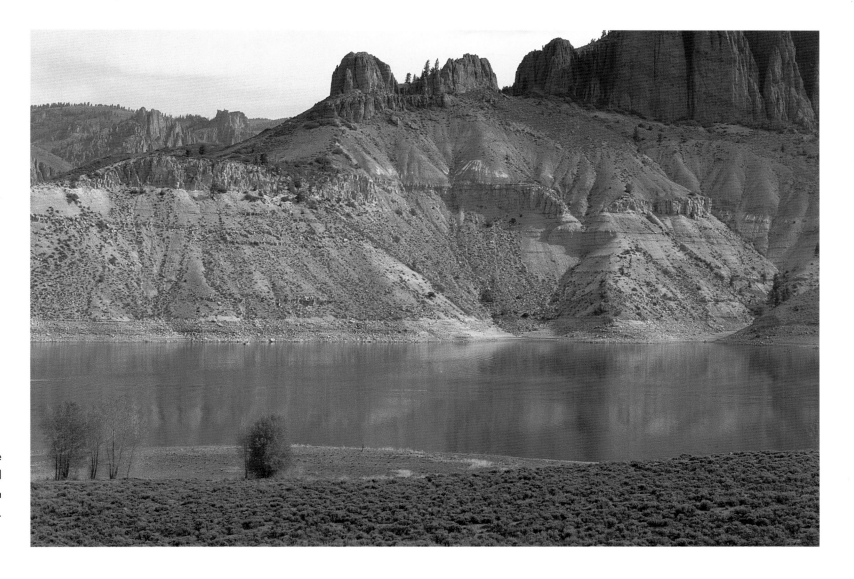

Cimarron River in the Curecanti National Recreation Area in southern Colorado.

over our sweat-encrusted heads. Though I love the open desert, and often seek it, at this moment I am drawn forcefully—literally from the interior of all my cells—toward the world of green that this emergence of water has made possible. Refreshed, we settle in to this camp I name "Touching Edges." Here, in the length of a stride, a person can exchange worlds, as different as life and death. There is no zone of gradual transition, only an abrupt boundary between the dry and the wet, and thus the sparseness and abundance of life.

Now, after telling you two tales of too little water, let me share two more of too much.

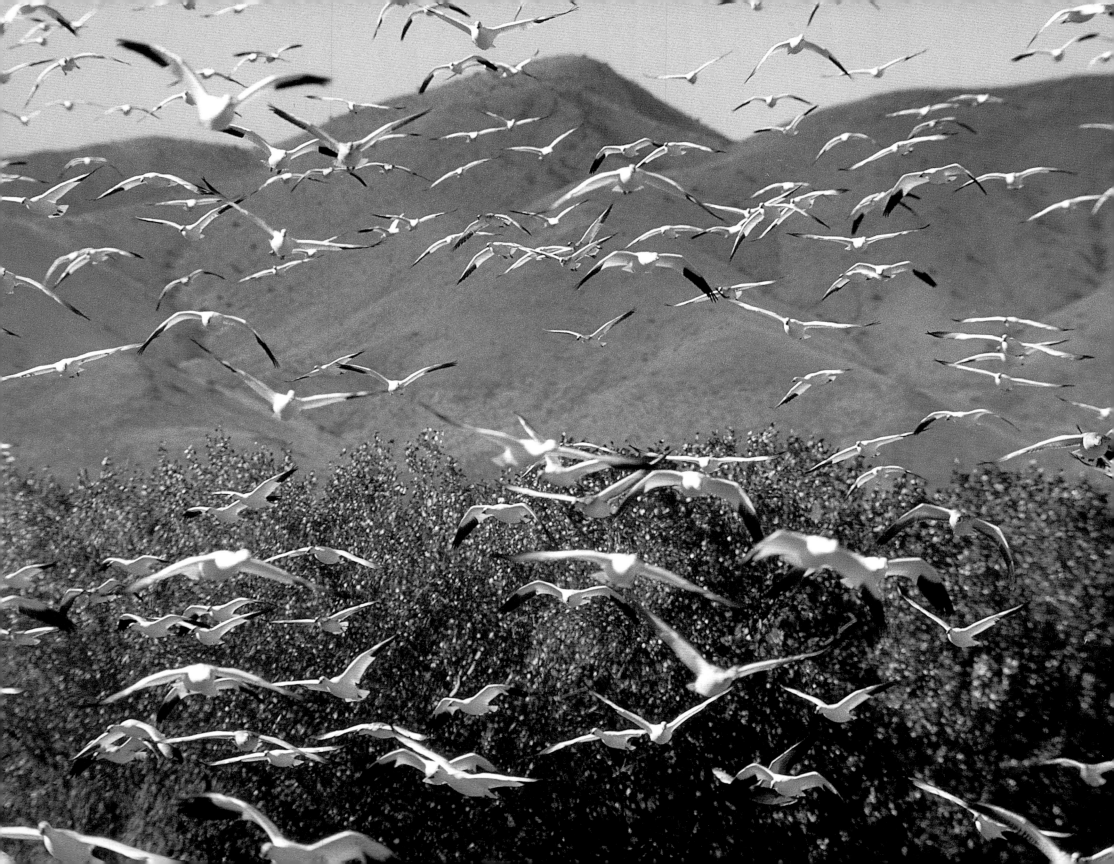

Top left: Wetlands in Glendale, Utah.

Top right: Uncompahgre River high in the San Juan Mountains, Colorado.

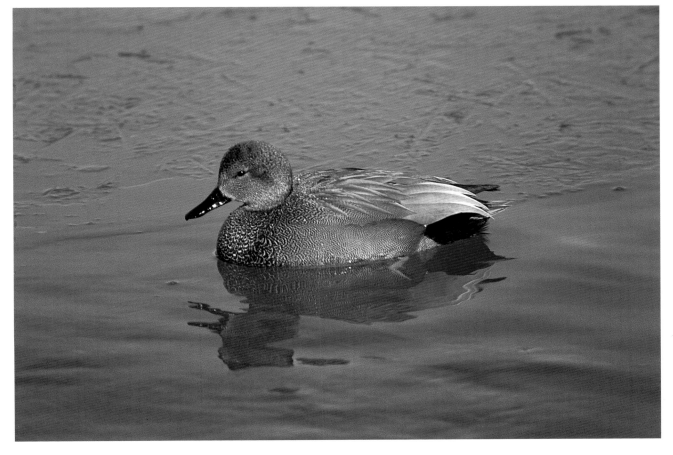

Bottom: Gadwall (*Anas strepera*) on Farm Loop in the Bosque del Apache National Wildlife Refuge, New Mexico.

Opposite: Snow geese (*Chen caerulescens*) against the Chupadera Mountains, Bosque del Apache National Wildlife Refuge, New Mexico.

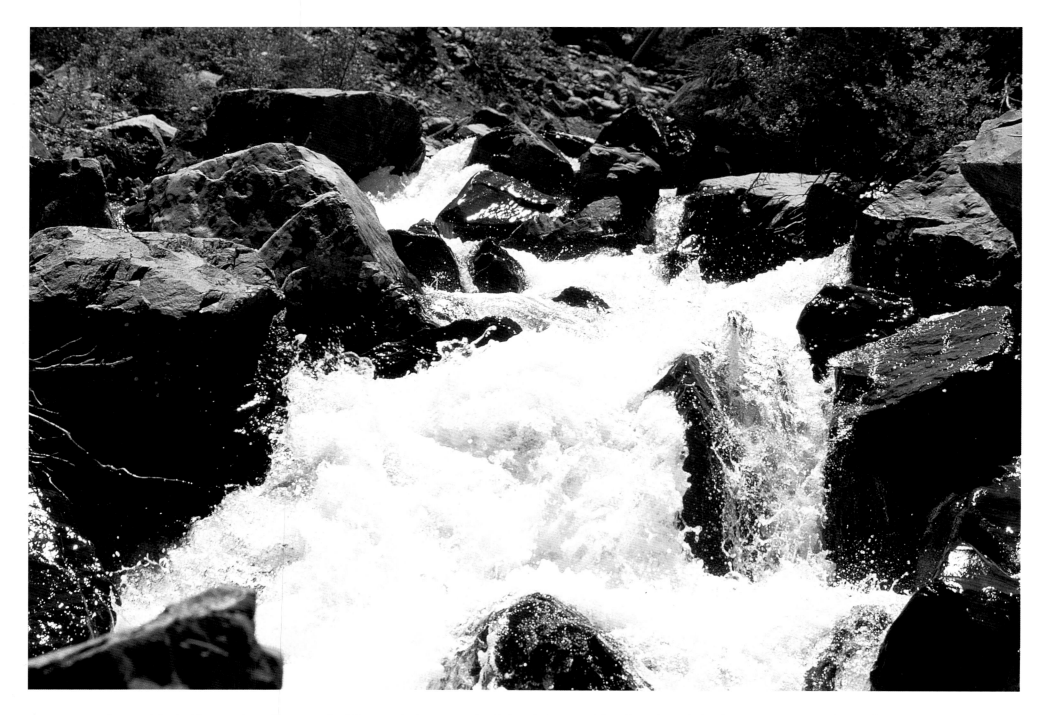

Snowmelt in the Uncompahgre Gorge south of Ouray, which runs into the Colorado River and then flows through the dry Mojave Desert to the Pacific, Colorado.

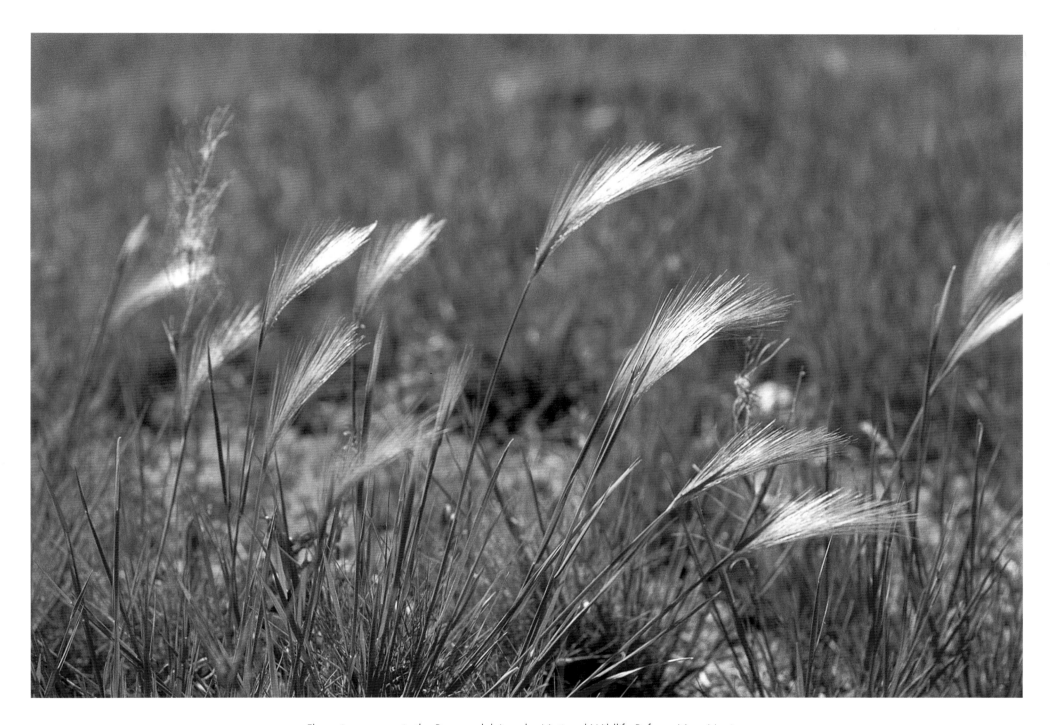

Flowering grasses in the Bosque del Apache National Wildlife Refuge, New Mexico.

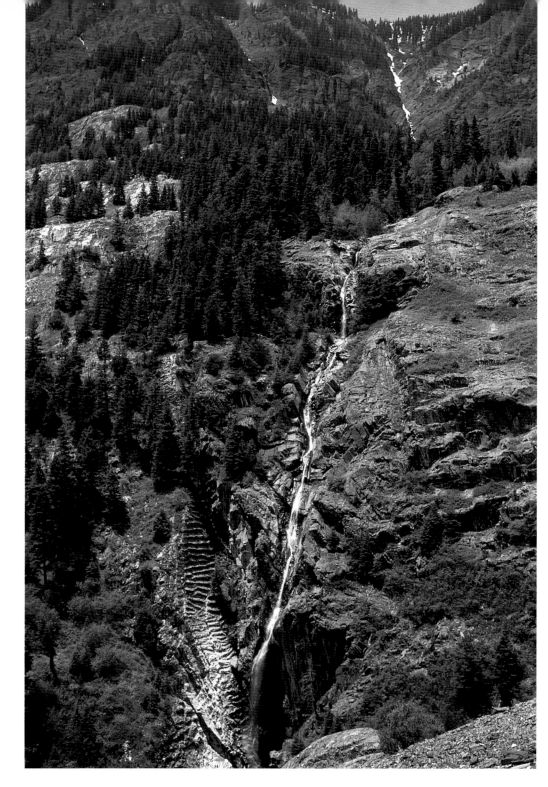

Black Canyon of the
Gunnison River National
Monument, Colorado.

One spring my five oldest friends
converged in Arizona so that we might
renew our long companionship. We
rendezvoused at the Phoenix airport,
then headed southwest, eventually to
a remote region of the Sonoran Desert,
just a few miles from the Mexican
border. We hiked in and set up camp
on a terrace beneath the dark trunks
of mesquite trees. After emptying our
packs of gear we headed back out to
the truck and loaded up again, this
time with nothing but large containers
of water, which we humped back to
our camp. With water now present, our
camp was complete, and we settled in
to a wonderful week of natural history,
rambling exploration, and fine conver-
sation. It had been an especially wet
winter, and the desert had responded

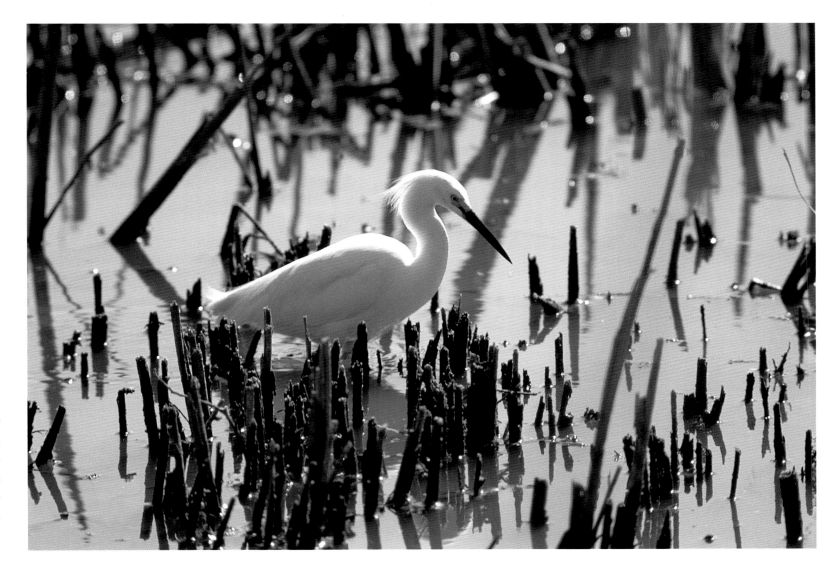

A snowy egret (*Egretta thula*) on Pond Loop in the Bosque del Apache National Wildlife Refuge, New Mexico.

with green exuberance. The spring bloom was so spectacular that we had to step with great care to avoid trampling flowers.

Blue skies and hot sun prevailed as we explored the braided network of broad, sandy washes. Mesquite trees intertwined their branches above level terraces sheathed in dense thickets of golden fiddlenecks, purple *Phacelia,* and green grasses. Always there was the flickering presence of birds. The wide washes were our highways—a hundred or so feet across of dry sand and colorful pebbles, unobstructed by vegetation. During our final hours here, however, we were reminded why they were so open.

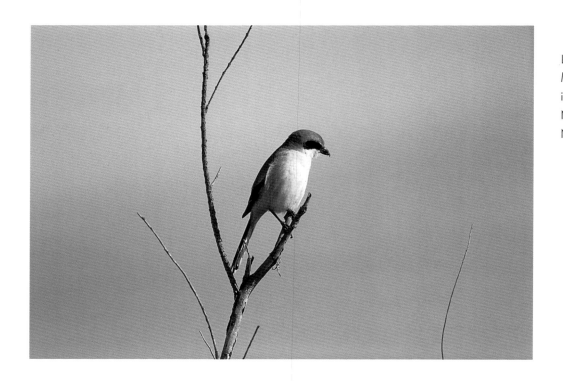

Loggerhead shrike (*Lanius ludovicianus*) on Pond Loop in the Bosque del Apache National Wildlife Refuge, New Mexico.

The afternoon before departure, we sat drinking tea and talking, contemplating our dispersal back to the nation's far corners. For the first time, shadows were absent—gray, not blue, canopied us. As the day progressed, wind picked up and clouds scrunched closer together. By late afternoon a light rain wet the wind. After supper, though, the rain abated and we fell asleep in a damp but rainless world, prepared to arise before dawn and begin our trek toward the distant airport.

We awoke in the dark to a faint drizzle. Our flashlights flicked over our backpacks as we quickly finished packing. But something was conspicuously different. *Sound*—an urgent pulsing not far off—had replaced the silence of the desert. We walked through dripping grasses to the edge of the terrace. The wash we had wandered dozens of times—indeed, had passed hours sitting smack in the middle of—had become a real river, with an impatient current and the roiling surface that forms when water can't wait. We found a stout branch and tentatively stuck it into the liquid muscle—over the knees of our tallest and nearly to the waist of our shortest. It dawned on us then— we were now on an island. Our whole geography had altered as we were forced to consider our escape route—what was island and what the "mainland"?

Yet there was no choice but to plunge into the opaque torrent. It was still so dark we could see barely see our partners, let alone anything in the water. In pairs, with arms locked for stability, we hobbled awkwardly into the rushing current. Burdened by heavy packs, we were buffeted by the stream

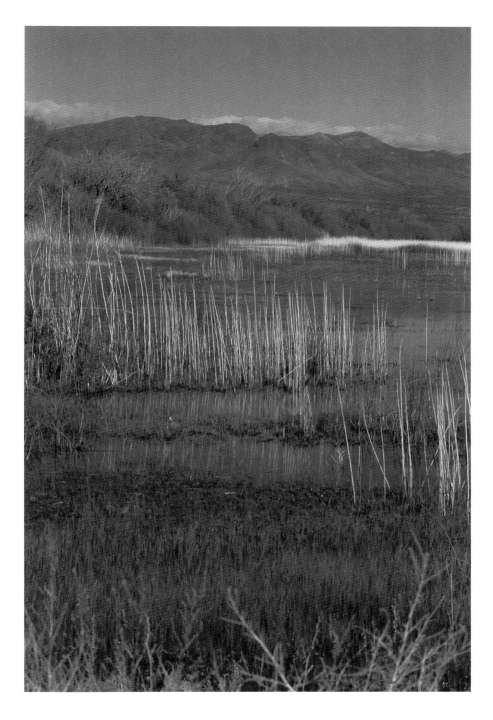

Pond Loop in the Bosque del Apache National Wildlife Refuge, New Mexico.

Rio Grande/Rio Bravo del Norte

This river, known as the Rio Grande in the United States and the Rio Bravo del Norte in Mexico, begins along the continental divide in the San Juan Mountains in southwestern Colorado, gathers runoff from the Sangre de Cristo, Jemez, Sandia, Manzano, Magdalena, and other mountain ranges, and then flows south through the length of New Mexico, until it curls eastward, forming the border between Texas and the Mexican states of Chihuahua, Coahuila, Nuevo Leon, and Tamaulipas, finally emptying into the Gulf of Mexico. Below El Paso, Texas, the river's flow is sparser and more sporadic than further upstream. Along its entire length, the Rio Grande is heavily used by people. More than 80 percent of New Mexico's human population lives along the river. A series of dams have created a string of impoundments, with all the attendant ecological complications described elsewhere in this book. Since flood regimes began to be altered by dams in the 1930s, exotic species have replaced native cottonwood-willow riparian forests over great areas—Russian olive has been especially prominent in the north and tamarisk in the south. Biologists have predicted the real possibility of cottonwood stands disappearing altogether from the Rio Grande. The conservation group, American Rivers, declared the Rio Grande to be one of the most endangered rivers in North America. In spite of this dubious honor, though, many ecological treasures remain. The biological richness of Bosque del Apache is described elsewhere in this text. Further south, studies at Elephant Butte Marsh revealed the largest known breeding congregation of water birds in New Mexico. But if the remaining riparian "bosque" (forest) is to be maintained—and hopefully restored throughout its former range—strenuous attention must be paid to the hydrologic dynamics throughout the Rio Grande watershed. Land managers concerned with the future of the Rio Grande have called for the reestablishment of natural seasonal flow patterns, management of groundwater pumping, and elimination of human disturbance in the remaining sections of native vegetation.

For more information see Abell et al. 2000, Biological Interagency Team 1993, Finch and Tainter 1995, Howe and Knopf 1991.

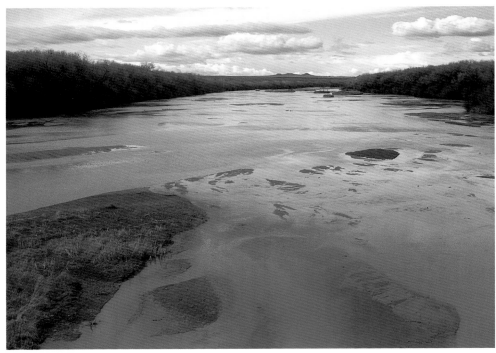

Top: The Rio Grande water flow is substantial in Albuquerque, New Mexico.

Bottom left: The Rio Grande has half the flow of water at San Antonio in contrast to the flow in Albuquerque, New Mexico.

Bottom right: Rio Grande at Las Cruces is just a trickle, New Mexico. All three pictures were taken on the same day.

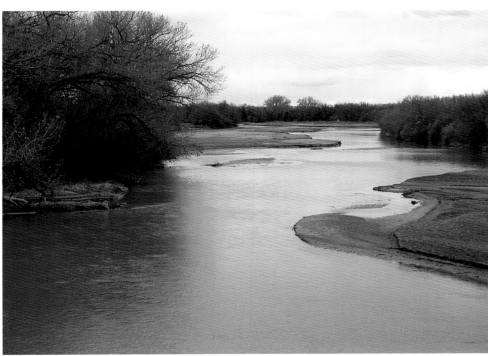

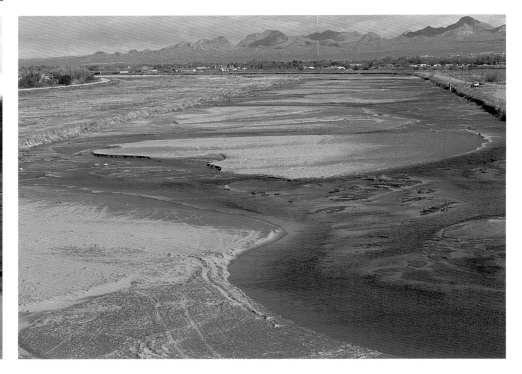

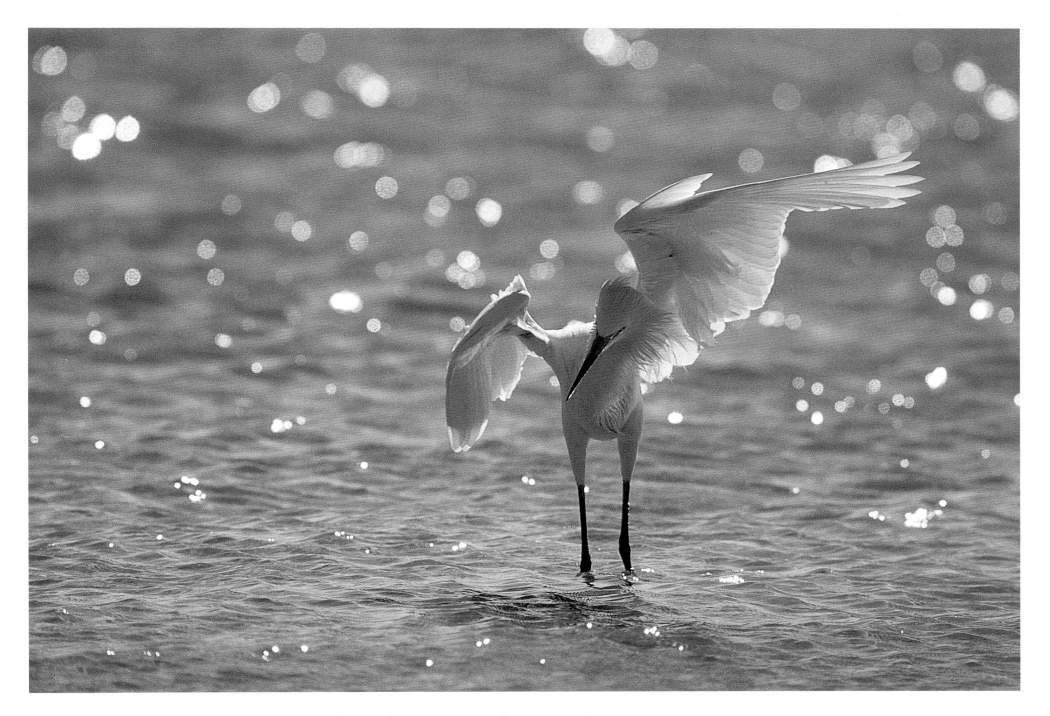

White-reddish egret (*Egretta rufescens*) in the Laguna Madre outside of Corpus Christi, Texas.

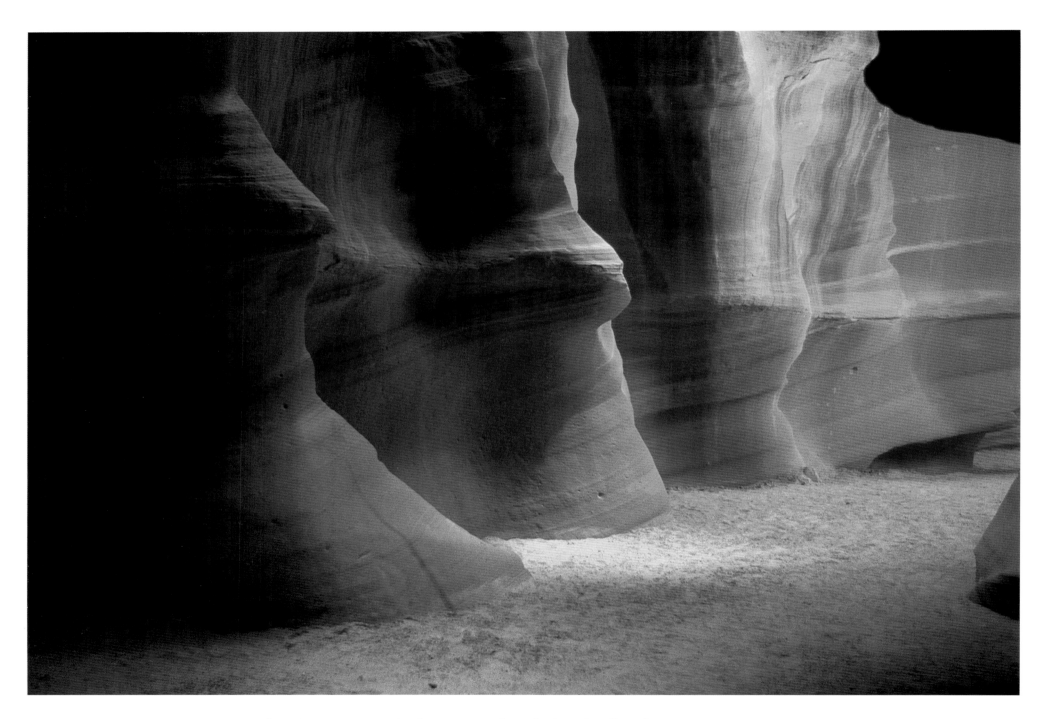

Lower Antelope Canyon was carved in the Navajo sandstone by the rushing flow of water over time near Page, Arizona.

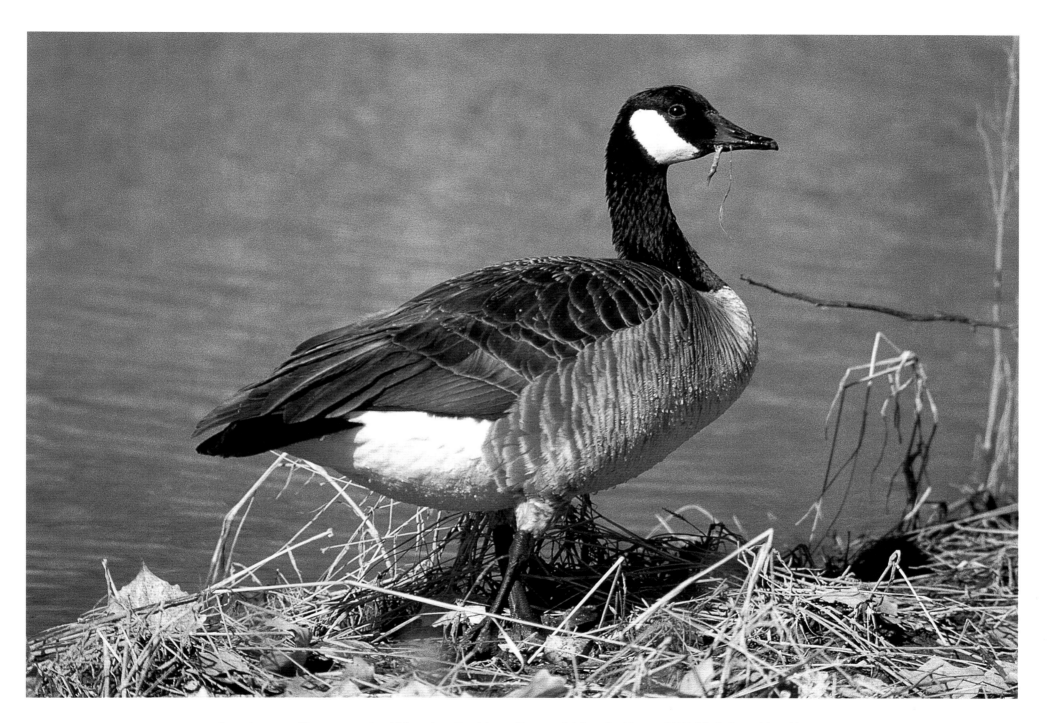

Canada goose (*Branta canadensis*) found on Pond Loop, Bosque del Apache National Wildlife Refuge, New Mexico.

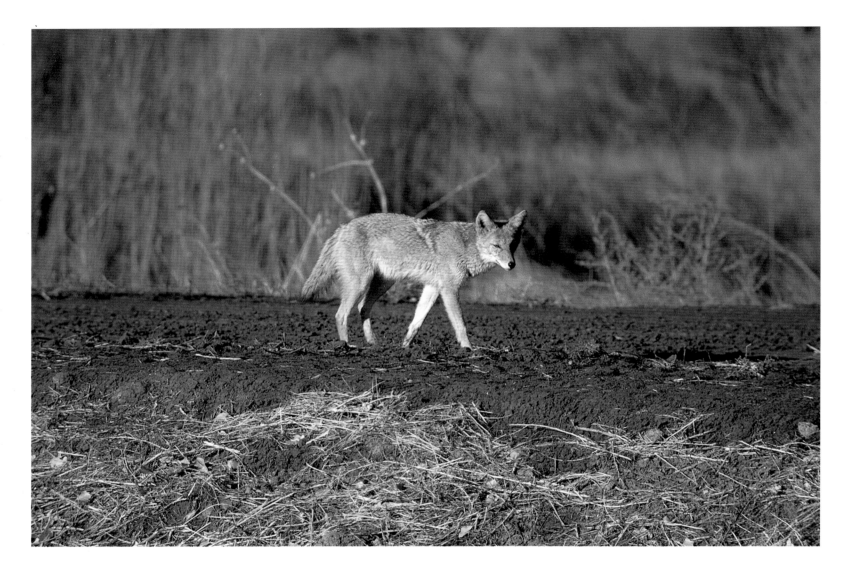

Left: Coyote (*Canis latrans*) foraging in the Bosque del Apache National Wildlife Refuge, New Mexico.

Opposite: The upper end of the Lake Powell reservoir—the flooded remains of Glen Canyon, Utah

as we stumbled into holes we couldn't see. Finally, we all made it across and began to traverse the rocky slope on the far side. We picked our way between tall saguaros and short cliff bands, paralleling the new river. The drizzle had ended and dawn arrived— pastel colors yielding to a brightening sky. The sun pierced the clouds as we reached our truck, but the surge of water still reverberated among the usu-ally silent desert terraces.

Yet another canyon, another student group. It is fall equinox. The past two weeks have been limned by the golden light of Indian summer—hot sunny afternoons, full of wild sunflowers, but with nights crisp enough to foretell the

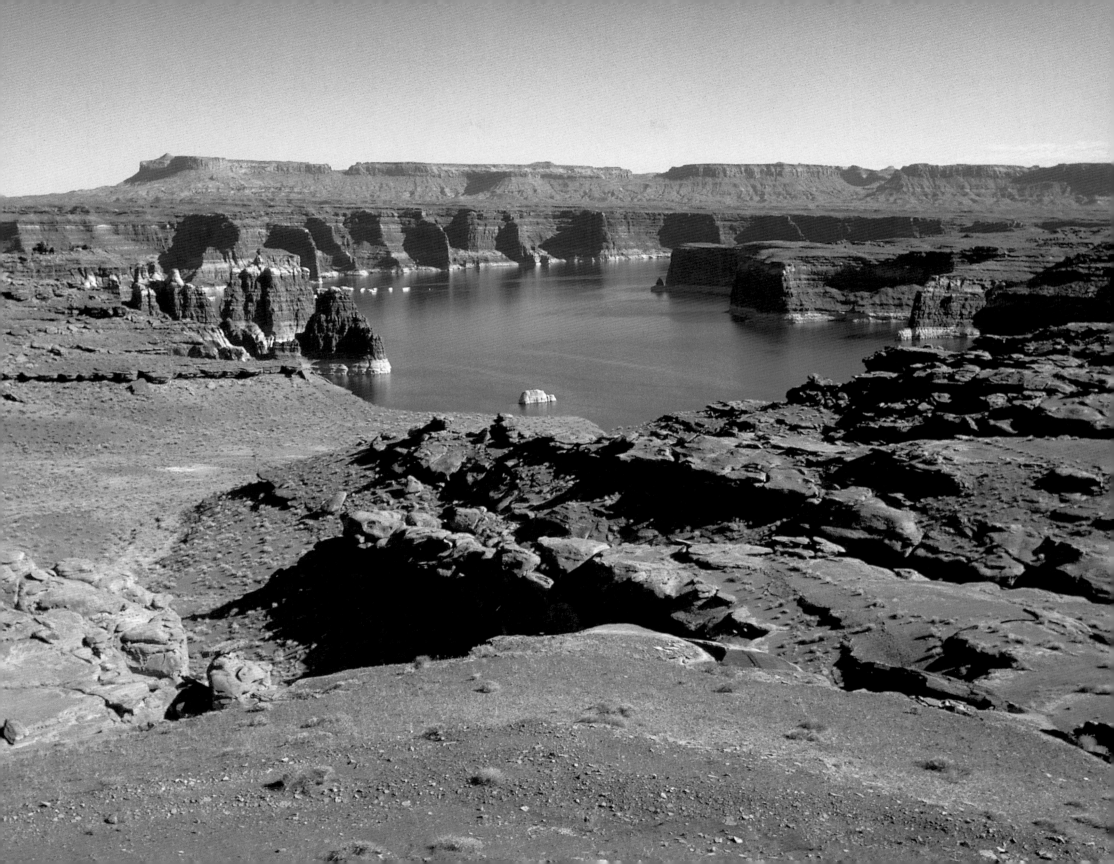

Top: Flowers along Vermillion Cliffs near the Colorado River, Arizona.

Bottom: Reeds on Farm Loop, in the Fall, Bosque del Apache National Wildlife Refuge, New Mexico.

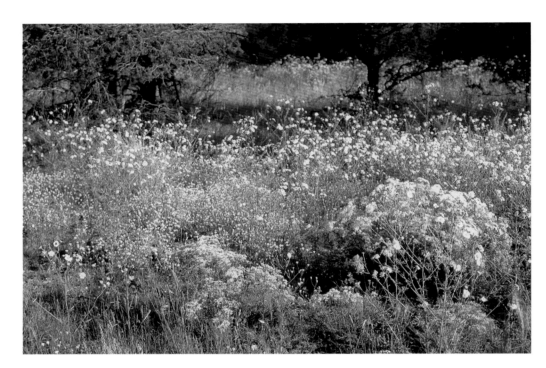

season ahead. But as we approach the canyon system we plan to explore for the next week, the golden light has disappeared behind a close canopy of gray. Clouds blow in, then rain sputters, emphasizing this dramatic change of weather and season. We camp on soggy sand at the trailhead and listen to drizzle dance on the tent and depart, dance and depart all night long.

As we prepare to hike in the morning, the rain picks up a bit, but still just feels like a minor inconvenience. We begin to move toward our intended camp—a dry alcove awaits us within two hours of easy walking. By the time we reach our halfway point, though, the situation has radically worsened. We lean under the slim shelter of a narrow overhang; with shaking, stiff

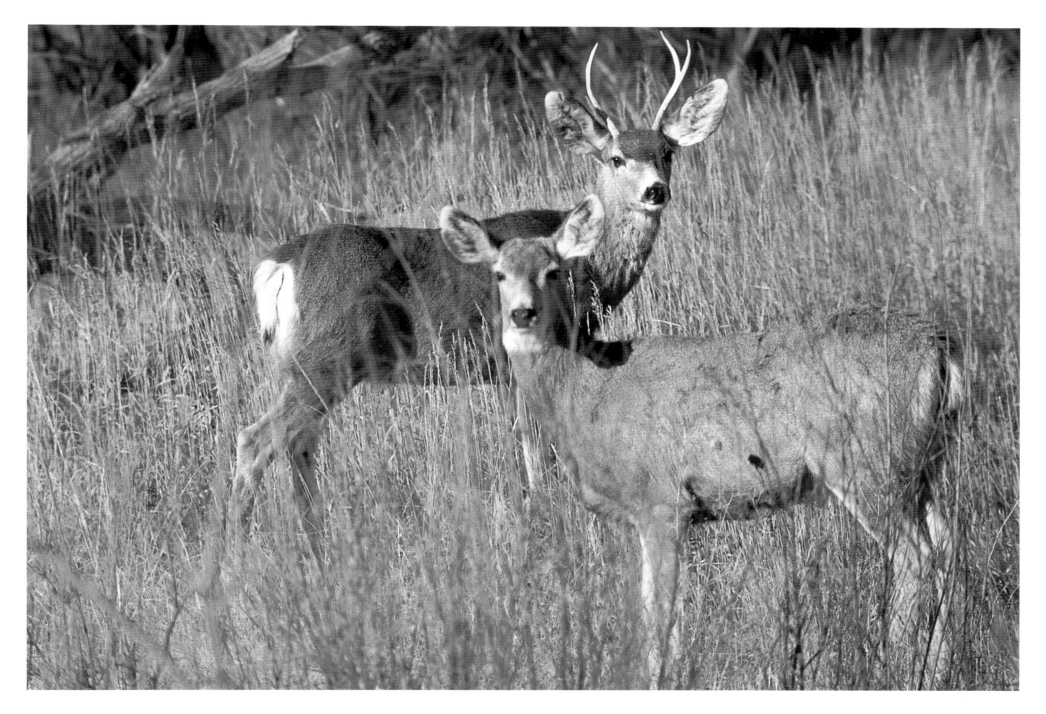

Mule deer (*Odocoileus hemionus*) in the Maxwell National Wildlife Refuge, south of Raton, New Mexico.

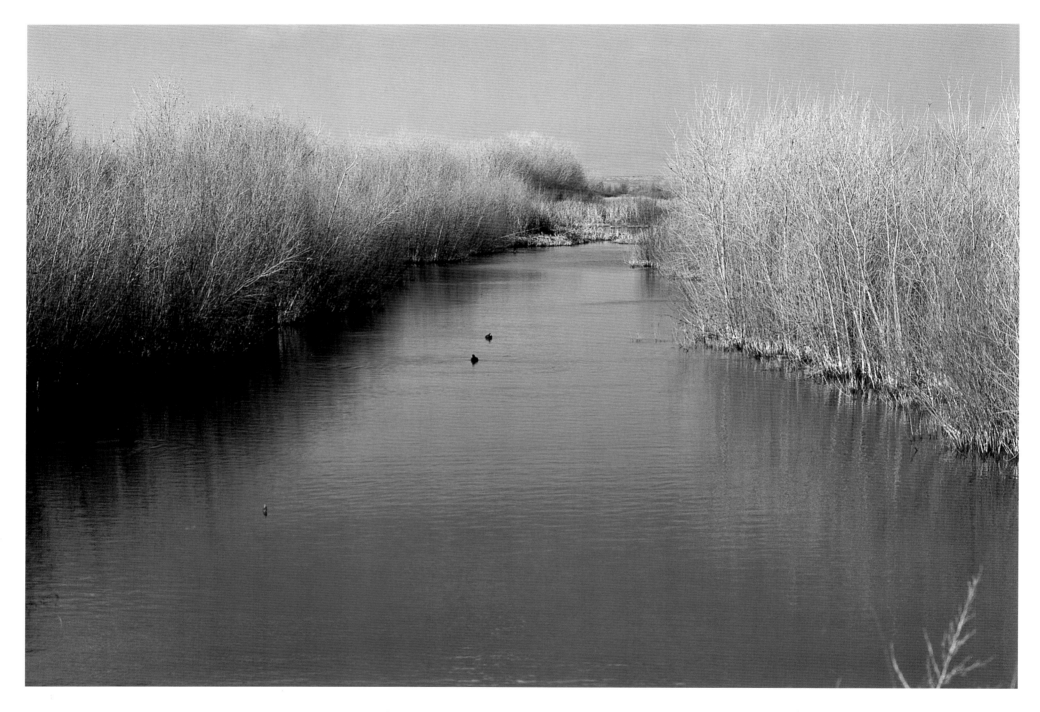

Waterscape on Pond Loop in the Bosque del Apache National Wildlife Refuge, New Mexico.

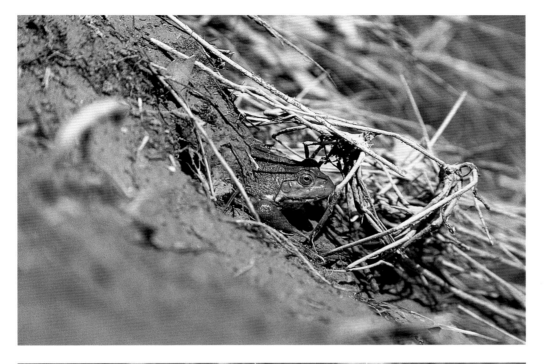

Top: Frog on the bank of the San Pedro River, Arizona.

Bottom: Bosque del Apache National Wildlife Refuge Pond Loop reeds, New Mexico.

fingers we replace dripping t-shirts with winter layers and rain coats. The watercourse—usually to my ankles in the deepest pools—now swirls past in a muddy torrent, sweeping away chunks of the sand terrace we stand upon. If I didn't know that an enormous flood-proof alcove lay around a few more bends, I would probably direct us to retreat.

Wary now, hiking in tight pairs, we lunge into the stream, which is now up to everyone's thighs or higher. We make it safely to the alcove, bundle into all our clothing, and slide into sleeping bags while we eat lunch. The rain continues for just another hour, but all afternoon we watch hundred-foot waterfalls leap off the rock ledges above us as we sit behind a ragged

Marshes Along the Rio Grande:
Bosque del Apache National Wildlife Refuge (New Mexico)

Twenty miles south of Socorro, New Mexico, the Bosque del Apache National Wildlife Refuge straddles the Rio Grande. Here, near the northern edge of the Chihuahuan Desert, almost thirteen thousand acres of moist bottomlands create a mecca for waterfowl, sandhill cranes, and other wetland birds. The floodplain of the Rio Grande itself comprises almost a third of this acreage, while on the remainder diversion and active management of the river's precious water creates a mosaic of wetlands, riparian forests, and grain fields. These fields are tilled in summer so that they might provide food for the refuge's avian visitors in winter. From November through February, Bosque del Apache hosts many thousands of water birds, including sandhill cranes (each fall the refuge celebrates their return with a Festival of the Cranes), various species of ducks and geese, white pelicans, and a multitude of others. Although details of the wetlands here have been altered by recent human management, this section of the Rio Grande valley has traditionally been a haven for wetland species and for people. "Bosque del Apache" is Spanish for "forest of the Apache," as these native people frequently camped in the area. Evidence of earlier human occupation makes clear that these wetlands harbored Piro Indians more than seven hundred years ago. Today the floodplain of the Rio Grande and other wetlands of Bosque del Apache continue to provide an ideal setting for people to encounter desert wetlands.

For more information contact U.S. Fish and Wildlife Service, Bosque del Apache National Wildlife Refuge, P.O. Box 1246, Socorro, NM 87801.

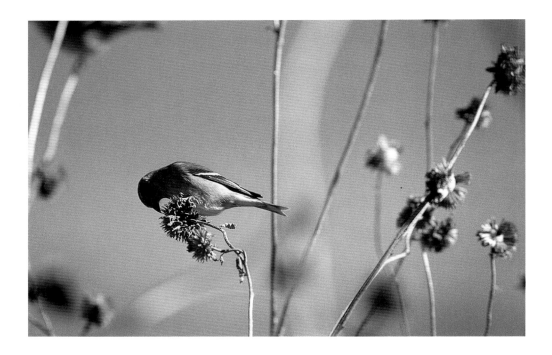

Above: Female Lesser goldfinch (*Carduelis psaltria*) on Pond Loop in the Bosque del Apache National Wildlife Refuge, New Mexico.

Opposite: Fall on the Pond Loop in the Bosque del Apache National Wildlife Refuge, New Mexico.

curtain of water. For two days we cannot leave the safety of the alcove, for crossing the trickle-turned-torrent would be too perilous. The stream is so sediment-laden that we cannot see our own fingers in it; before drinking this slush we must let the silt settle for an hour or two.

The storm passes through; sun and brilliant blue sky reassert themselves. Though the stream still rips along, its level has dropped enough that we can safely make it across and clamber up onto the slickrock bluffs above. Here,

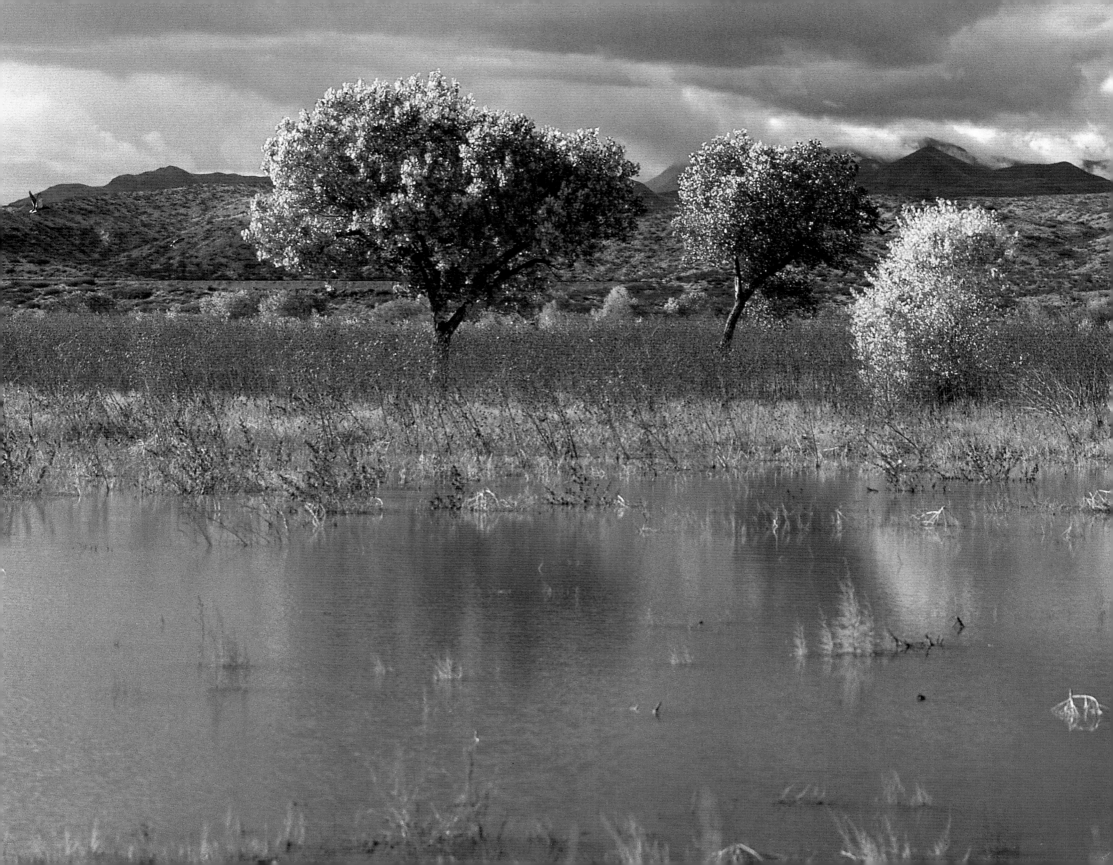

where it is normally dry as the moon, cradled in bare rock we find muddy pools a hundred feet across and three feet deep. As we watch, the water jiggles with life. Thousands of small crustaceans propel themselves through the aquatic habitat that didn't exist three days before.

Water plays by different rules in the desert. It appears when we don't expect it, hides when we want it most. One day we find an old spring dry and another usually barren rock swimming with life. Rain falls from dark thunderheads, but never reaches the parched ground. Dry washes abruptly become rivers. In all this unpredictability, one thing holds true: water in the desert enables life. Surely this gift of intense life, so rare in desert country, is worthy of the name *magic.* Surely it is worthy of our attention and gratitude.

Here's the simple fact: there is no greater alchemy on earth than the simple addition of water to dry country. Medieval technicians in turreted castles, cauldrons of quicksilver bubbling and steaming, strove to fashion gold from simpler metals. But none could hope for as fundamental a magic nor as priceless a product as the collaboration of clear water and parched earth. Together they spin the fabric of life out of invisible threads. Add water to the desert and you create life itself. Next to this, what is gold?

Whether in a rain puddle suddenly infused with prehistoric-looking tadpole shrimp, a seep of fossil water squeezed to the surface by tilted rock layers and framed by ferns, or a desert stream bursting with birdsong in spring—there is no greater alchemy, no finer fabrication. Wealth has long been associated with scarcity—rare items are always valued more highly than common ones. Water in the desert epitomizes wealth: rich green life comprises the scarcest, most enabling treasure among stony hills.

The story of water in the desert, though, is not only about miracles and natural splendor. For water does indeed represent wealth in desert lands, and like all forms of wealth, it has often inspired rash and greedy human actions. Landscapes once rich with life

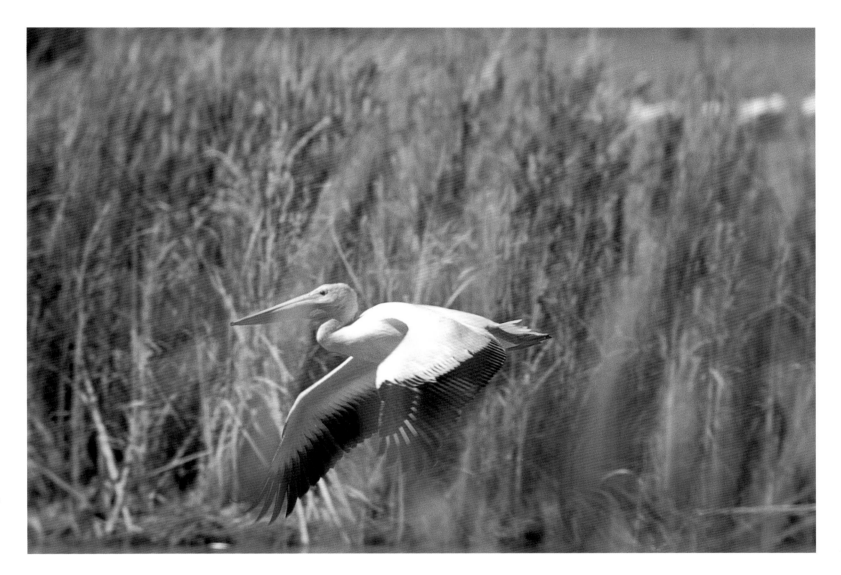

White pelican (*Pelecanus erythrorhynchos*) on Pond Loop in the Bosque del Apache National Wildlife Refuge, New Mexico.

have been degraded beyond recognition. Green worlds have turned brown. Exploration of desert wetlands—whether on foot, with photographs, or in words—involves vacillating between tremendous, uplifting beauty and great, heartbreaking degradation. We offer the images and words in your hands that you might grasp the beauty more readily and join the chorus of voices calling for an end to despoiling of these treasure-lands.

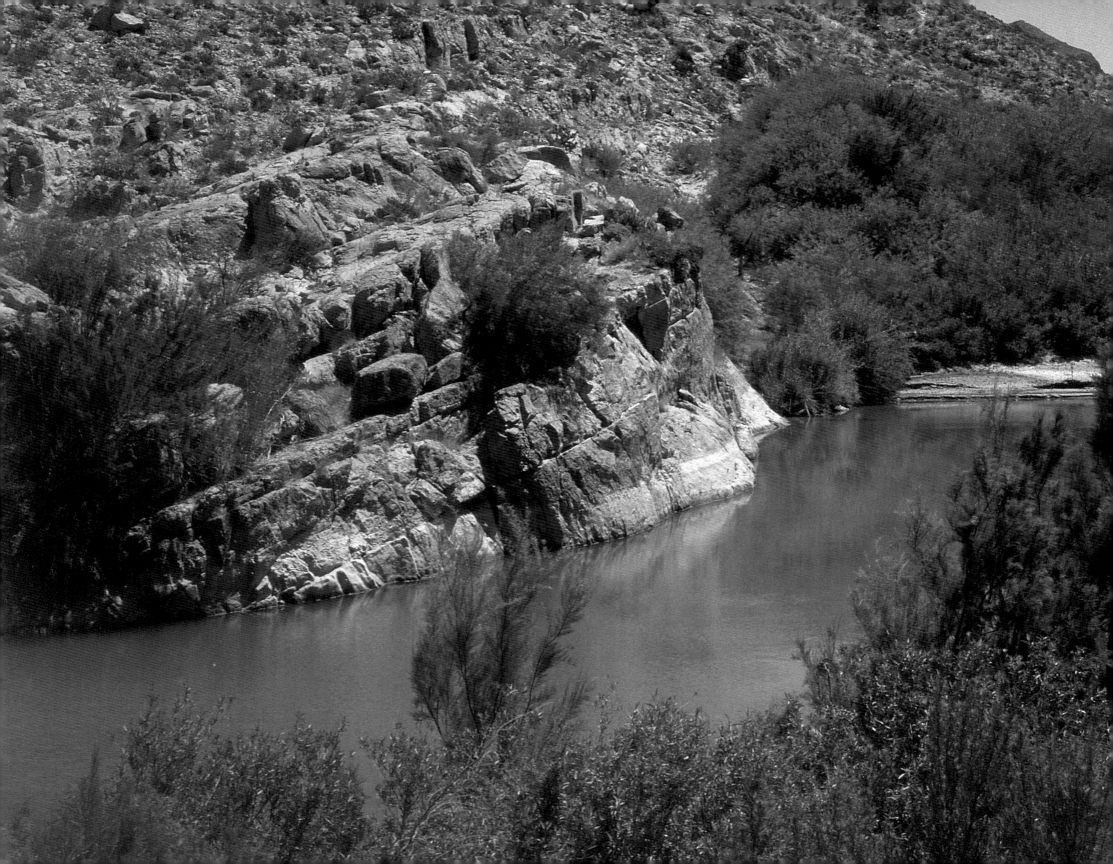

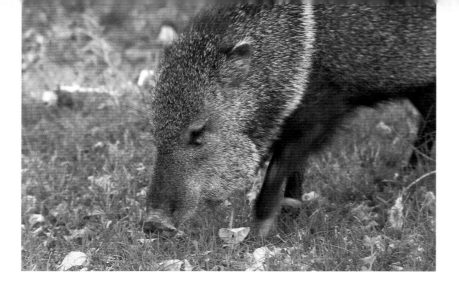

Above: Javelina (*Pecari angulatus*), Cottonwood Campsite, Big Bend National Park, Texas.

Opposite: Rio Grande, Big Bend National Park, Texas.

2. Getting Our Bearings

At first glance "desert wetlands" is a contradiction in terms: wetlands in drylands? So let's get clear what we mean by "desert" and "wetlands"— and how they might implausibly intersect.

The word "desert" comes from a Latin root meaning abandoned or forsaken. While this tells us more about the cultural values of Romans than about ecology, it is clear that what has forsaken these lands we call deserts is water. It turns out that deserts are remarkably difficult to define, but the one thing that all definitions share is extreme aridity. *How* dry a place must be to be considered desert becomes more problematic. Some geographers have simply measured how much moisture came out of the sky, and if less than ten inches per year, declared the place a desert. More sophisticated definitions concern the relationship between an ecosystem's water input—precipitation—and its tendency to lose water to the atmosphere. Water can be lost from the ground (evaporation) or through the tissues of plants (transpiration). *Potential evapotranspiration* refers to the amount of moisture that could be lost to the atmosphere, both directly from the ground and through the workings of plants, if only it was there to lose. Potential evapotranspiration, then, gauges the environment's capacity to suck moisture out of an ecosystem. One simple way ecologists get a handle on this capacity is to place a broad pan of water out in the elements and measure how much water evaporates in the desert sun. This so-called "pan evaporation" shows, for example, that the climate of Tucson can evaporate

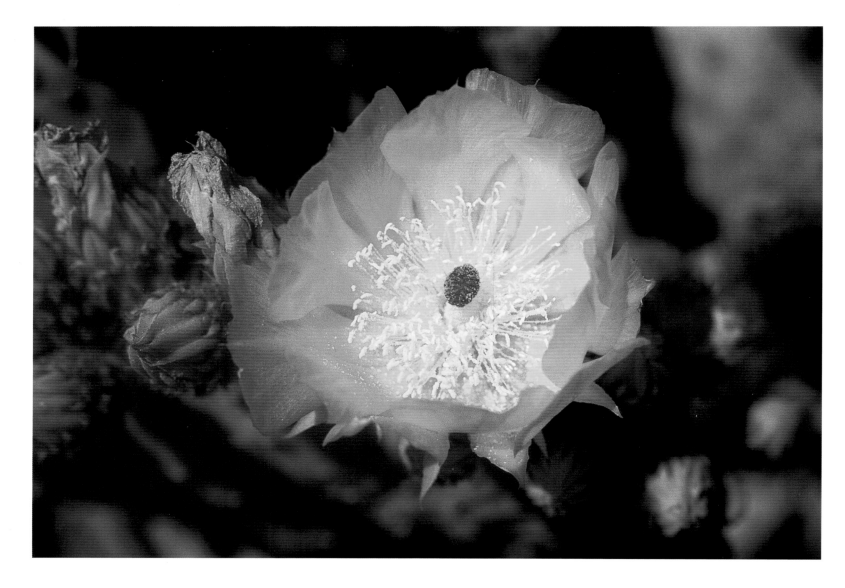

Left: Big Bend prickly pear cactus flower (*Opuntia phaeacantha*), Big Bend, Texas.

Opposite: Sandhill cranes (*Grus canadensis*) roost overnight before dispersing for food, Bosque del Apache National Wildlife Refuge, New Mexico.

eight times more water than it actually receives as rain. (An oft-used conversion factor considers potential evapotranspiration to be sixty percent of pan evaporation.) Lands where potential evapotranspiration exceeds precipitation—where the power of drying exceeds the capacity for wetting—are usually considered deserts.

Some ecologists have attempted to define deserts from a more biological perspective; one recent definition posits that "a desert is a biological community in which most of the indigenous plants and animals are adapted to chronic aridity and periodic, extreme drought, and in which these conditions are necessary to maintain

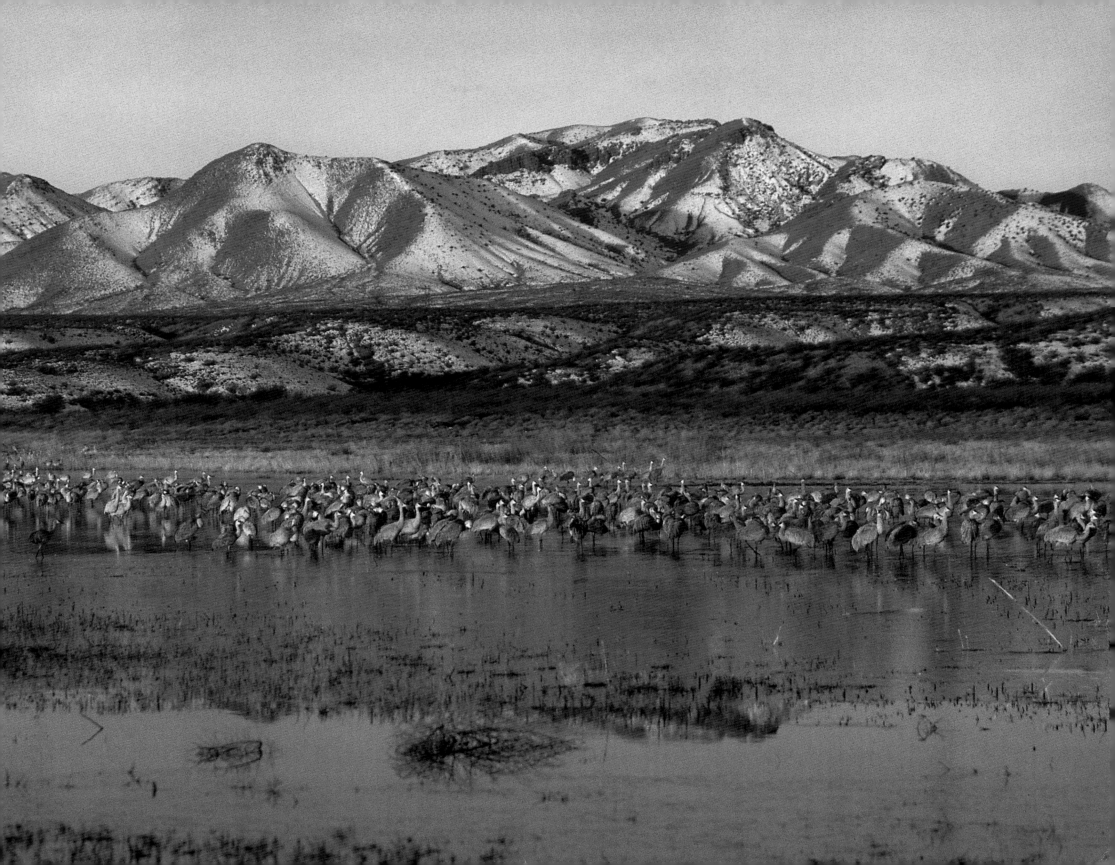

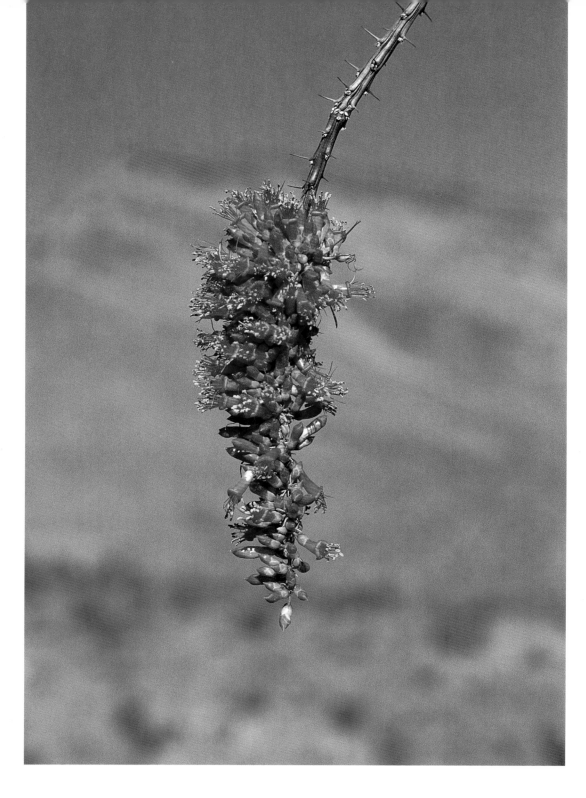

Ocotillo (*Fouquiera splendens*) in bloom. It plays an important role as food for hummingbird migration in early February, Big Bend National Park, Texas.

the community's structure." While exact, universal definitions of a desert will likely remain elusive (along with those of virtually any ecological community—Nature doesn't lend itself to simplifications!), suffice it to say that lack of available moisture defines a desert.

In attempting to understand the vast desert lands of North America, which range 1,800 miles from north to south and 1,200 miles west to east, geographers have found it useful to distinguish four different deserts, based on flora, fauna, and climate, especially precipitation patterns. The northernmost, highest, and coldest of the North American deserts is the Great Basin Desert (sometimes called the Intermountain Desert because it extends well beyond the hydrographic

Bog in Rio Grande Village, Big Bend National Park, Texas.

region of internal drainage known as the Great Basin). In this vast area between the Cascade-Sierra ranges and the Rocky Mountains, low winter temperatures limit plant growth to the summer. Low, small-leaved shrubs such as sagebrush, blackbrush, and saltbush characterize plant communities; trees are virtually absent and succulents rare.

The Sonoran Desert includes much of southern Arizona and southern California and a large portion of three Mexican states—Baja California Norte, Baja California Sur, and its namesake, Sonora. In the Sonoran, freezes are quite rare, and the flora is more tropically derived. Blessed with two rainy seasons—wet frontal systems in winter and localized monsoons in summer—the Sonoran Desert has a resulting high diversity of both species

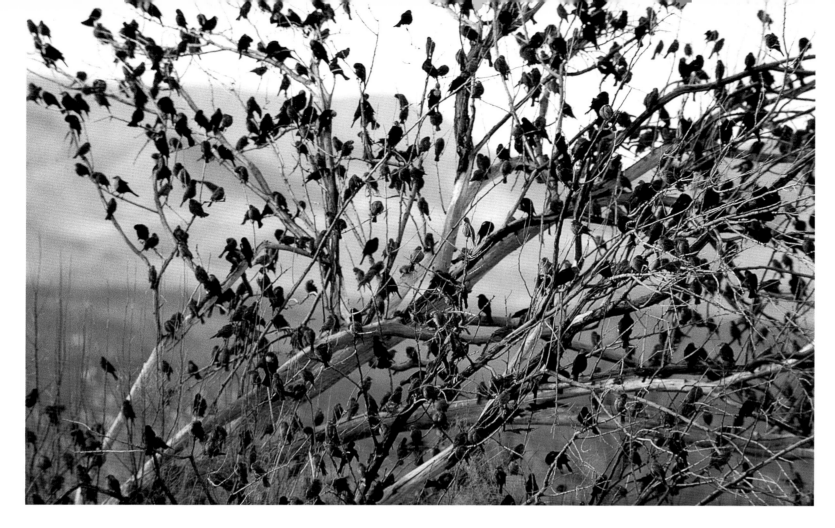

Red-winged and yellow-headed blackbirds (*Agelaius phoeniceus* and *Xanthocephalus xanthocephalus*) in the Bosque del Apache National Wildlife Refuge, New Mexico.

and plant growth forms. Characteristic plants include columnar cacti, such as saguaro, organ pipe, and cardón, and several trees of the legume family, including mesquite, ironwood, palo verde, and acacia—for this reason it is sometimes referred to as an arborescent desert. A few years back I knew of an ecologist from Saudi Arabia who came to visit the famous Sonoran Desert (probably the most studied desert in the world, it figures prominently in the scientific literature). When he arrived, eager to see the Sonoran at last, he was ushered from the airport to open space at the edge of Tucson. As he gazed upon a plain of tall cacti and abundant small trees, he quietly inquired, "Where's the desert?"

The relatively small Mojave Desert of southeastern California, southern Nevada, and northwestern Arizona has prominent winter precipitation. Freezing temperatures are common at higher elevations, but not in low, hot basins such as Death Valley. The famous

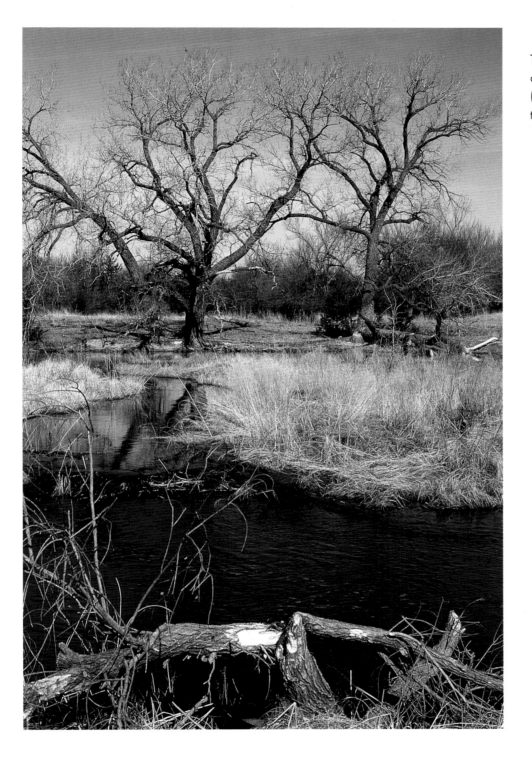

Joshua tree, often thought to indicate the Mojave, primarily grows only along its upper perimeter. Many low basins of the Mojave are sparsely vegetated by hardy shrubs, such as creosotebush. Some ecologists think the Mojave Desert doesn't really exist. Rather, these skeptics suggest this region may simply be a broad transitional zone between the Great Basin and Sonoran Deserts.

The Chihuahuan Desert extends from southeastern Arizona through southern New Mexico and southwestern Texas down onto the Mexican Plateau. Although it is the southernmost of the deserts, it is subjected to winter freezes due to its high elevation. Typical vegetation consists of low shrubs, abundant leaf succulents, such as agaves, and

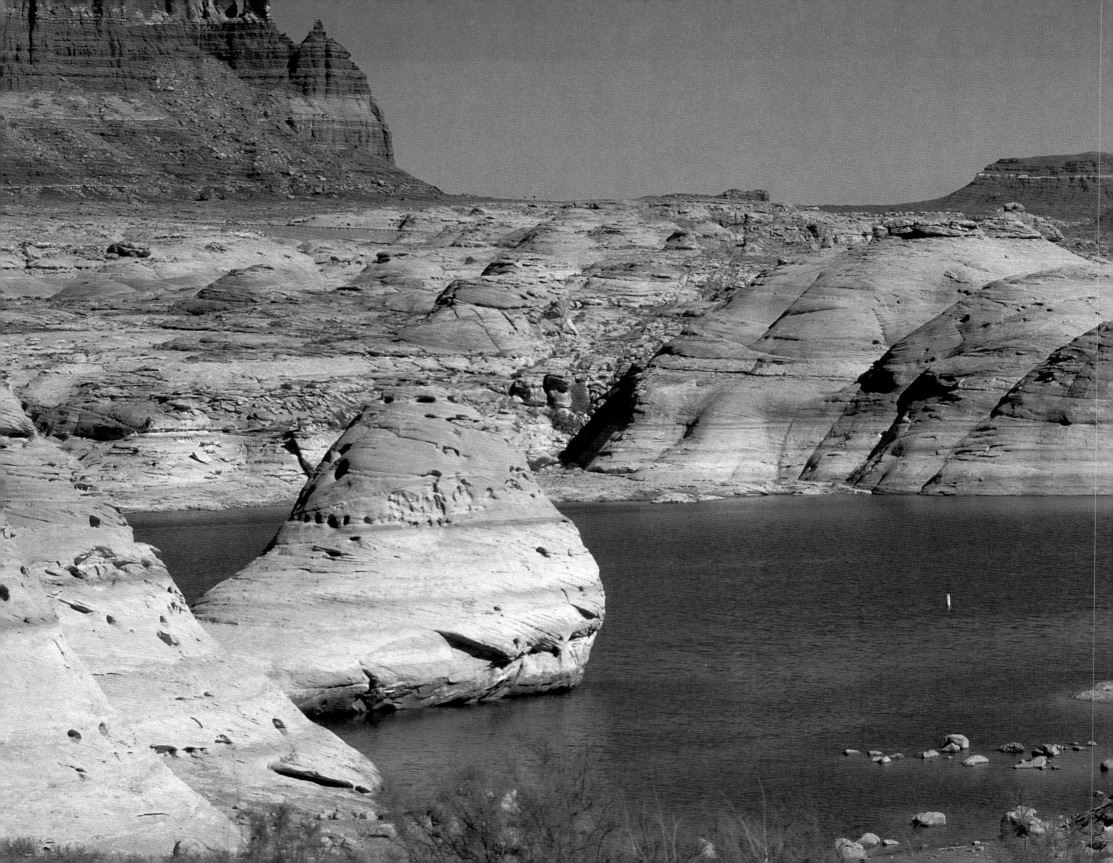

Top left: American avocet (*Recurvirostra americana*) snoozing off Farm Loop, Bosque del Apache National Wildlife Refuge, New Mexico.

Top right: Big Bend National Park, Hot Spring on the Rio Grande.

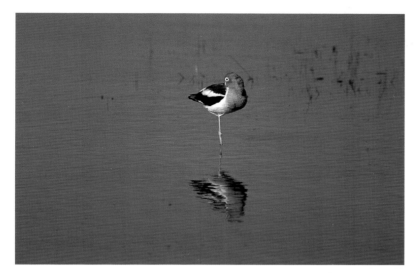

Bottom: Big Bend National Park, Texas.

Opposite: Lake Powell was created by the damming of the Colorado River. Some people believe the dam should be removed, reopening Glen Canyon, Utah.

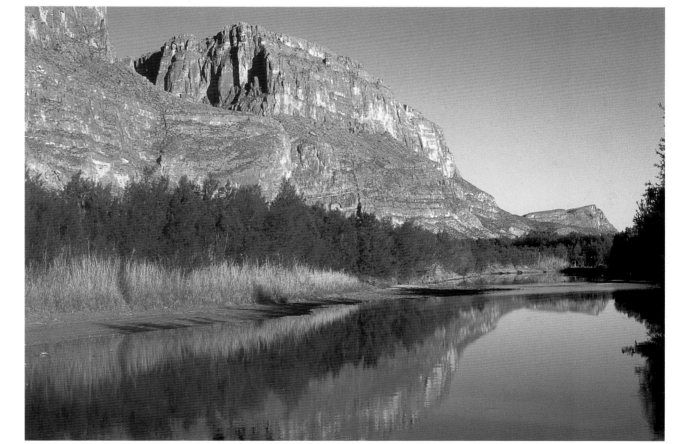

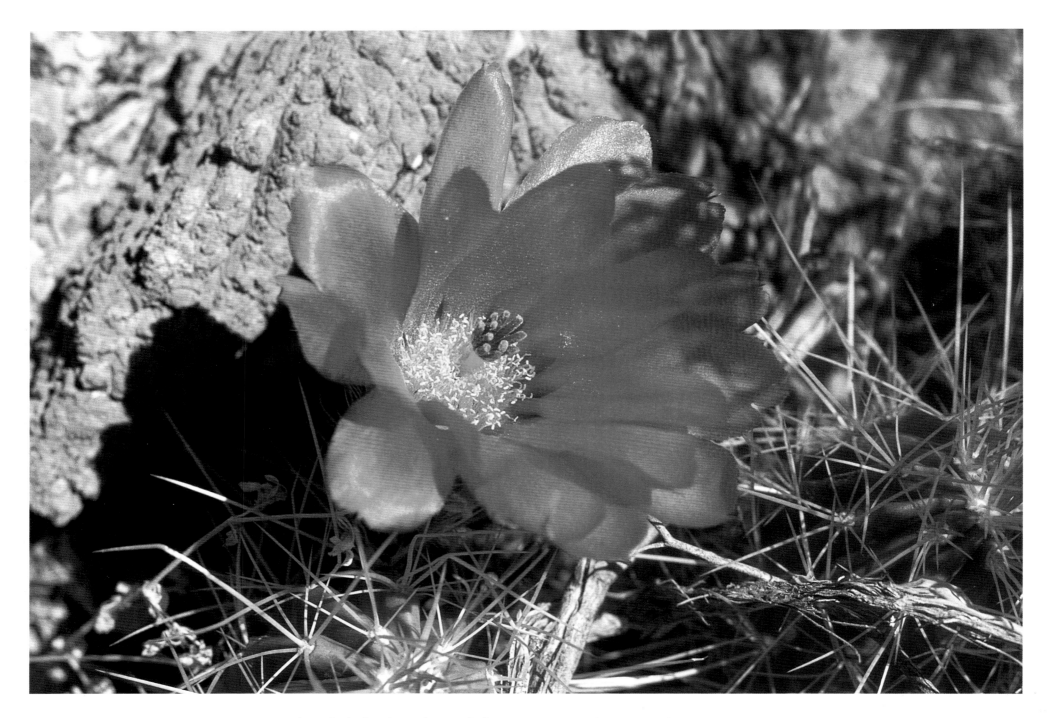

Strawberry hedgehog (*pitaya*) cactus (*Echinocereus enneacanthus*), Big Bend National Park, Texas.

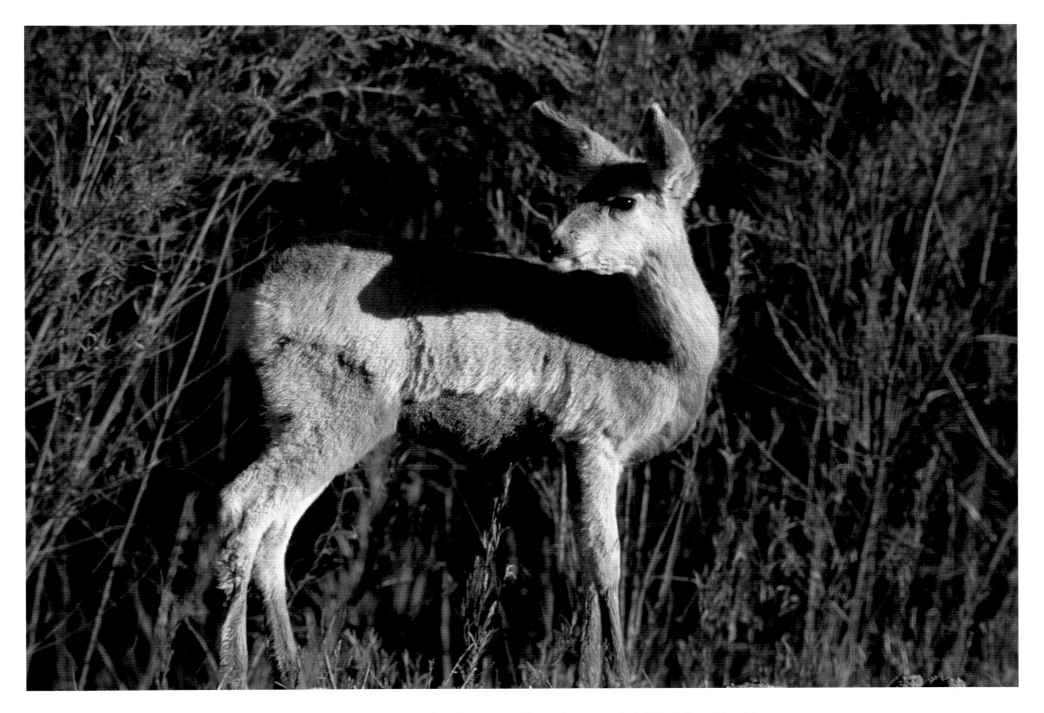

Mule deer (*Odocoileus hemionus*) in the Bosque del Apache National Wildlife Refuge, New Mexico.

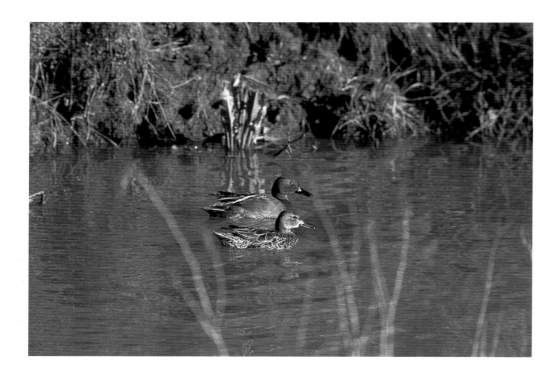

Left: Cinnamon teal (*Anas cyanoptera*) on Pond Loop in the Bosque del Apache National Wildlife Refuge, New Mexico.

Opposite: Cimarron River east of Cimarron, Colorado.

small cacti. In contrast to the Sonoran, the Chihuahuan Desert generally lacks trees. Predominant precipitation arrives as summer rain. Because of its more easterly position, Chihuahuan Desert vegetation in some areas mixes influences with the adjacent Rocky Mountains and Sierra Madre of México. The northernmost frontier of Chihuahuan Desert extends, finger-like, up the valley of the Rio Grande in New Mexico. The rich wetlands of the Bosque del Apache refuge lie in this northern finger.[1]

While the boundaries between the four deserts sometimes interfinger and blur—as in southeastern Arizona—they provide a useful framework for understanding arid ecosystems on this continent. Most of the photographs you see in this book come from the Sonoran and Chihuahuan Deserts.

What, then, is a wetland? This term has a much shorter history of human usage than "desert," having only been coined in the 1950s. Like "desert," though, "wetland" is more difficult

to define than one might assume. Some ecologists have simply defined a wetland as an area that receives moisture in excess of local precipitation. This excess moisture derives from the configuration of the physical landscape—whether mountainous topography funnels runoff into a lowland, or underground geologic structure lifts groundwater to the surface. In either case, regional geology determines hydrology, which in turn influences the geographic distribution of wetland habitats.

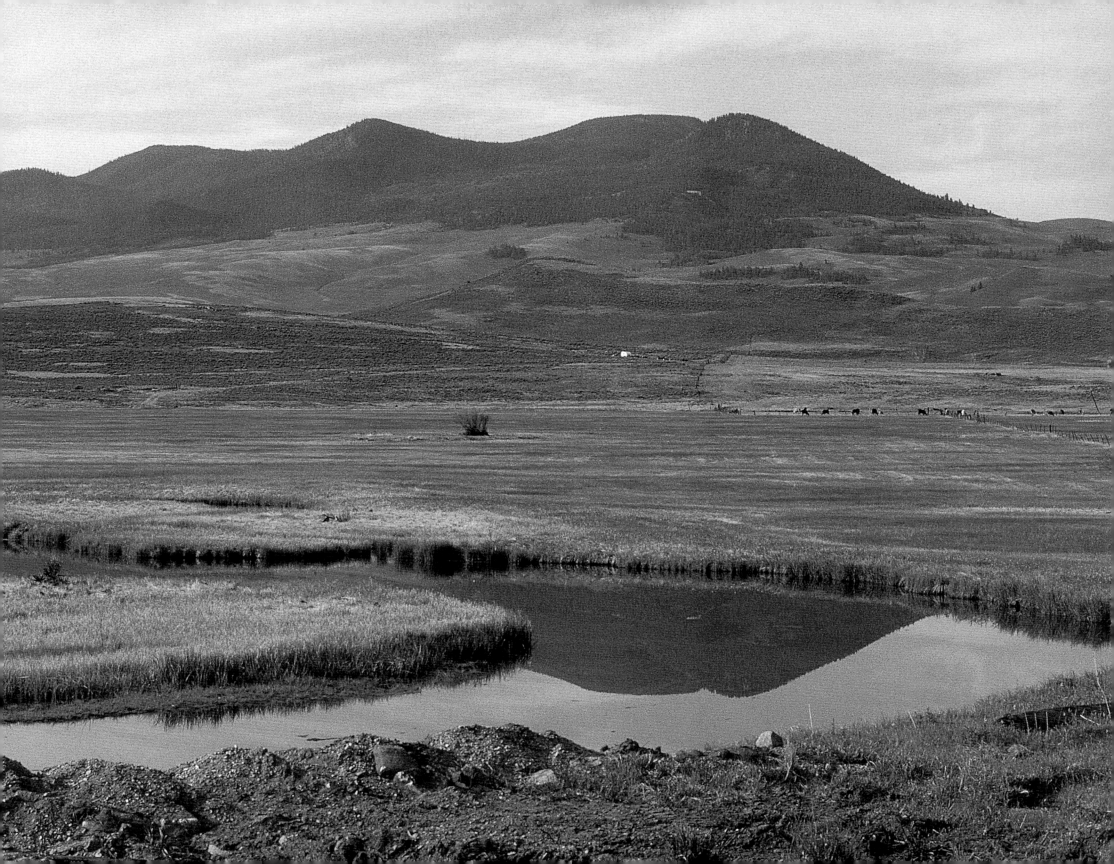

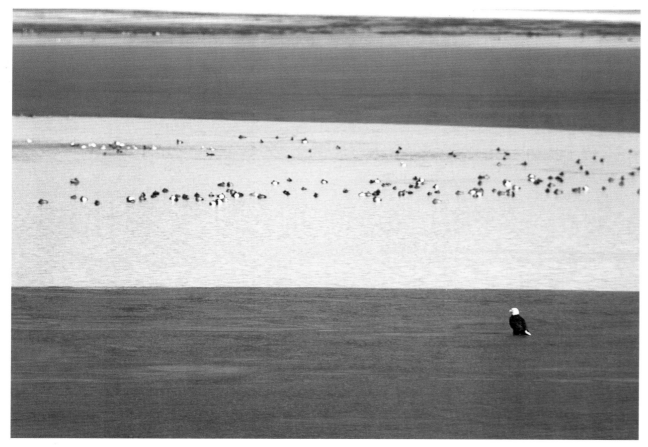

Top: A bald eagle (*Haliaeetus leucocephalus*) on mudflat, Maxwell National Wildlife Refuge south of Raton, New Mexico.

Opposite: Hooded merganser (*Lophodytes cucullatus*) in the Bosque del Apache National Wildlife Refuge, New Mexico.

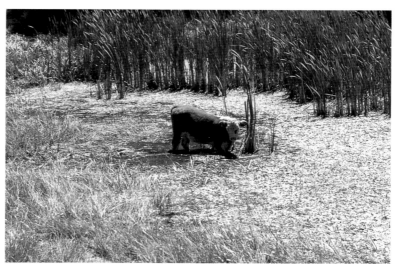

Bottom left: Winter runoff flows into the Rio Grande, which provides water for a whole desert region, Hondo River north of Taos, New Mexico.

Bottom right: One of the major influences on desert wetlands, cattle feeding in a bog high in the Jemez Mountains, New Mexico.

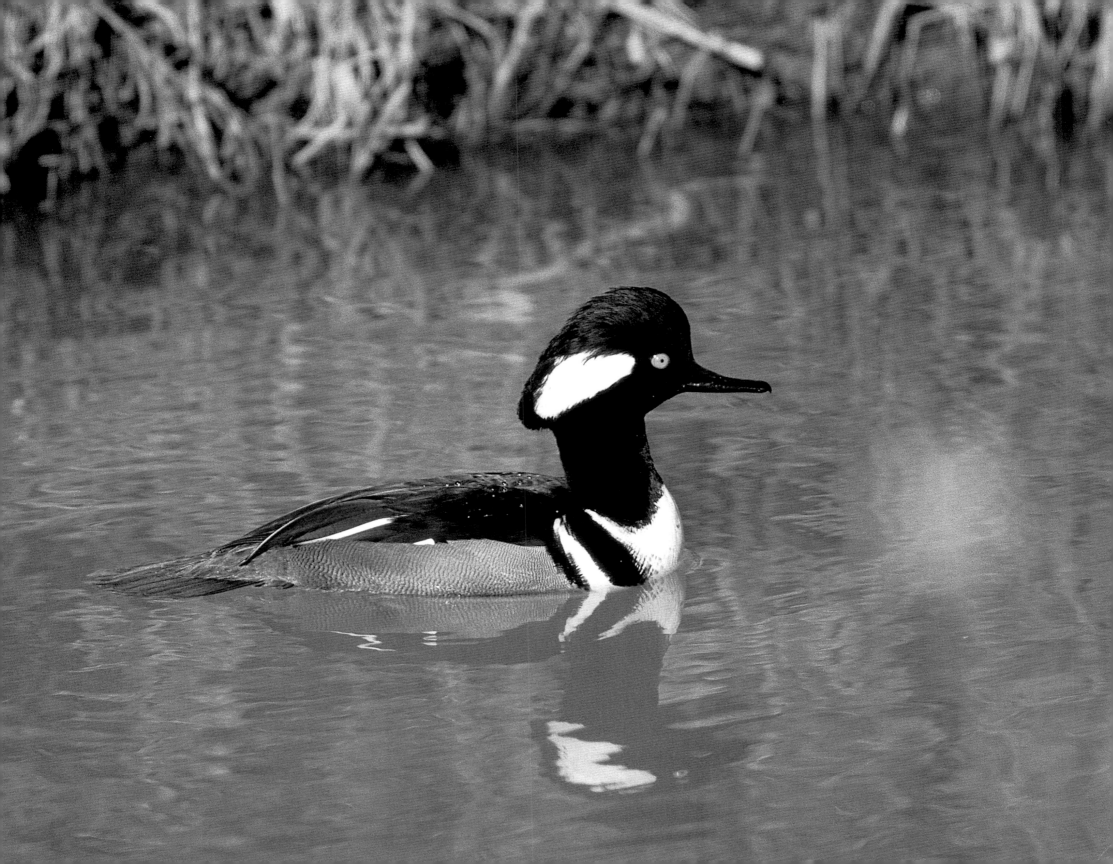

Non-native tamarisk on Farm Loop, Bosque del Apache
National Wildlife Refuge, New Mexico.

Galapagos of the Desert:
Cuatro Ciénegas Basin (Coahuila, México)

In the Chihuahuan Desert of the Mexican state of Coahuila, about four hours south of the U.S. border, lies a desert wetland ecosystem of remarkable biological diversity and significance. The Cuatro Ciénegas Basin supports desert wetlands almost unparalleled in the world. Amidst limestone mountains and immense gypsum sand dunes, this desert valley supports a complex hydrologic system, with lakes, streams, springs (some of them geothermal), and marshes. The great abundance of surface water here is rare in North American deserts. The water is not only abundant, but also highly varied. Over short distances there can be dramatic differences in water chemistry, temperature, and flow rates. This diversity of the aquatic habitat has allowed for the evolution of a diverse, unique biota. The biological diversity is unusually high, but even more striking to biologists and conservationists is that many species are *endemic*—meaning they occur nowhere else in the world. For example, of the fifteen fish species found in the basin (a very high number in itself), twelve are endemic. There are also endemic reptiles, crustaceans, mollusks, insects, scorpions, and plants. Endemic species in so many different, unrelated taxonomic groups occurs nowhere else in the world. When most desert wetland ecosystems have been degraded, why is Cuatro Ciénegas still relatively intact? The basin's saving grace has been its unusual chemistry: water tends to be quite high in dissolved solids, and soils are saline. These related conditions have rendered both water and land unsuitable for agriculture or industry. Threats to this globally significant site have been growing, however. Commercial interests have been mining gypsum dunes at an alarming rate—threatening to upset delicate ecologic balances in the basin. An increase in recreation has caused problems in places, too, as banks have been trampled. The basin was established as a national protected area in 1994. There is great scientific consensus, supported by two international symposia, that the area merits the highest conservation protection possible.

For more information see Contreras-Balderas 2000, Marsh 1984, Minckley 1969, Minckley 1992, or the excellent website of the Desert Fishes Council: www.desertfishes.org/cuatroc/.

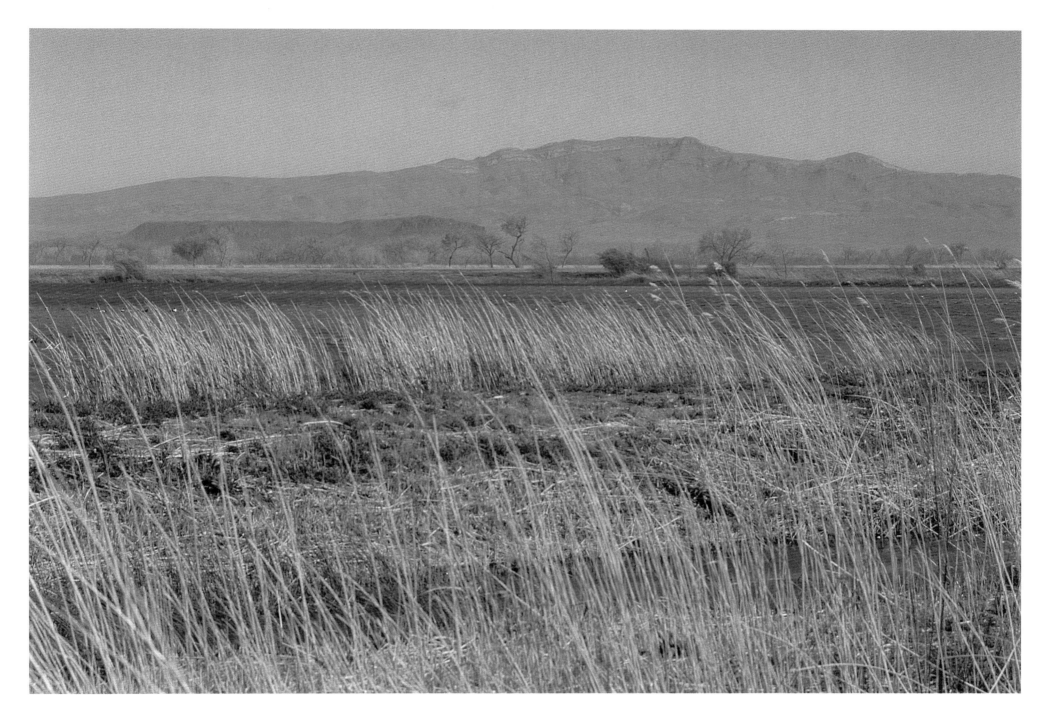

Grasses in the Bosque del Apache National Wildlife Refuge, New Mexico.

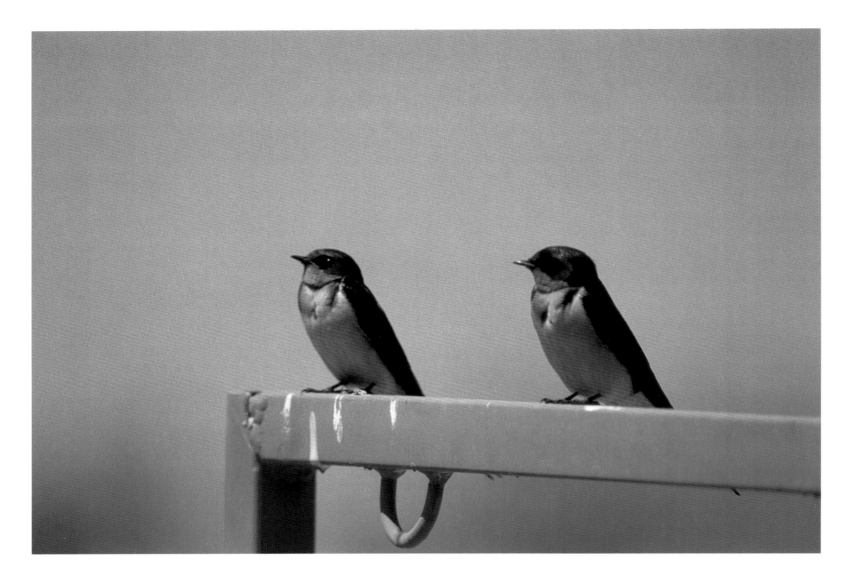

Barn swallows (*Hirundo rustica*) in the Bosque del Apache National Wildlife Refuge, New Mexico.

More formal definitions of wetlands usually include three main components: the presence of water, either at the surface or in the root zone; unique soil conditions that differ from adjacent uplands; and vegetation that is adapted to wet conditions (these plants are referred to as hydrophytes). Deciding that a particular piece of land qualifies as a wetland can be tricky, though, because all three of these characteristics—water, soil, and plants—vary tremendously from site to site and throughout the seasons. The amount of water present at a site may vary dramatically from season to season and may be highly influenced by human activity. Some plant species—cattails, for example—can only exist in wet

environments. Both these *obligate* wetland species and those that can live in a wider range of conditions—*facultative* wetland species—can serve as indicators of wetlands. Public attention to wetlands intensified in the 1970s as growing environmental awareness collided with wariness about new conservation regulations. As a result, a group of scientists with the U.S. Fish and Wildlife Service spent several years carefully defining and categorizing wetlands. This definition remains the most comprehensive and ecologically useful:

> Wetlands are transitional between terrestrial and aquatic systems where the water table is usually at or near the surface or the land is covered by shallow water. . . . Wetlands must

have one or more of the following three attributes: (1) at least periodically, the land supports predominately hydrophytes; (2) the substrate is predominately undrained hydric soil; and (3) the substrate is nonsoil and is saturated with water or covered by shallow water at some time during the growing season of each year.[2]

Note that this definition specifies that a wetland must have at least one (but not necessarily all) of the three attributes—water at the surface, water-loving plants, and water-influenced soils. A wetland, as the definition makes clear, represents the interface of terrestrial and aquatic systems. A wetland has ample water to saturate soil, but not so much that it stands more than a meter or so

deep. The trough of a large river like the Colorado, by this formal definition, wouldn't be considered a wetland, but its shallows and moist margins would. Perhaps the simplest definition is the most obvious: a wetland is wet land.

Wetlands cover about six percent of the world's land surface and just over three percent of the United States. These relatively low numbers belie their biological importance, however. One basic way ecologists compare different types of ecosystems is by measuring their primary productivity—the rate that plants transform solar energy into biological energy (measured as grams of carbon produced per unit area per unit time). Freshwater wetlands have among the highest rates of primary productivity

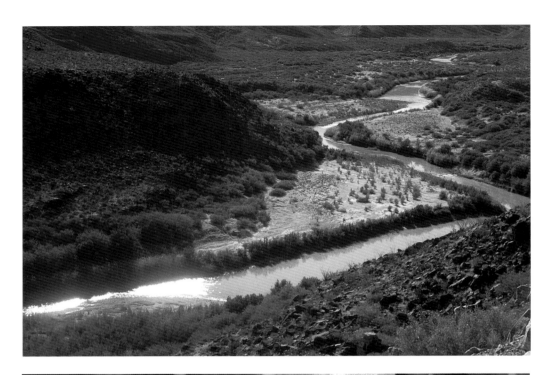

Top: The Rio Grande in the Big Bend State Park, Texas.

Bottom: Red eye prickly pear cactus (*Opuntia violacea*) Big Bend National Park, Texas.

of any ecosystems in the world—in fact, only tropical rain forests come close to matching the high primary productivity rates of cattail marshes.[3] Put another way, wetlands create life more intensively than any other habitat on earth (including those associated with crop agriculture). Deserts have among the lowest rates of primary productivity of the world's ecosystems, so the presence of wetlands in deserts is especially important biologically. Additionally, wetlands perform important ecological functions concerning chemical nutrients: because dead plants and animals tend to decay more slowly in wetlands than in dryer habitats, wetlands can store, transform, and cycle nutrients in ways that benefit adjacent ecosystems.[4] Again, this can be especially important in deserts, where

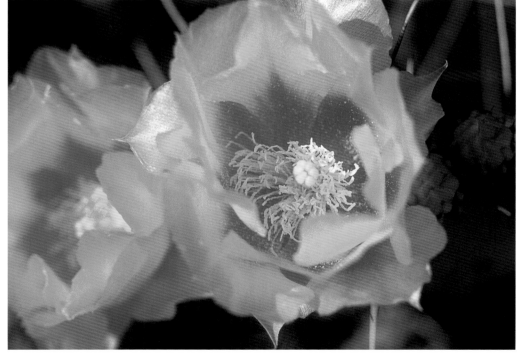

Patagonia Lake State Park, Arizona.

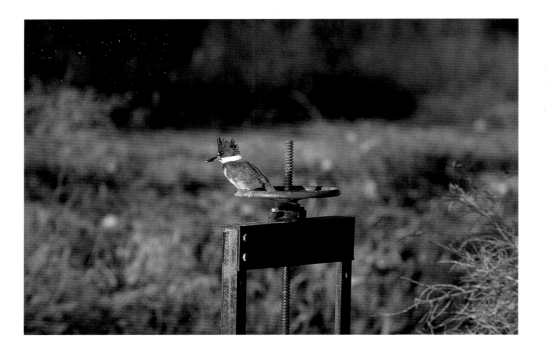

Belted kingfisher (*Ceryle alcyon*) watching from a water gate, Bosque del Apache National Wildlife Refuge, New Mexico.

nutrients are extremely scarce. Wetlands play another important role: they harbor a disproportionately high percentage of threatened and endangered species. In the United States, where wetlands occupy 3.5 percent of the land mass, approximately 50 percent of endangered animal species depend on this habitat.[5]

Aquatic biologists distinguish between two primary types of freshwater wetlands—*lotic* and *lentic* habitats. Flowing waters (streams and rivers) comprise lotic habitats, while more stationary waters (lakes, ponds, marshes) are classified as lentic habitats. Aquatic habitats also get distinguished on the basis of their vertical position—waters on the surface are referred to as *epigean,* while those that are underground, or occurring interstitially (between sediment grains) are known as *hyporheic* habitats.[6]

Compared with mountains and the courses of many large rivers, present-day wetlands are geologically quite young. As we shall see in greater depth in the final section, these relatively new, dynamic ecosystems have been altered dramatically by humans during the past couple hundred years. More than half the wetlands in the contiguous United States were lost between 1780–1980, as they were converted to agriculture, urban development, and other human purposes.[7] Wetland habitats in the Southwest, before the radical landscape changes wrought by Euro-Americans, were primarily lotic. Lakes and ponds (lentic habitats) were rare for several reasons—general aridity, high evaporation and siltation rates, lack of recent glaciation, and steep topography. Because lakes and large bodies of quiet water were absent or seasonal,

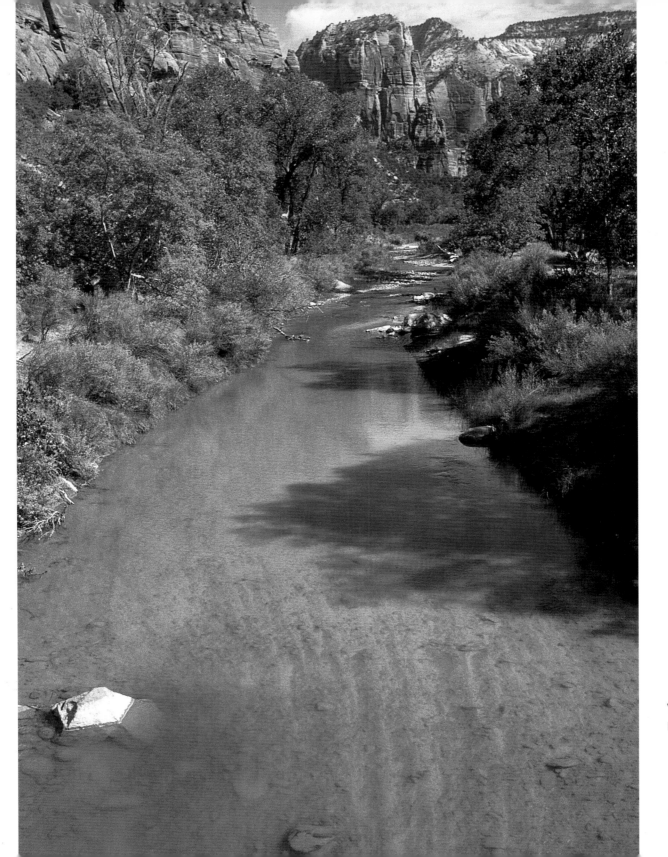

Virgin River in Zion
National Park, Utah.

Top: A frozen creek near Taos, New Mexico.

Bottom: Northern pintail (*Anas acuta*) on Pond Loop in the Bosque del Apache National Wildlife Refuge, New Mexico.

the unique aquatic life of the region became largely adapted to streams or was restricted to remnant springs and seeps.[8] In the last century, dams, diversions, and groundwater pumping have caused many streams to dry up or become seasonal, while artificial impoundments—reservoirs, farm ponds, cattle tanks—began to dot the landscape. As a result, these human-made lentic habitats became more common than the native lotic habitats, with which the region's fauna had evolved.[9]

So we have the fundamental paradox of this book's subject: desert wetlands derive from the presence of water in the midst of a region defined by water's absence. But where does this water come

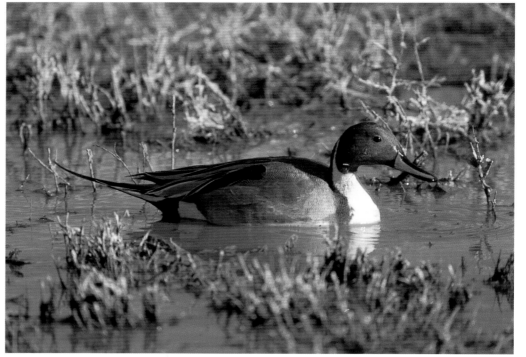

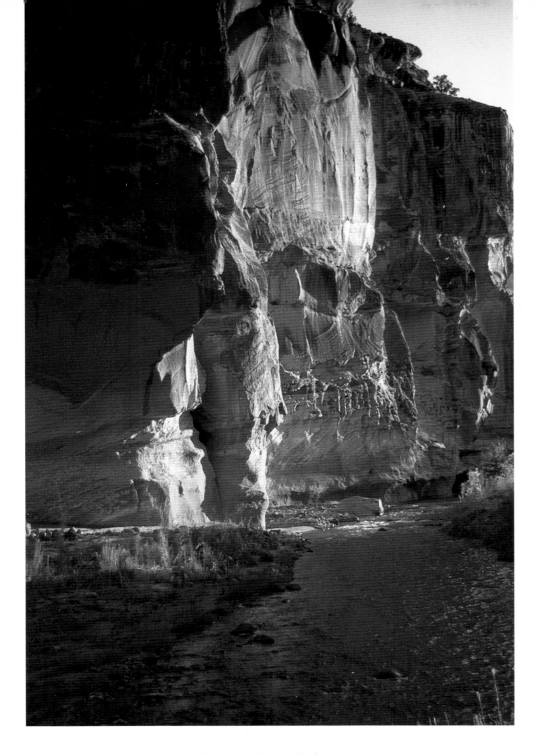

Escalante River in Utah.

Flowing Through the Land of Singing Stone: The Escalante River (Utah)

Once called "the crookedest river on earth"—its course takes thirty-five river miles to travel fourteen straight-line miles—the Escalante carves its way hundreds of feet deep into the burnished sandstone layers of slickrock country as it meanders its way from the high Aquarius Plateau to its confluence with the Colorado River (which is currently inundated by the Lake Powell reservoir). Known for its dramatic beauty—cottonwood green contrasting with red rock walls and deep blue skies—the Escalante is also significant for being the last undammed river on the entire Colorado Plateau, an area more than twice as large as New England. The Escalante was the last river in the contiguous United States to be discovered and named by Euro-Americans, and to this day it flows through the middle of one of the largest de facto wildernesses in the lower forty-eight states, touched by only a single road. Most of the river's length is protected as part of either the Glen Canyon National Recreation Area of the National Park Service or the Grand Staircase–Escalante National Monument, administered by the Bureau of Land Management. Along the river a hiker encounters an intact and extensive riparian zone, dominated primarily by Fremont cottonwoods and graceful, wand-like coyote willows. The lush riparian corridor grows on terraces composed of sediments eroded from the sandstone walls—sediments eroded by flowing water, then deposited elsewhere. Parts of the canyon system were once heavily grazed by livestock, but with increasing recreational activity, cattle have been largely phased out of the riparian corridor, with consequent recovery of vegetation.

For more information contact the Escalante Interagency Visitor Center in Escalante, Utah (administered jointly by the Bureau of Land Management, National Park Service, and U.S. Forest Service); and see Fleischner 1999b.

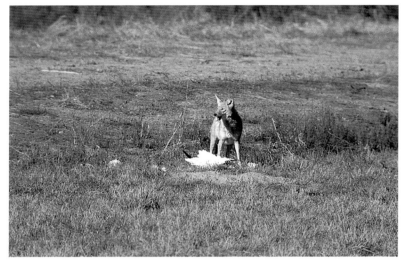

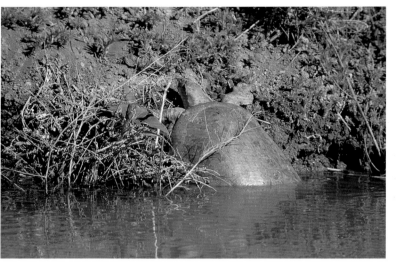

Top left: Coyote feeding on a snow goose in the Bosque del Apache National Wildlife Refuge, New Mexico.

Top right: Spiny softshell turtle (*Trionyx spiniferus*) in the Bosque del Apache National Wildlife Refuge, New Mexico.

Bottom: Summer in the Bosque del Apache National Wildlife Refuge, New Mexico.

Opposite: Saltpeter Mountain in the Maxwell National Wildlife Refuge south of Raton, New Mexico.

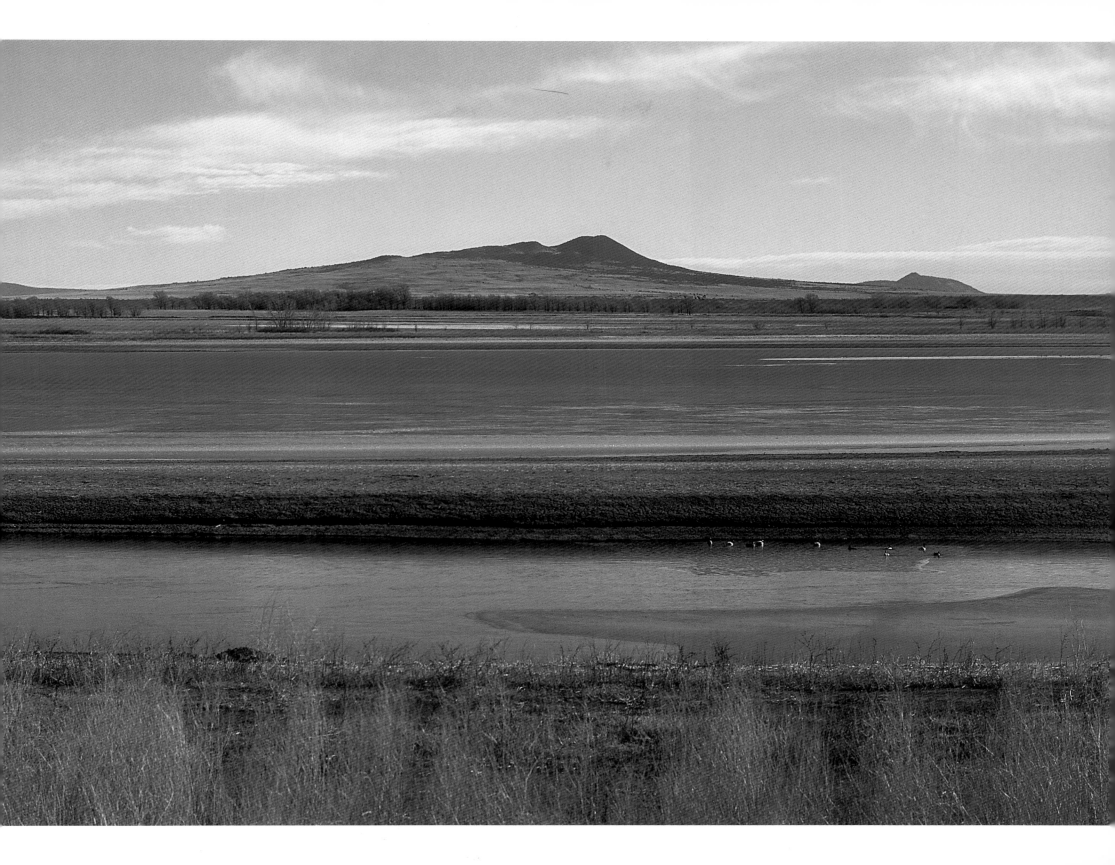

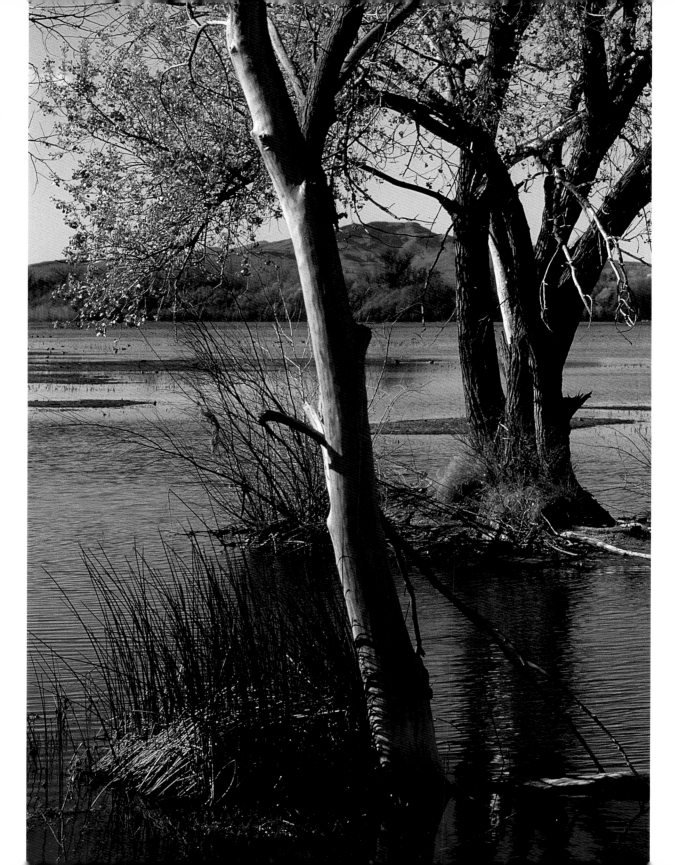

Waterscape on Farm Loop in the Bosque del Apache National Wildlife Refuge, New Mexico.

from? In one way or another, the answer always involves a geologic story: water comes from adjacent mountains that capture snow and rain; from springs that shove groundwater toward the surface; or from bare rock depressions that gather rainclouds into puddles and pools.

Desert waters can roughly be considered in two general categories—those that descend from above and those that arise from below. Western North America has been a region of tremendous tectonic activity, with repeated episodes of mountain-building and uplift, especially during the past 65 million years known as the Cenozoic Era. The convoluted topography and spectacular, signature landforms that define the West—rugged mountains, high plateaus, and deep canyons—have resulted from

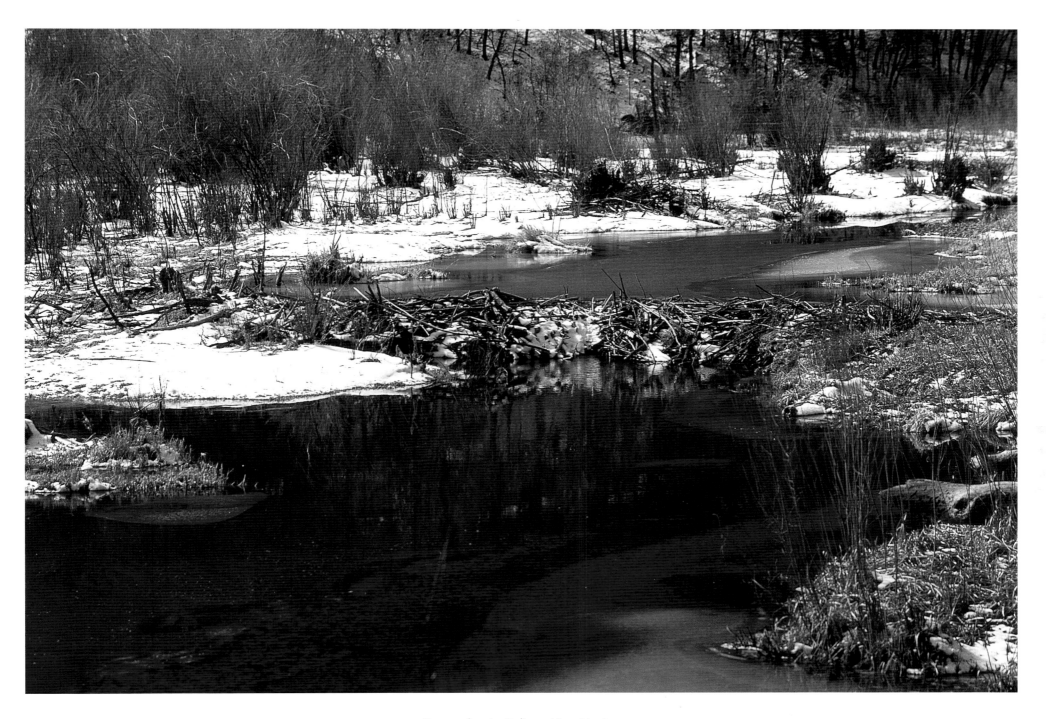

Beaver dam in Galinas, New Mexico.

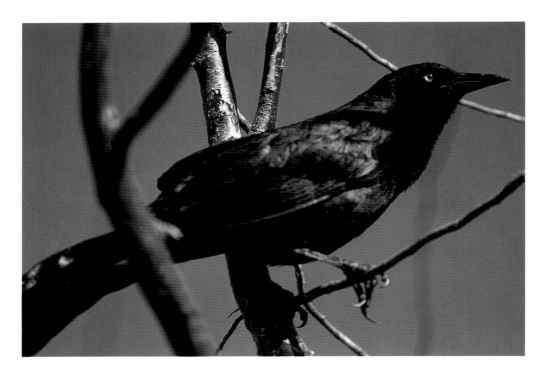

A great-tailed grackle
(*Quiscalus mexicanus*) in
the Bosque del Apache
National Wildlife Refuge,
New Mexico.

the activity of this restless edge of a continent. All the great rivers of the West—the Colorado, Columbia, Rio Grande, Snake, and others—originate as the melting of snow in high mountains. The Rockies, Sierra Nevada, Cascades, and countless other ranges—because they protrude into higher, cooler, and therefore wetter elevations—gather moisture and store it for later, more prolonged release during spring and summer melt. Without the expansive high country functioning as water storage facilities, the low deserts of the West would lack

rivers, the canyons they carve, and the wetlands they support. The Colorado River has its source in the high Rockies of Colorado and Wyoming; the Rio Grande emanates from the San Juan Mountains of southern Colorado, as does the San Juan River. So mountains wring water from clouds, store it as snow, release it as snowmelt, that deserts might know rivers.

But rivers are not the only watery worlds in deserts. The source of many desert waters, especially lowland springs and *ciénegas,* lie hidden underground.

Water is the ultimate shapeshifter: rivers flow into lakes and seas, these surface waters evaporate into the atmosphere, form into clouds, until they eventually condense and precipitate out, falling as rain or snow back to earth, where they recommence the hydrologic cycle. Many detours await this path of water during its earthbound phase. Much of it transforms into the tissues of plants and animals, who exhale some of it, then replace what they have relinquished by soaking it up through their roots, sipping at a desert pool, or absorbing it

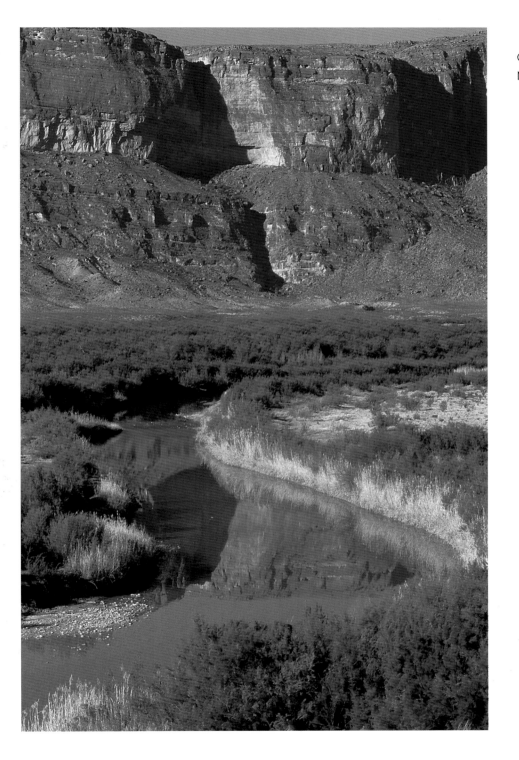

Cliffs in the Big Bend
National Park, Texas.

from the bodies of their prey. Under certain climatic and geologic conditions, some precipitation that falls on a region detours deep into the substrate, recharging underground stores of water held in cavities within rock or between rock layers. This groundwater remains beneath the surface of long periods of time—thousands of years in some cases.

But it doesn't stay there forever, for water is ever on the move. Many geologic structures unseen by our eyes—a slight tilt in rock strata or a fault—can direct groundwater toward the surface, where it leaks out as a spring. In rare situations a huge volume of water issues forth, forming a stream in an instant, as at Thunder River in the Grand Canyon. More commonly, it seeps out, dampening the ground or dripping slowly and

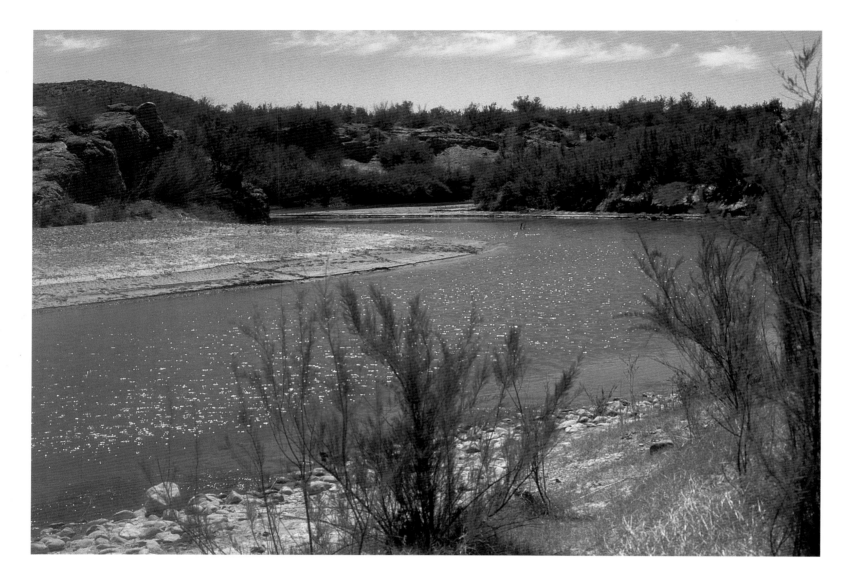

Left: Big Bend National Park, Texas.

Opposite: Fall on Pond Loop in the Bosque del Apache National Wildlife Refuge, New Mexico.

steadily from an overhang of rock. The Navajo Sandstone, the most widespread rock type of the Colorado Plateau, is extremely permeable to water. The rock holds water in the tiny gaps between cemented sand grains; eventually this most precious of desert substances, aided by the relentless pull of gravity, descends to the bottom of this stratum. There it hits a finer-particled, less permeable layer and flows laterally until it emerges from the base of sandstone cliffs as a spring. A great many sites of prehistoric human settlement can be found along this geologic contact because people's lives depended on an understanding of this hydrology.

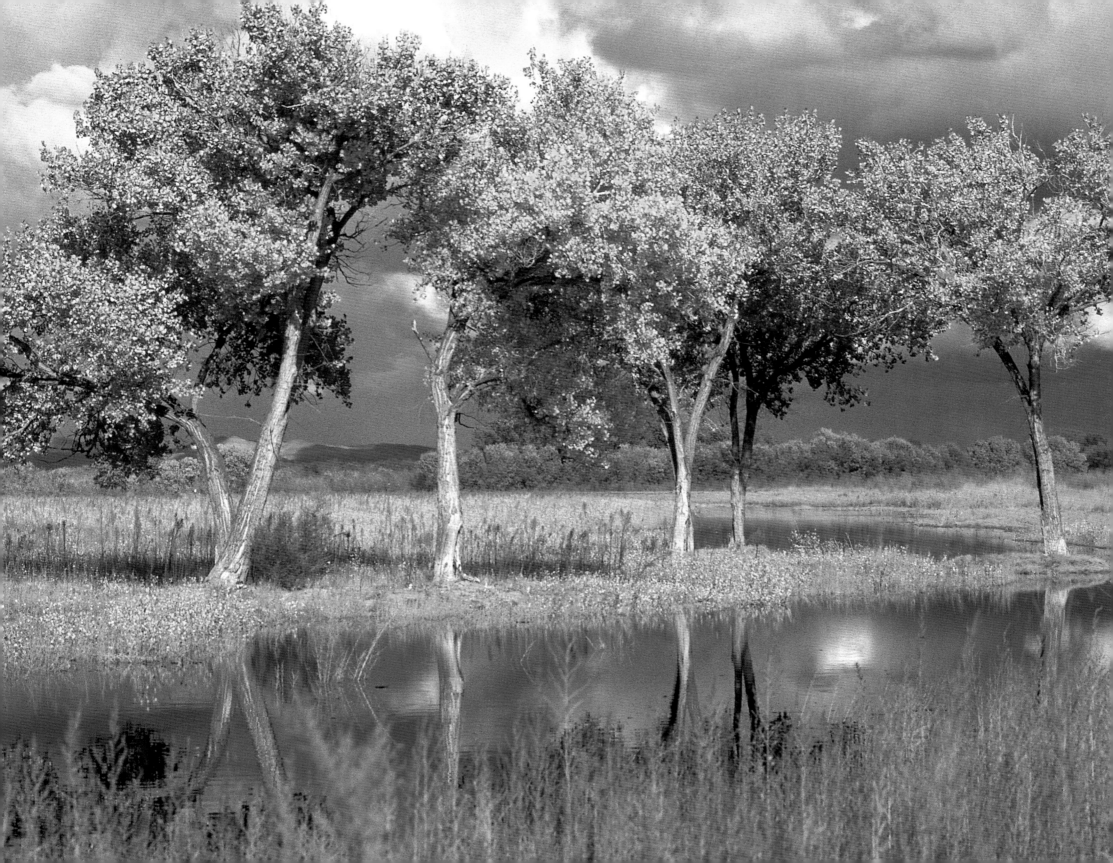

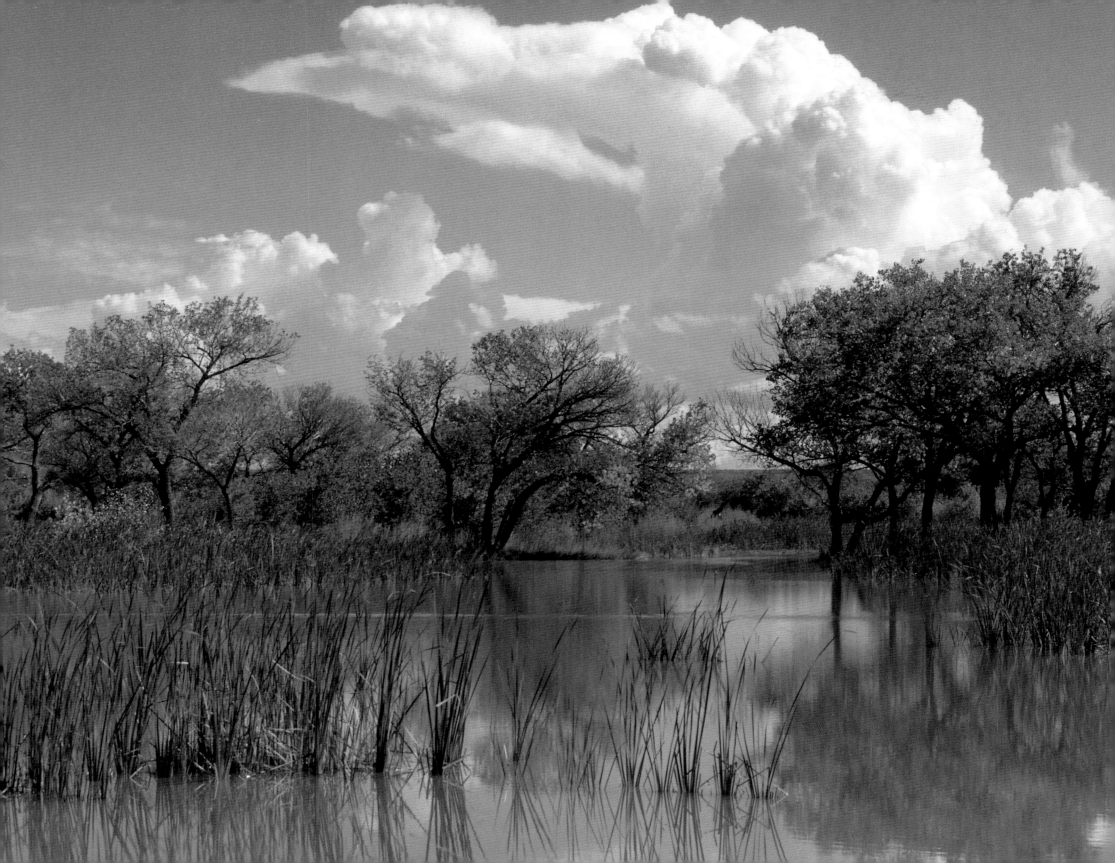

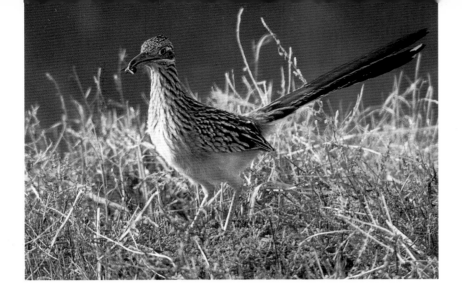

Above: Greater roadrunner (*Geococcyx californianus*) in the Bosque del Apache National Wildlife Refuge, New Mexico.

Opposite: A summer waterscape on Pond Loop in the Bosque del Apache National Wildlife Refuge, New Mexico.

3. The Many Faces of Desert Water

Water, then, is a gift to the desert from geologic and climatic processes above and below the surface. This water creates a diversity of wetland habitat types. Some are remarkably ephemeral, others more stable. Some are born in an instant, and others are remnants of worlds long past.

RIBBONS OF GREEN

Certainly the most dramatic wetland habitats in the Southwest deserts—and arguably the most important biological habitats in the entire region—are the riparian zones associated with streams. The word *riparian*—from the Latin "ripa," the bank of a river—refers to the linear habitats that form ribbons of green life, draped delicately across the dry world of the desert. Specialists differ on exact definitions of riparian, but the common theme is that they represent the zone of interaction between aquatic and terrestrial ecosystems. The Arizona Riparian Council defined this habitat as "vegetation, habitats, or ecosystems that are associated with bodies of water (streams or lakes) or are dependent on the existence of perennial, intermittent, or ephemeral surface or subsurface water drainage." Two key features of riparian areas are their markedly greater soil moisture in contrast to adjacent habitats, and the less stable, shifting nature of this substrate.[10]

The Southwest provides many variations on the theme of riparian plant communities, but two community types stand out—cottonwood-willow forests and mixed

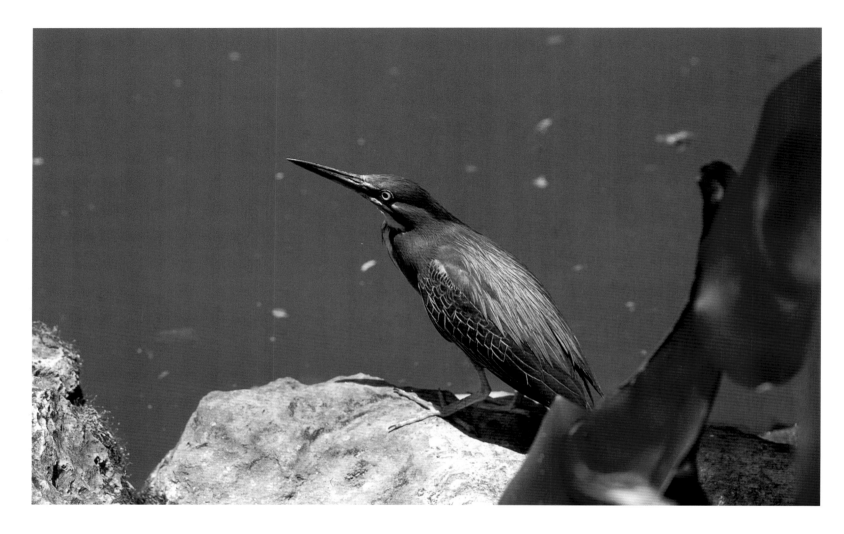

Left: Green heron (*Butorides virescens*) feeding in the San Antonio River from the river walk in San Antonio, Texas.

Opposite: Sandhill Cranes and snow geese foraging together in their winter habitat on Farm Loop in the Bosque del Apache National Wildlife Refuge, New Mexico.

broadleaf forests." The former is dominated by Fremont cottonwood (or Rio Grande cottonwood, which some consider a subspecies of Fremont and others a separate species) and Goodding and coyote willows (the former a tree, the latter a wand-like shrub). Cottonwood-willow communities are typically encountered on alluvial sands, clays, and gravels on flood plains; stream flows may be perennial or intermittent. Mixed broadleaf riparian forests are composed of the "big six" tree species—sycamore, alder, walnut, and ash, in addition to cottonwood and willow. These communities tend to occur along rockier, rubble-bottomed streams with flows that are perennial or nearly so. Both types of riparian forest represent relicts of an earlier era—during the early Tertiary period similar communities were more widespread, but their ranges contracted as the climate

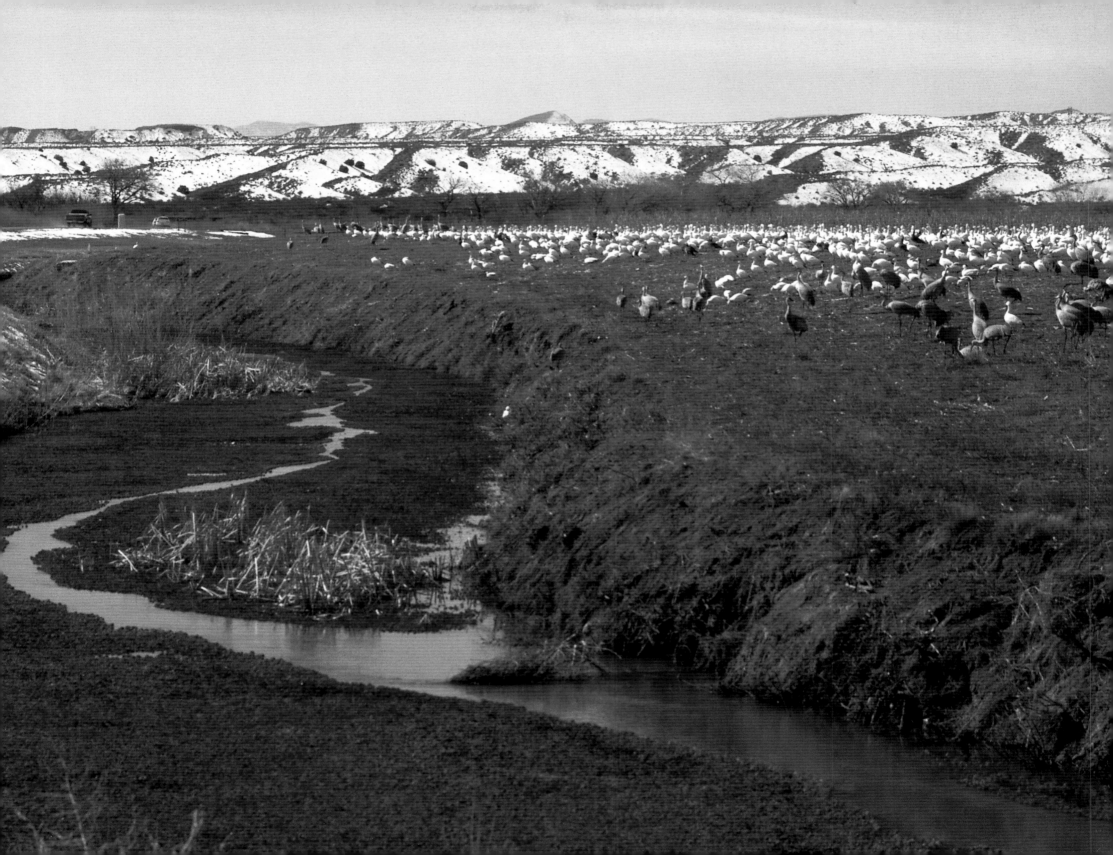

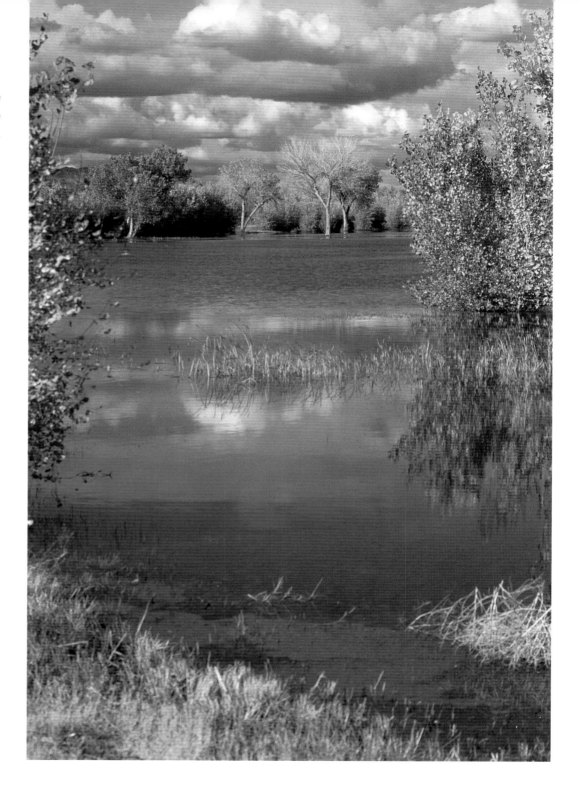

Fall on Pond Loop, Bosque del Apache National Wildlife Refuge, New Mexico.

dried and warmed since the end of the Pleistocene.[12]

One of the essential ingredients for a healthy, functioning riparian ecosystem in the Southwest is the natural disturbance of floods. Many riparian species depend on this periodic disturbance to complete their life cycles and maintain populations in the face of competition. One group of biologists referred to floods as "the principal driving force" structuring ecosystems along river floodplains.[13] Floods can scour away vegetation, creating open sites for seedlings, deposit and reposition sediments, and provide moisture necessary for seed germination. Timing and intensity of floods are critical, however, because different woody plant species disperse

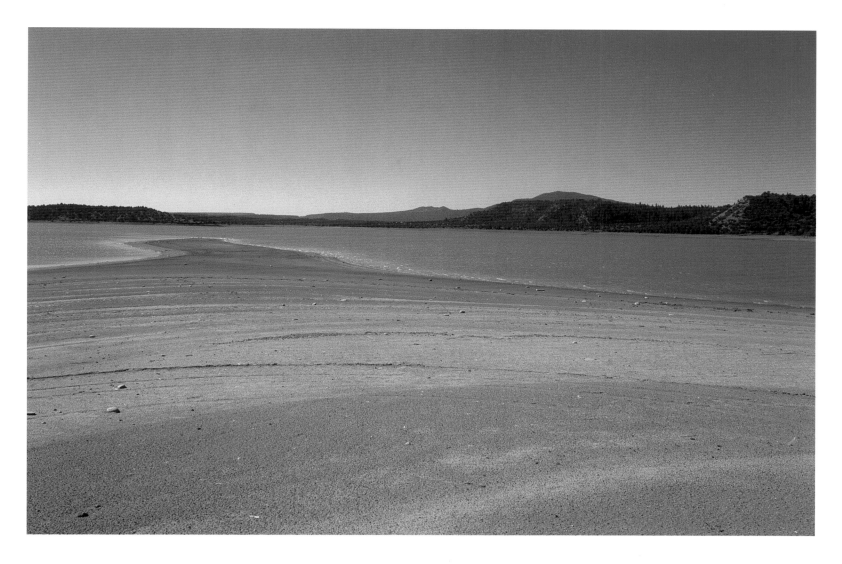

El Vado Lake in
northern New Mexico.

seeds at different times. Each species
not only has its own particular time for
seed germination, but also has specific
needs for degree of soil saturation.

Cottonwoods, to take one impor-
tant example, love early spring floods—

and the floodplains they form. Seed
production coincides with the timing of
late winter rains and spring snowmelt.
Seeds are dispersed by both wind—
witness the cottony showers so evident
in springtime canyons—and flowing

water. Ideally, the early floods will clear
out other streamside brush and saturate
the soil, but then the water level will
subside quickly enough to leave germi-
nation sites that are moist but not
drenched. In years of especially large

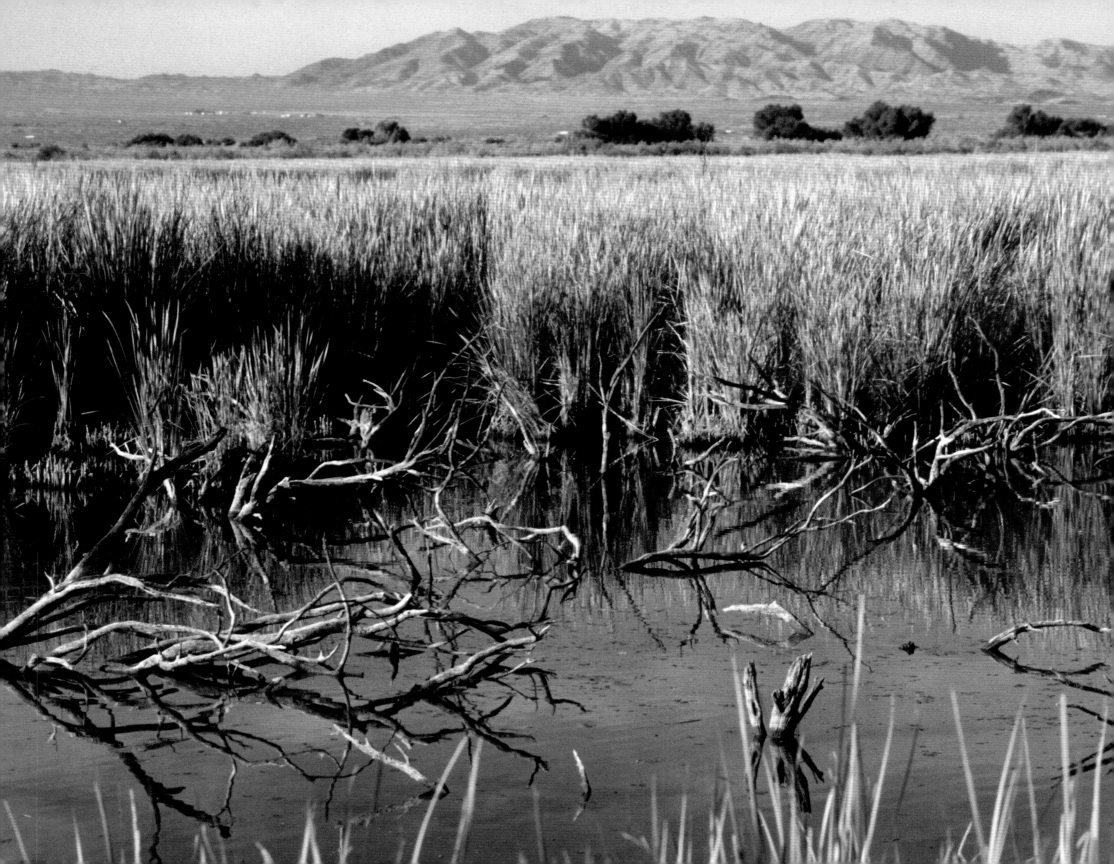

Top left: Green-eyed skimmer dragonfly (*Epicordulia corduliidae*) in Montezuma, New Mexico.

Top right: Pecos River, New Mexico.

Bottom: Canada goose gosling (*Branta canadensis*) prepared to enter the water. Bosque del Apache National Wildlife Refuge, New Mexico.

Opposite: The Colorado River overflow creates the marsh at Havasu National Wildlife Refuge on the Arizona side.

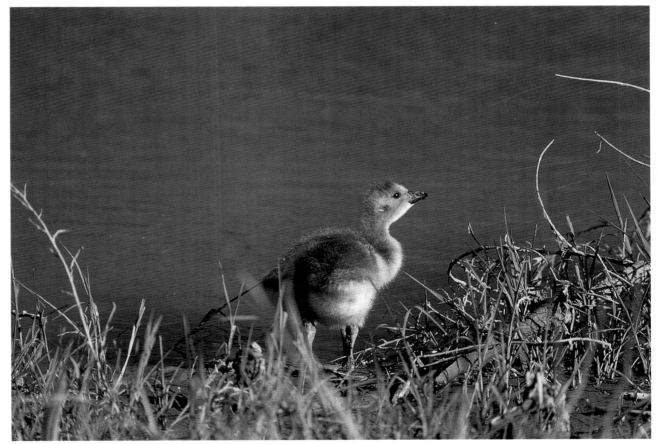

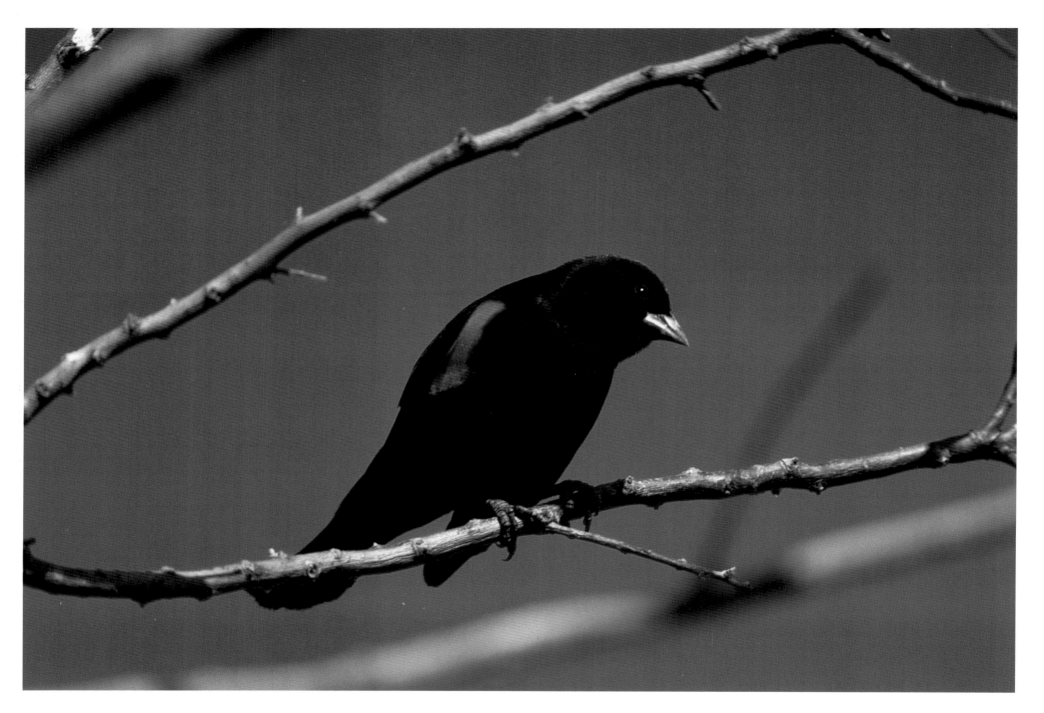

Red-winged blackbird (*Agelaius phoeniceus*) on Farm Loop in the Bosque del Apache National Wildlife Refuge, New Mexico.

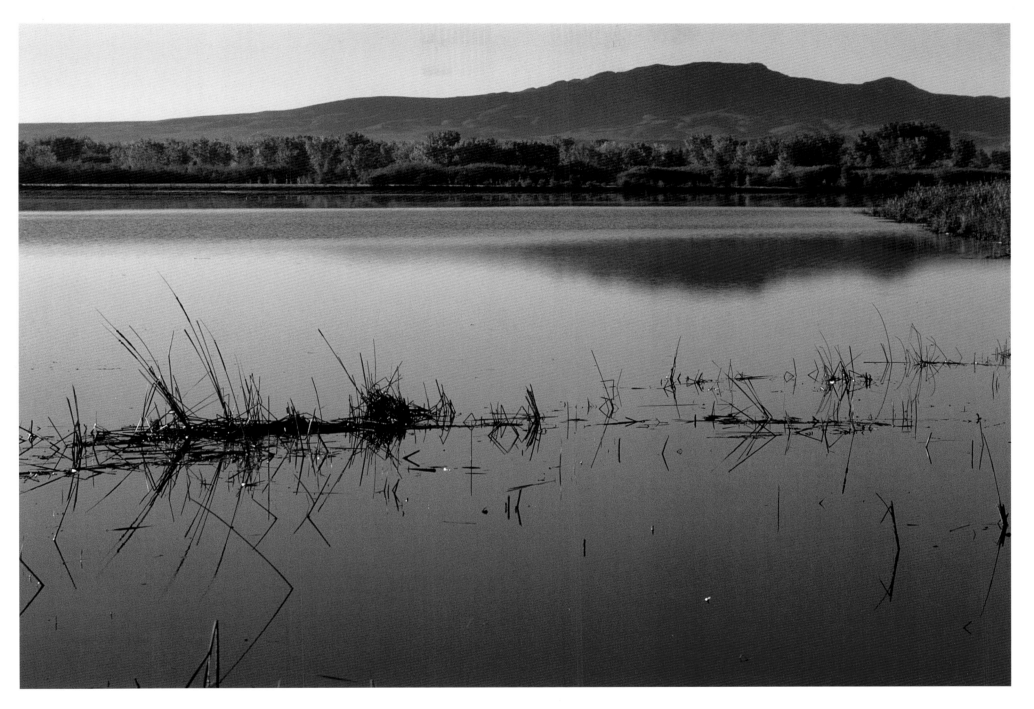

Waterscape on Pond Loop in the Bosque del Apache National Wildlife Refuge, New Mexico.

Montezuma Well in Arizona in an
Ancient Puebloan living area.

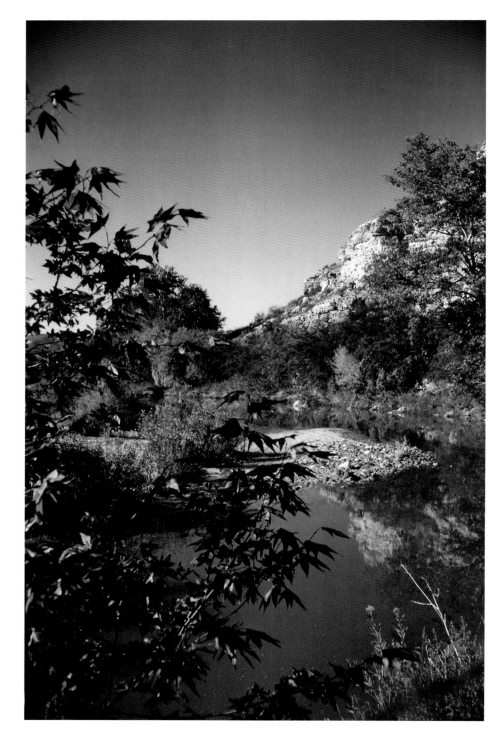

floods, such as during an El Niño event, the water level may stay higher than normal for months. This can work to the disadvantage of cottonwoods, which have only a brief (roughly month-long) germination period. Some competitor species, such as tamarisk, arrowweed, and seep willow, disperse seeds later and longer. When streambanks stay moist well beyond the cottonwood's magic month, these competitors often become established.[14]

Even though floods provide the necessary conditions for life, they can have a downside as well. Deluges can rip trees out of the ground and toss them downstream. Brittle stems break in the face of moving water. Many cottonwoods have adapted by becoming "flood-trained": floods flatten and bury

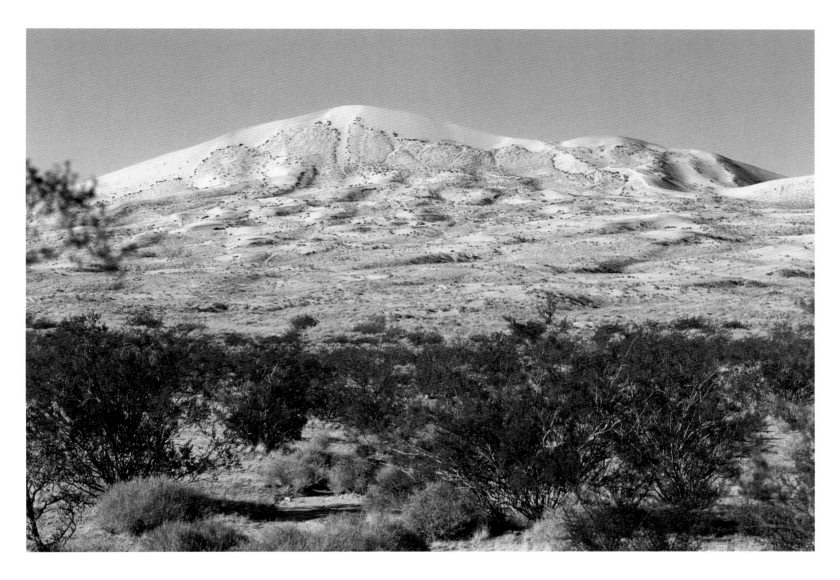

The Mojave Desert in California with creosotebush *(Larrea tridentata)* in foreground.

supple young saplings in mud, but the saplings resurrect themselves by bending at right angles back up toward the light. Several clones can arise from a single large subterranean cottonwood. Floods temporarily alter water chemistry and

turbidity and can have more permanent consequences. One winter flood in an Arizona stream destroyed a population of an endangered fish and delivered new populations of a native frog and a non-native tree.[15]

It would be difficult to overestimate the importance of riparian habitats to wildlife in the arid West. Riparian vegetation covers less than 1 percent of the Western landscape, yet provides habitat for more species of birds than

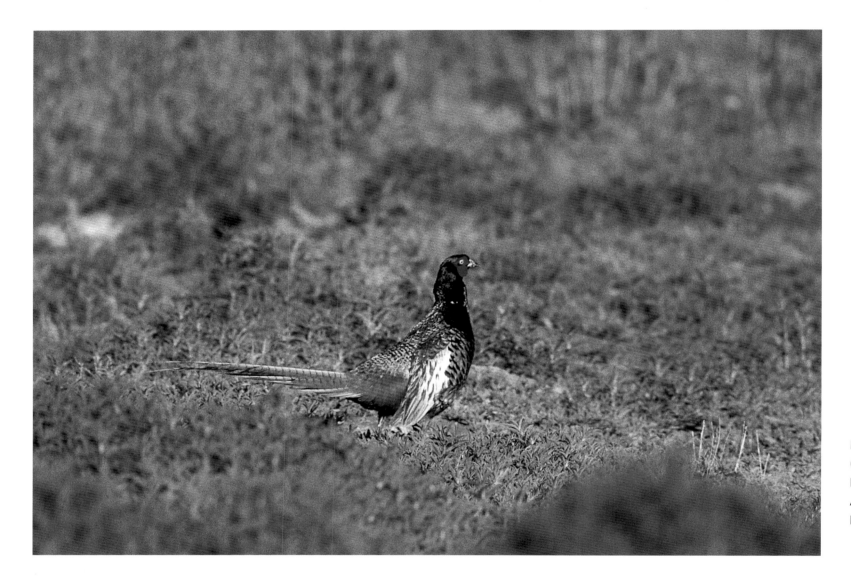

Ring-necked pheasant (*Phasianus colchicus*) on Pond Loop, Bosque del Apache National Wildlife Refuge, New Mexico.

all other habitats combined. In Arizona and New Mexico three-quarters of all vertebrate species depend upon riparian habitat for at least some portion of their life cycle. One regional analysis concluded that more than three-quarters of the bird species of Southwestern deserts were dependent in some manner on water-related habitat; well over half were completely dependent. These researchers arrived at this frightening conclusion: if riparian habitats were destroyed in the Southwest, we could lose almost half our species of lowland nesting birds, while less than a quarter of the species would remain unaffected. A similar study of passerines (songbirds and

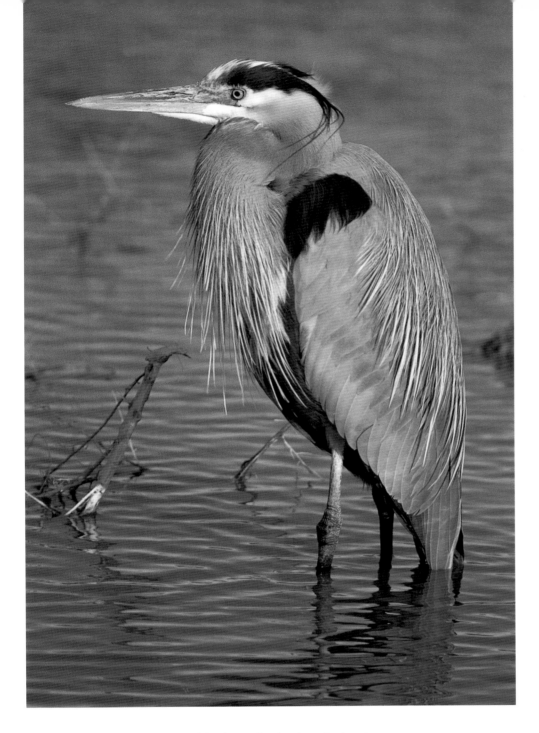

Great blue heron (*Ardea herodias*) in the
Bosque del Apache National Wildlife Refuge, New Mexico.

In the Land of Cranes:
Playas and Wetlands of the Sulphur Springs Valley (Arizona)

The native vegetation of the broad Sulphur Springs Valley, framed by the Dragoon Mountains on the west and the Chiricahua Mountains on the east, was semi-desert grassland and Chihuahuan desertscrub, coursed by ephemeral washes. Much of the native grassland has been converted to agriculture, but many wetlands, created to varying degrees by human enterprise, support abundant populations of wintering birds, including waterfowl, shorebirds, raptors, and, most famously, sandhill cranes. Whereas the pumping of groundwater has been disastrous for many desert wetlands, in this valley agricultural irrigation has created a number of seasonal wetlands. This habitat, alongside vast fields of corn stubble, has lured more than twenty thousand sandhill cranes to the valley in recent winters. The cranes gather nightly in a few congested wetlands, where their otherworldly trumpeting swells and recedes like waves on a shore, then disperse throughout the valley during the day to feed. One of the main wetland features of the valley is the immense Willcox Playa, just south of the town of Willcox and Interstate-10. Like all playas in the Southwest, this alkaline lakebed is often dry. Here, however, certain corners of the vast playa are routinely wet by human activity, such as near an electric power generating station and a golf course. Birds do not seem to care whether these wetlands are "natural" or not, and such sites have become renowned as wildlife viewing areas. Unlike many of the sites profiled, most of the wetland areas in the Sulphur Springs Valley are on private lands. The state game and fish department also manages a couple wildlife areas—at Whitewater Draw and Willcox Playa.

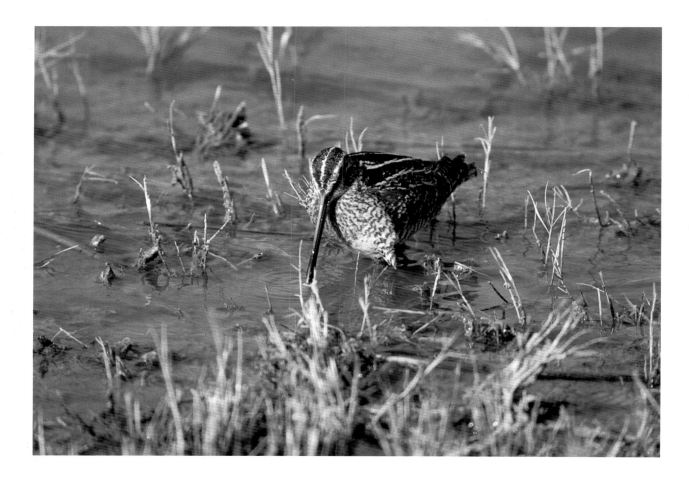

close relatives) in central and southern Arizona found higher species richness and density—more types of birds and more individuals—in riparian habitats than in immediately adjacent nonriparian areas. This pattern holds true even when water is only occasionally present. In so-called "xeroriparian" (dry riparian) habitats—normally dry corridors that intermittently carry floodwaters

through low deserts—bird species diversity and density is five to ten times higher than adjacent uplands.

Cottonwood-willow communities are particularly rich with birds. Indeed, the highest density of breeding birds ever recorded in North America was in a cottonwood grove along the southern edge of the Colorado Plateau. Biologists suspect this avian richness

stems from three aspects of cottonwood-willow communities. They are tall—and more vertical diversity creates greater bird habitat diversity. They are leafy—their voluminous foliage provides cover, nest-sites, and feeding grounds for birds. And they provide a habitat conducive to high insect productivity, offering birds a smorgasbord of high-protein delicacies.[16]

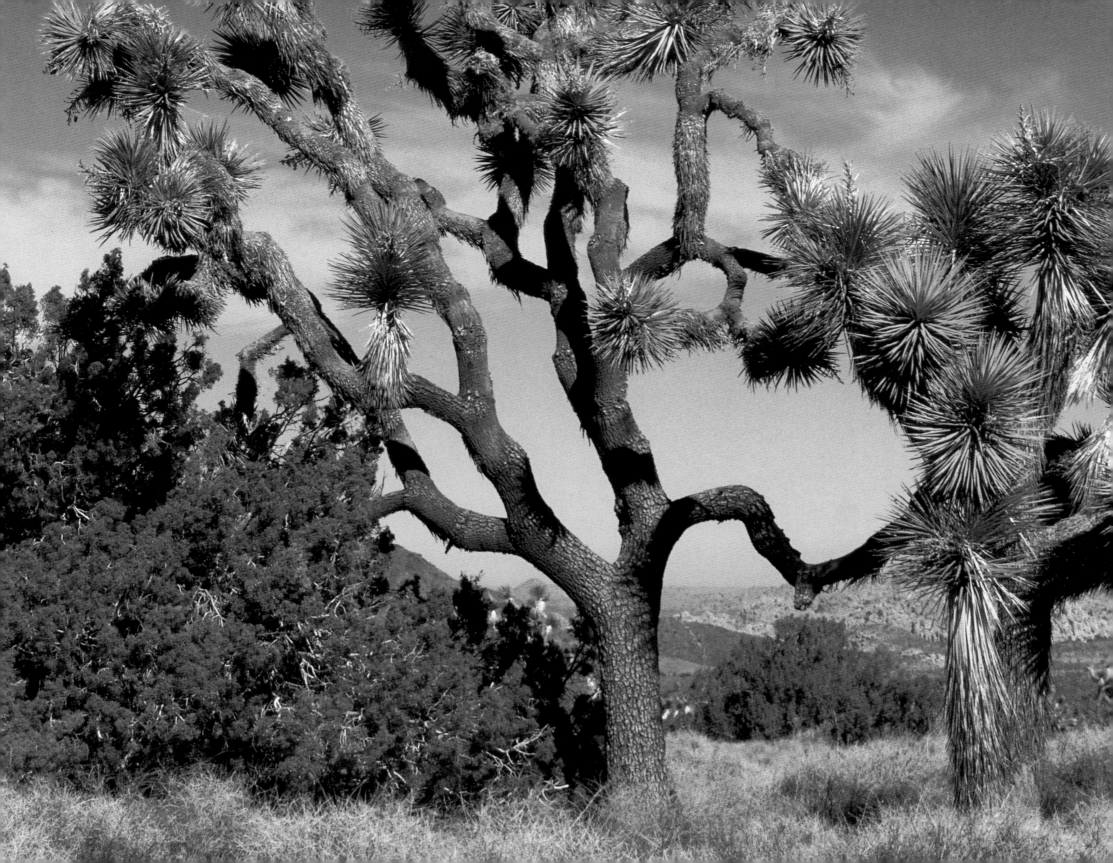

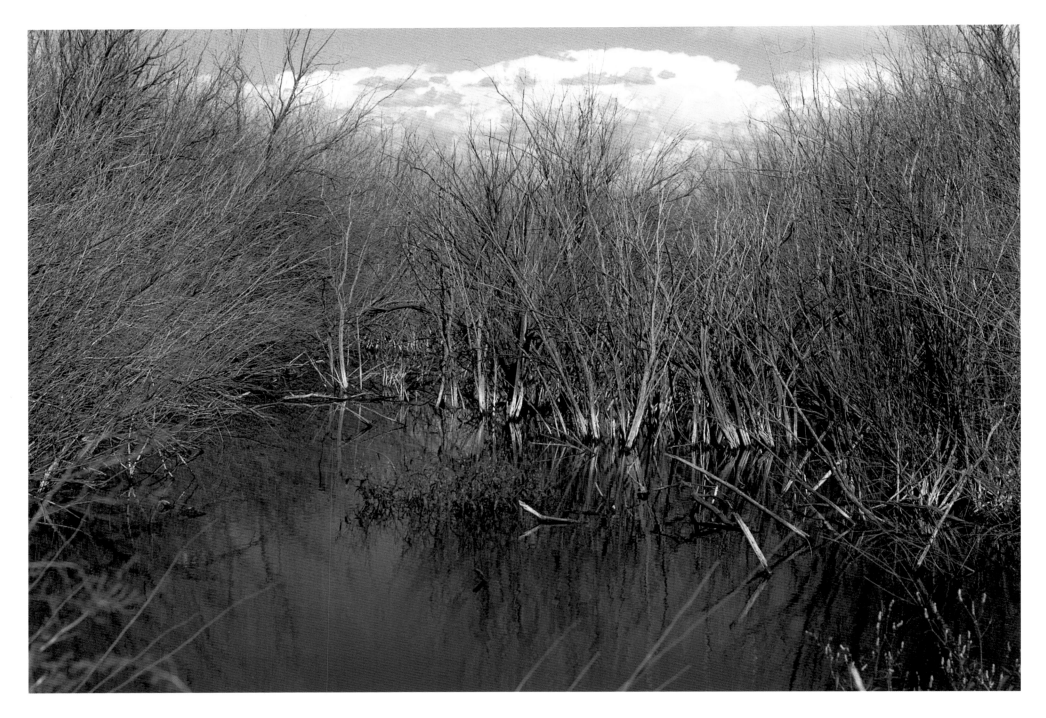

Winter in the Bosque del Apache National Wildlife Refuge, New Mexico.

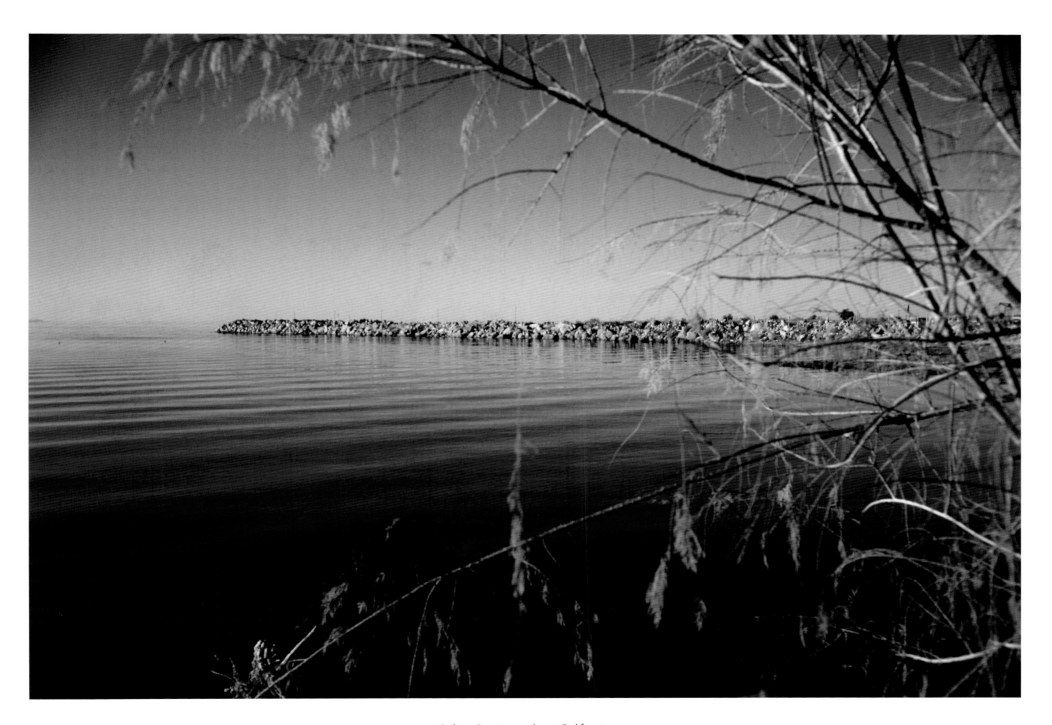

Salton Sea in southern California.

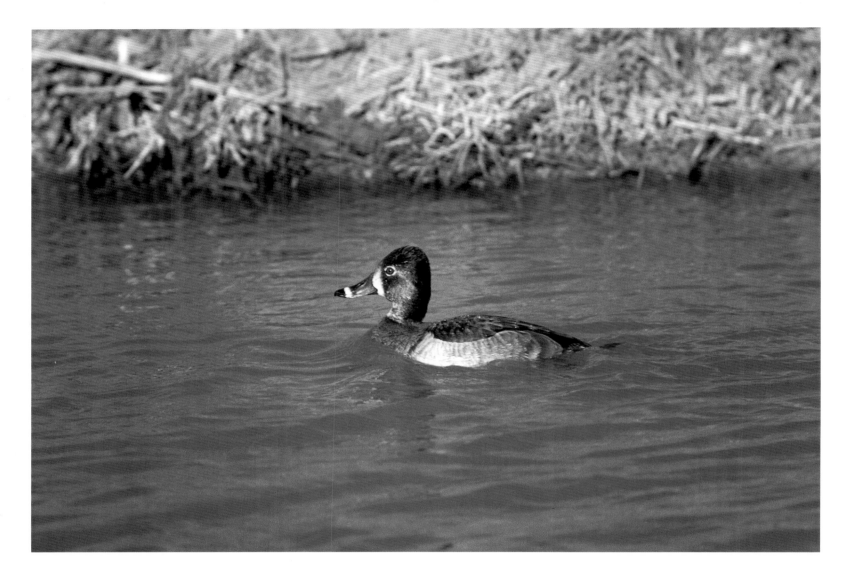

Left: A female ring-necked duck (*Aythya collaris*) in the Bosque del Apache National Wildlife Refuge in New Mexico.

Opposite: White morph of the egret (*Egretta rufescens*) in the Laguna Madre near Corpus Christi, Texas.

THE HUNDRED WATERS—CIÉNEGAS, MARSHES, AND SPRINGS

True marshes, sun glinting on still water, are scarce in the Southwest. But groundwater does make its way to the surface to create marshy habitats of all sizes, from tiny seeps and springs, which are widespread and abundant, to larger—but rare—true marshlands. Marshes often occur in abandoned river oxbows, on poorly drained lands where groundwater saturates the surface, or in closed mountain basins. The latter, especially common in the Chihuahuan Desert region, may represent remnants of what were once large lakes in the Pleistocene. Under today's significantly drier climatic regime, these lakes have

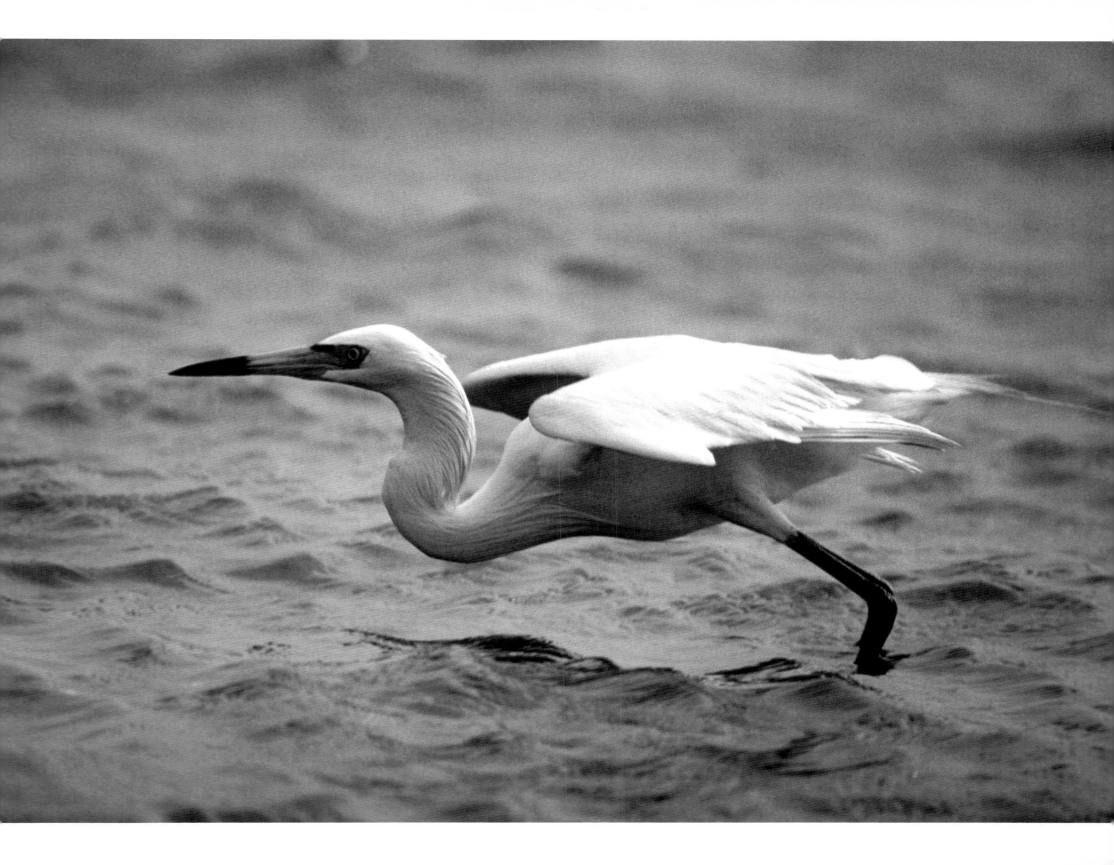

Top: American turkey (*Meleagris gallopavo*) on Farm Loop, Bosque del Apache National Wildlife Refuge, New Mexico.

Bottom: The Ramsey Canyon leopard frog is a newly discovered species and very rare, Ramsey Canyon, southern Arizona.

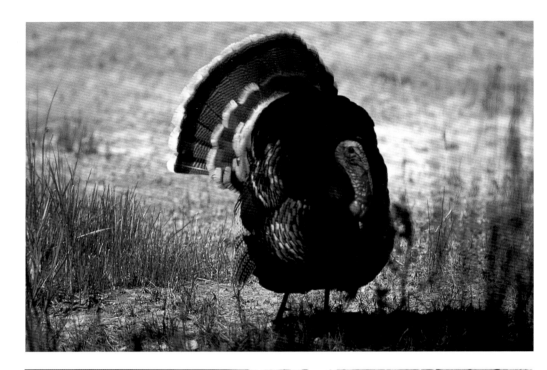

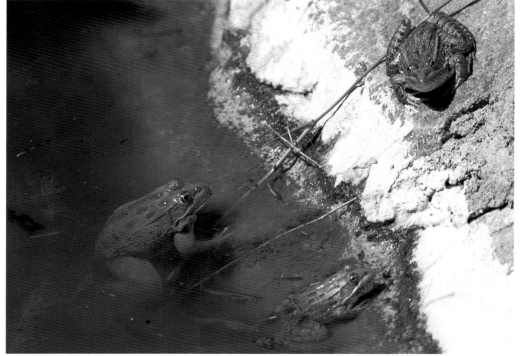

shrunken into marshes, which may or may not have standing water, depending on the year's rainfall. In fact, great seasonal and annual variation in precipitation sometimes leaves them dry for months or even years at a time. The larger of these, though, such as the Cuatro Ciénegas Basin in Coahuila, México, harbor diverse and productive plant and animal communities— including cattails, reeds, sedges, native fishes, and migratory waterfowl. The fishes, in particular, denote great ecological value, for many are endemic (occurring only here) to particular basins. At Cuatro Ciénegas a remarkable three-quarters of the twenty fish species are endemic. The spring-fed pools of the Death Valley area of California (also remnant from larger Pleistocene lakes)

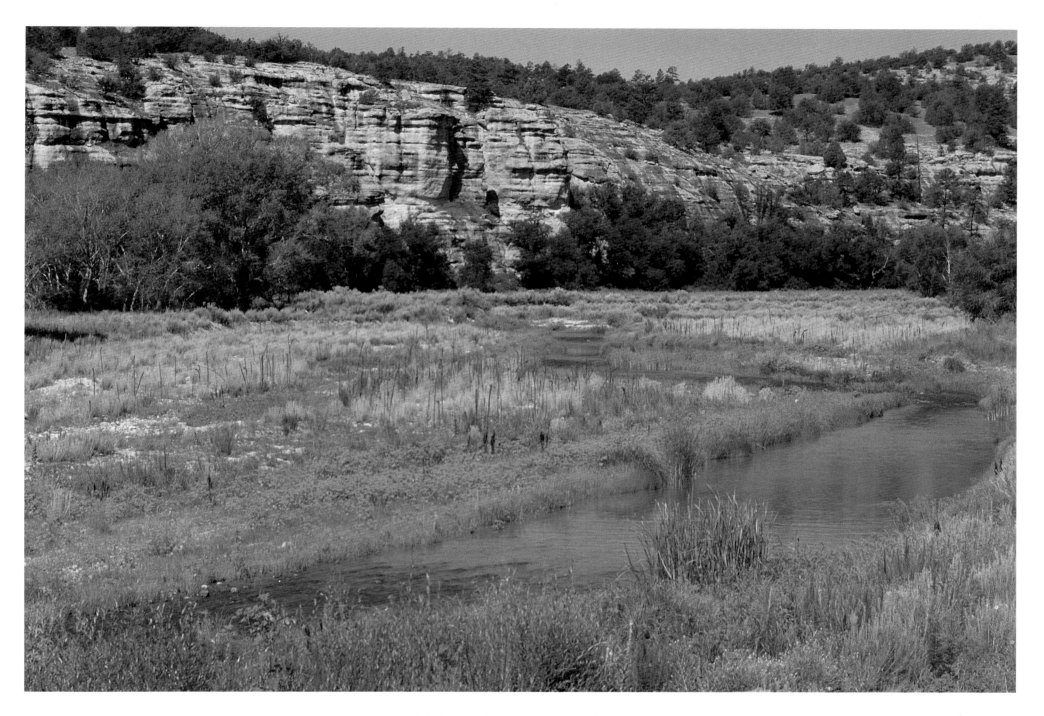

Gila River, Gila Mountains, New Mexico.

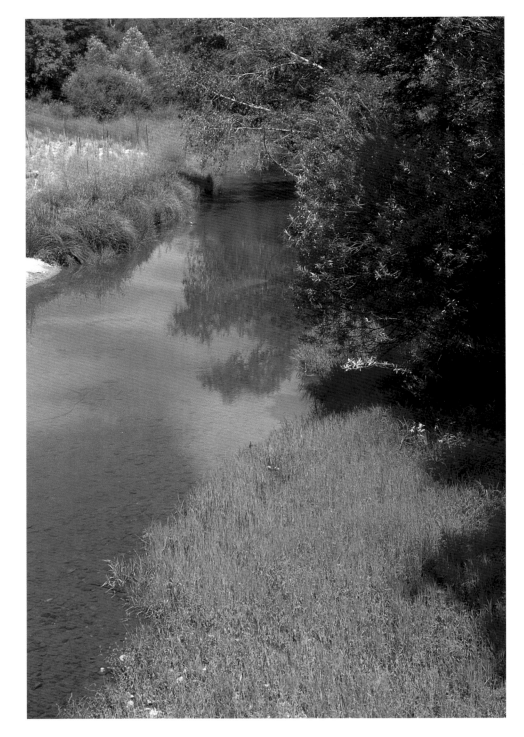

similarly boast many endemic desert
fishes. Some of these species, in spite
of great geographic isolation, are
exquisitely, if extremely, adapted for
their desert homes. Fishes such as the
Moapa Dace and *springfish* of Nevada live
only in water so hot it would be lethal
for many other species—in fact,
through such physiological adaptation
they have ecologically isolated them-
selves, effectively protecting themselves
from invasion by exotic species.[17]

Human-managed (or encouraged)
marshlands—such as those at Bosque del
Apache National Wildlife Refuge in New
Mexico, and Willcox Playa and White-
water Draw in Arizona are more com-
mon than the large, natural marshes
described above. Marshlands in the
desert, of whatever origin, hold great

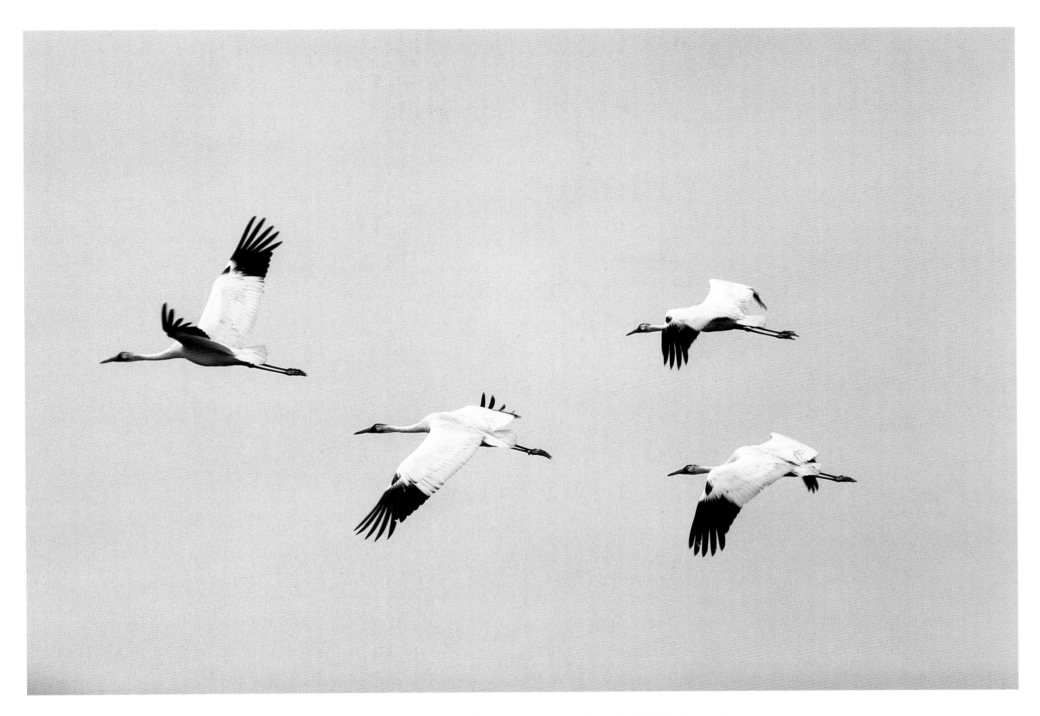

Whooping cranes (*Grus americana*) flying at Aransas National Wildlife Refuge in Texas.

Ribbon of Green: the San Pedro River (Arizona)

The San Pedro River of southern Arizona and adjacent Sonora—one of the only undammed rivers in the Southwest—is a remarkably important bird habitat, as well as an encouraging example of ecological restoration. Its location at the confluence of three major biogeographic provinces—the Chihuahuan Desert, the Sonoran Desert, and the Rocky Mountains—predisposes it toward biological richness. Being the greenest ribbon for a very long ways and being oriented north-south contribute to its key role as a migratory corridor. Between one and four million individuals of fifty Neotropical migrant bird species (those that breed in North America and winter in the tropics) use this riparian habitat each year. They are joined by some 350 other bird species, making this narrow corridor one of the richest bird habitats in North America. While especially well-known as an avian paradise, the San Pedro is home to more than birds. It hosts one of the richest assemblages of land mammals in the world: over eighty species have been seen here in the last century and a half. More than twenty different biotic communities have been described in the upper San Pedro basin. Three of these—the Fremont cottonwood-Goodding willow forest, ciénegas, and big sacaton grasslands—are considered endangered habitats. (This type of grassland has declined more than 90 percent.)

The picture along the San Pedro wasn't always so green. In the mid-1980s, the San Pedro was a heavily pounded watercourse, trampled and gouged by cattle, off-road vehicles, and mining operations. In 1988 Congress created the San Pedro Riparian National Conservation Area, to be managed by the federal Bureau of Land Management (BLM). The RNCA stretches about forty river miles, from the international border northward, averaging two to three miles in width. The BLM—in the past often accused of serving ranching and mining interests at the expense of natural ecosystems—rose admirably to the new management challenge. Mining, grazing, and most off-road vehicle use were prohibited. The beneficial results of this ecological management speak for themselves. The rebirth of life here is evidenced by the stunning numbers reported above and can be felt firsthand by a visit to this easily accessible riparian area. In spite of this uplifting recovery, the San Pedro remains at risk due to increasing groundwater use by the rapidly growing human population in the area.

For more information contact the Bureau of Land Management, San Pedro Riparian National Conservation Area, 1763 Paseo San Luis, Sierra Vista, AZ 85635; and see Hanson 2001.

Southern Arizona's San Pedro River is a critical wildlife corridor.

wildlife value. Bosque, Whitewater, and Willcox all host thousands of sandhill cranes each winter; listening to the rising and falling tones of a vast chorus of cranes is surely one of the more dramatic wildlife spectacles in the region. Managed versus natural wetlands quickly becomes a hazy distinction. While Bosque del Apache is mostly "natural," one of the prime viewing areas for cranes at Willcox Playa is adjacent to a power plant. Frankly, my own aesthetic tastes tend toward the indigenous habitats, but perhaps the cranes are telling us that in a

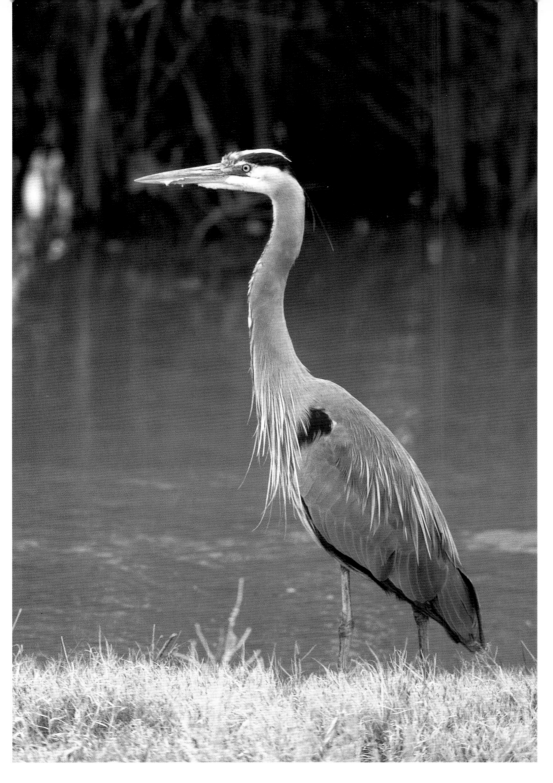

Great blue heron (*Ardea herodius*) in the Bosque del Apache National Wildlife Refuge, New Mexico.

land of degraded wetlands, human habitat manipulation is not one of their greatest concerns.

Undoubtedly, the most commonly encountered wetlands in the Southwest these days are human constructions. Countless cattle tanks and small stock ponds are sprinkled across the region.[18] Many are relatively lifeless, but a surprising number can support migratory ducks—a testament to how rare and essential wetlands are in this dry country. Where cattails and other native marsh vegetation become established, more diverse animal life can be found.

Ciénegas comprise a distinctive wetland type in the desert Southwest. The term has been used informally in the binational Southwest for many decades to describe many different types of riparian

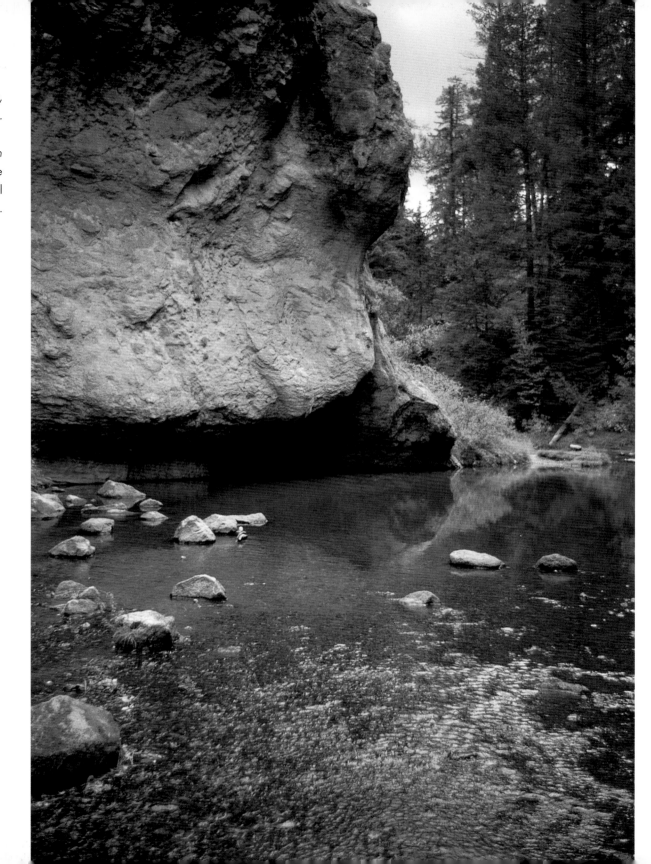

Right: East Fork of the Jemez River, Jemez Mountains, New Mexico.

Opposite: Snow and Ross' geese (*Chen caerulescens* and *Chen rossii*) in the Bosque del Apache National Wildlife Refuge, New Mexico.

and marshy wetlands. No one is totally sure, but it's generally thought that the word ciénega is a corruption of "cien aguas"—Spanish for "hundred waters." More recently, though, aquatic biologists have defined the term more precisely: a ciénega is a marshland community associated with perennial springs and headwater streams at middle elevations (between roughly 3–6,000 feet). In contrast to riparian corridors, flooding is absent from ciénegas. The "hundred waters" of numerous small springs and seeps saturate the soil of a ciénega. Typically, they are found in flat areas, where layers of rock or impermeable clay hold water at the surface, and where it is flat, so the moisture can't simply run off. This permanent saturation creates a specialized chemical environment—largely devoid of

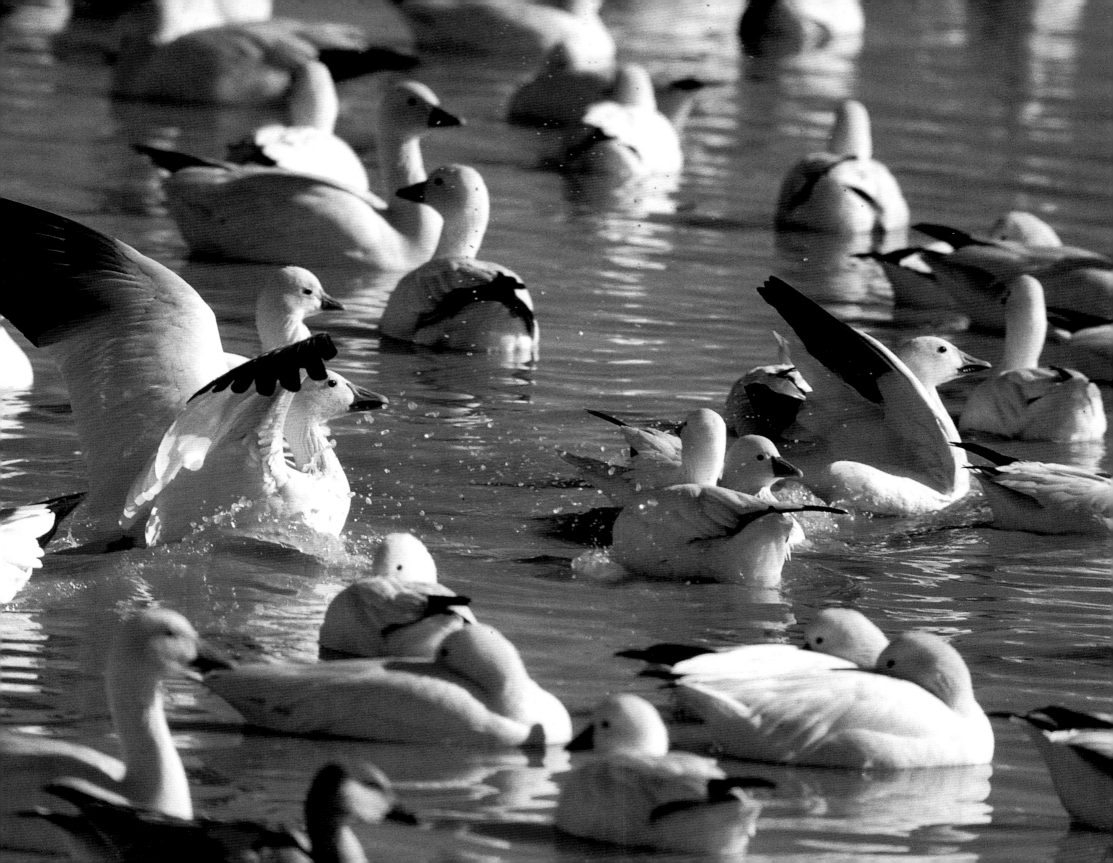

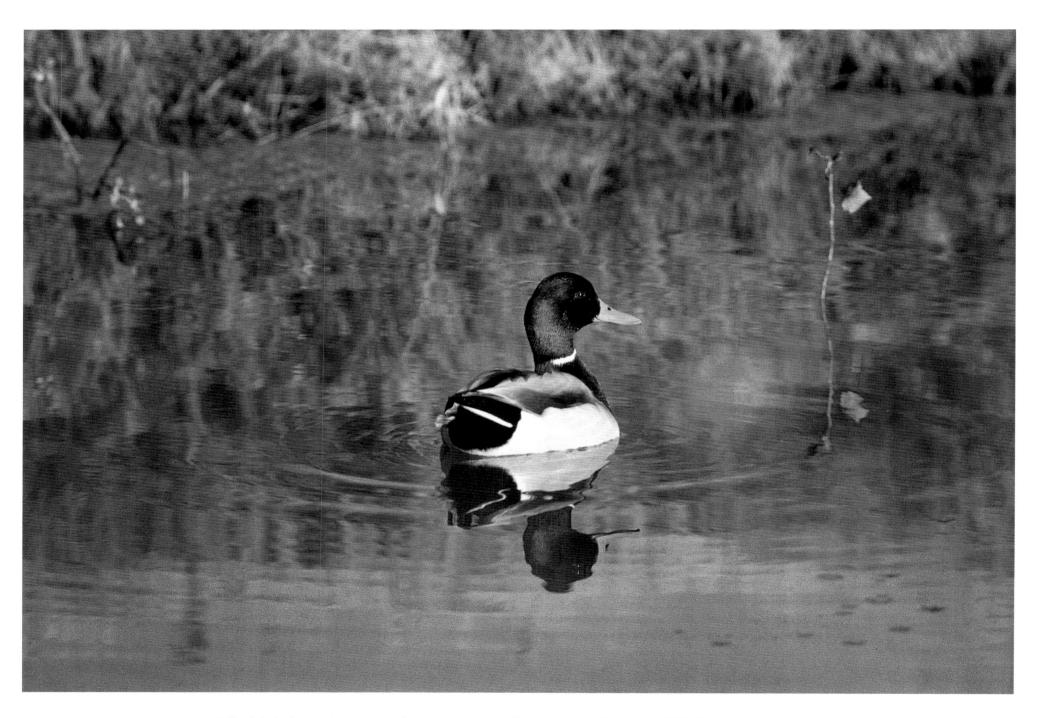

Mallard drake (*Anas platyrhynchos*) found on Farm Loop, Bosque del Apache National Wildlife Refuge, New Mexico.

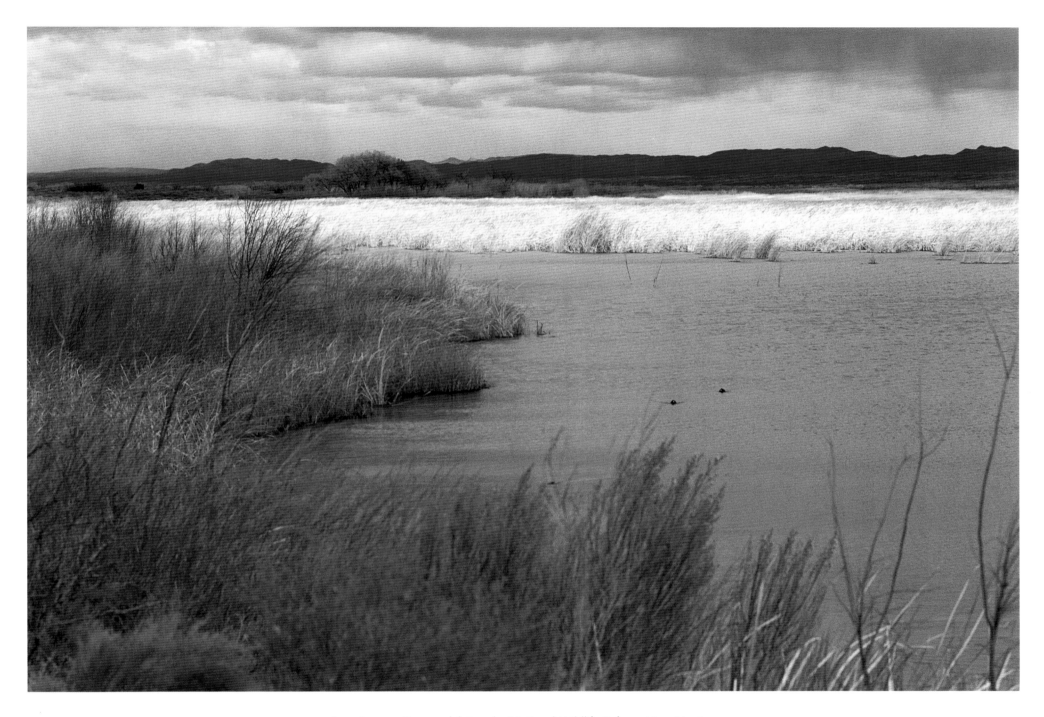

Farm Loop at Bosque del Apache National Wildlife Refuge, New Mexico.

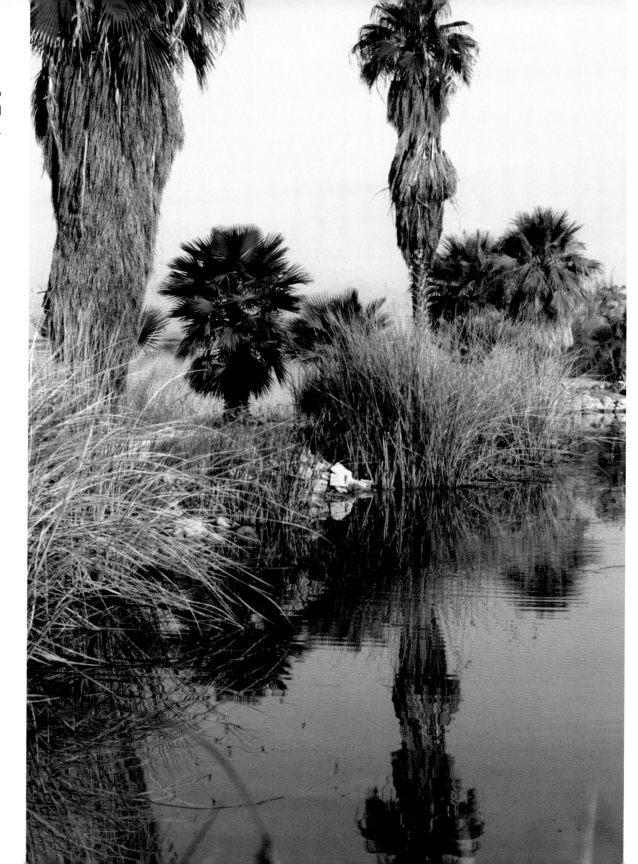

Wetlands on the Colorado River at the Havasu National Wildlife Refuge in Arizona.

oxygen—that is inhospitable to most species of plants. As a result, ciénegas have a specialized flora, usually featuring sedges and rushes; trees are rare, except occasionally around the perimeter. Although biological diversity tends to be low in ciénegas, productivity is high. Wildlife flourishes here in far greater abundance than surrounding arid uplands. This intense productivity, as in other desert wetlands, gets shared with adjacent, nutrient-poor uplands through the work and travels of herbivorous animals. As one of the rarest habitat types in the region, ciénegas are highly valued by biologists. Like other desert wetlands, ciénegas used to be much more widespread and common. But as water tables have been drained for agriculture and ranching, most ciénegas have simply dried up.[19]

Another type of spring-fed wetland has also dwindled, but not primarily due to human activity. While palm trees sometimes seem ubiquitous among Southwest and southern California human settlements, native stands of palms occur in only a handful of sites in the Sonoran Desert of southern California, Baja California Norte, and southwestern Arizona. These palm oases—relicts from a more widespread reign in earlier geologic periods—are restricted to isolated, perennial springs. California fan palms grow in all three states, while the blue fan palm doesn't reach into the United States. Yet another type of spring-fed wetland continues to fare well in its isolated locales: "hanging gardens" grow at seeps on the canyon walls of the Colorado Plateau.

These lovely, exuberant displays of plant growth often occur in grottoes or under overhangs. Such wetland species as columbines and maidenhair ferns cluster—sometimes, such as at Zion National Park, in great profusion— along fine rock cracks that exude precious moisture and contrast sharply with bare sandstone walls above.

Springs, whether they form a large marsh or a hanging garden dangling from a vertical rock wall, hold great biological importance. Because they are small and isolated, the total numbers of species they hold is relatively small. But they provide essential habitat for a large amount of biodiversity—out of all proportion to their surface area—because they often represent the only surface water for miles around. Moreover, springs and spring-fed aquatic habitats support a major percentage of the species of native fishes in western North America.[20]

WHERE DRY STONE SPROUTS WET LIFE

Another desert wetland habitat had its genesis during the Pleistocene Ice Age. *Playas*—normally dry lake beds that occasionally flood—are a conspicuous feature throughout many parts of the arid West. Especially prominent in the Great Basin of Nevada and western Utah and in the Rio Grande Basin, these flat, largely unvegetated expanses are remnants of the late Pleistocene, when the West was considerably cooler and wetter.[21] Were these old lake beds consistently dry, we wouldn't concern ourselves with them

Cottonwood seed in
the Bosque del Apache
National Wildlife Refuge,
New Mexico.

here. But they wait for periods of high rainfall, when they receive the runoff from adjacent mountains, and resume their status as lakes. At such times—even if only the playa's fringes hold water—they can suddenly teem with life. Aquatic invertebrates come out of dormancy and flocks of birds (ducks, geese, sandpipers, sandhill cranes) congregate to feast.

Other wetlands appear and disappear with the rains. Variously called waterpockets, potholes, *tinajas,* or rockpools, these slight basins in bedrock gather rainwater and keep it for a few days or a few seasons, a few being relatively permanent. Upon filling they quickly become infused with a renewal of life. Recall the pool swarming with tadpole shrimp I described in the first section—transforming in two days from bare, dry slickrock to a mass of wriggling life. Near Chaco Canyon in New Mexico I've seen these same prehistoric-looking critters swimming in an unglamorous muddy puddle along a dirt road just a few hours after rain.

These ephemeral aquatic systems remind us just how tenacious and creative life can be. Living and reproducing in these very temporary wetlands demands an array of ecological adaptations by aquatic organisms. Playas and potholes present enormous ecological and physiological challenges to their residents. Obviously, an aquatic system that is waterless most of the time presents a fairly fundamental challenge: what to do during the long dry stretches? But even in those precious intervals when they are truly wetlands, these habitats present unusual challenges. Water temperature can change

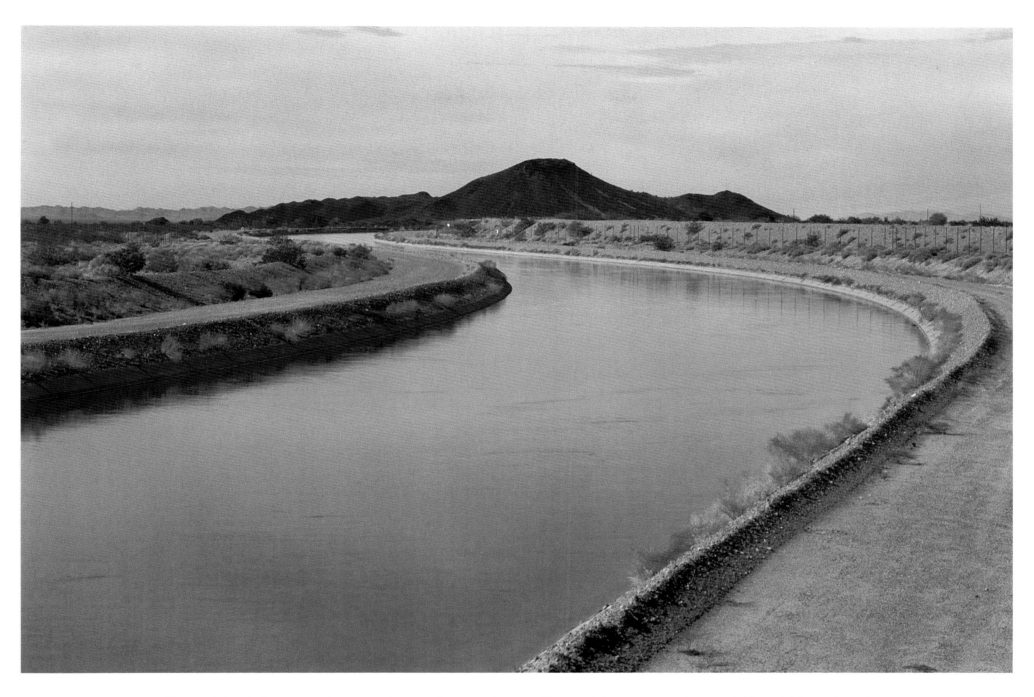

Phoenix-Colorado River water diversion project supplies water for use in Phoenix, Arizona, to serve the sprawl. (Central Arizona Project)
Unlike natural wetland habitats, canals like this are biologically depauperate.

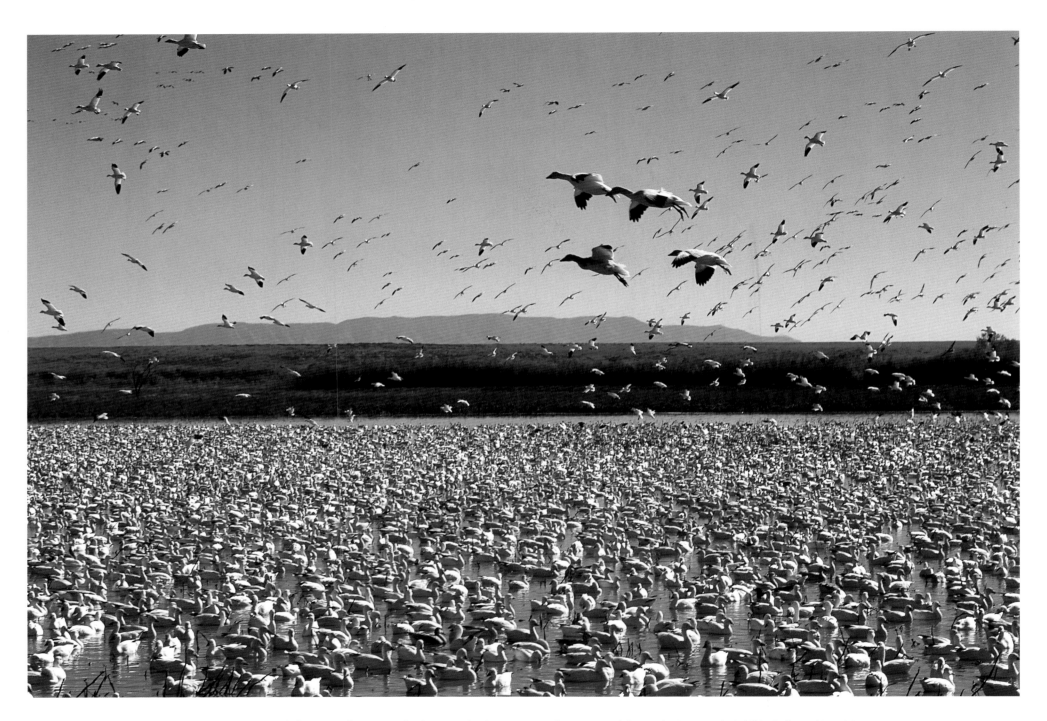

Snow and Ross' geese (*Chen caerulescens* and *Chen rossii*) taking wing at the Bosque del Apache National Wildlife Refuge, New Mexico.

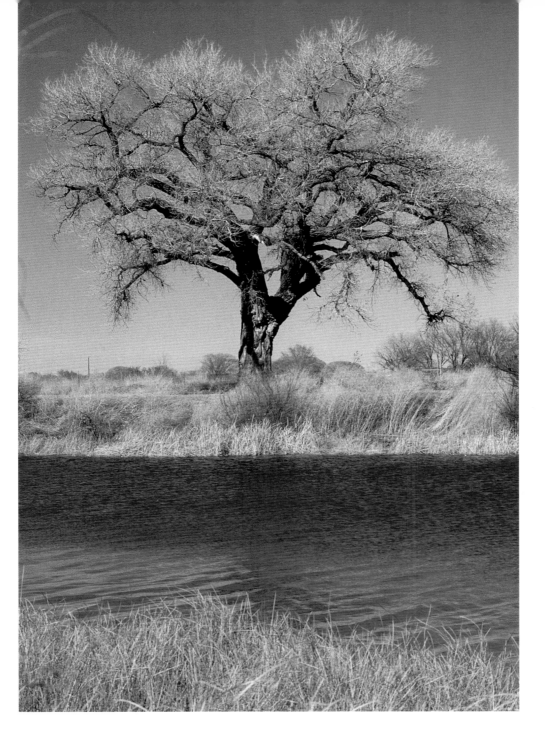

A cottonwood tree at the Bosque Redondo
on the Pecos River near Fort Sumner, New Mexico.

dramatically between day and night and between seasons—especially in small potholes. As pools dry, chemical and physical conditions—such as the concentration of dissolved oxygen, salinity, and amount of particulate matter—change quickly. Ultraviolet radiation can be intense. Pothole and playa critters, in essence, must be adapted for several different sets of aquatic conditions, which rapidly change. Some of the biota of these temporary wetlands come from the land—mosquitoes deposit eggs, which soon are wriggling larvae, for example—but many are true aquatic organisms. Most of these must enter long periods of dormancy during dry times, then erupt into hyperactive reproduction when the water returns. But even the return of rains can present a danger to

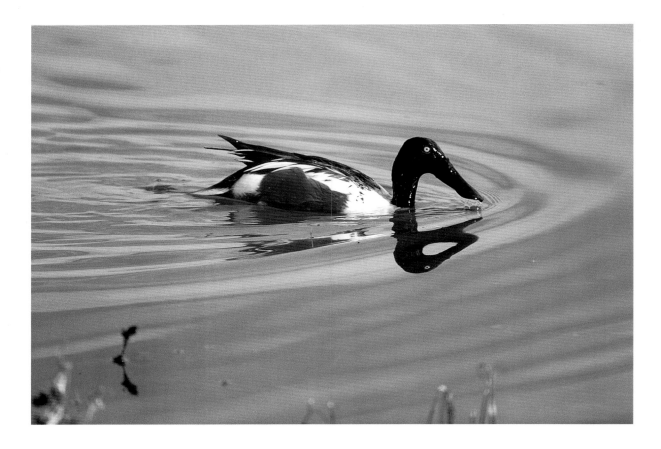

Left: Northern shoveler (*Anas clypeata*) on Pond Loop in the Bosque del Apache National Wildlife Refuge, New Mexico.

Opposite: Wall Lake deep in the Aldo Leopold Wilderness in the Black Range, New Mexico.

these animals. If they begin their reproductive cycle when the rains arrive, but the water doesn't last long enough to complete the cycle, they fail.

Fairy shrimp can survive as cyst-like shelled embryos for many years in dry playas of the Mojave Desert. After such a long wait, however, they are still persnickety about which rains to respond to. Careful study revealed that near-freezing, non-saline water especially promoted hatching. This makes great ecological sense. In the Mojave, the heaviest rains, and thus the longest-term flooding, occur in winter. And the floodwaters steadily grow more saline as the playa dries up. Thus, using temperature and salinity as signals leads to more successful hatching of cysts. When they hatch they face a new set of challenges: deteriorating conditions in the water—oxygen supply diminishing, temperature and salinity going up—and, often, the arrival of avian and insect predators. But the quintessence of a fairy shrimp involves doing two things—waiting patiently and reproducing fast. Give the new hatchlings ten days and they'll have produced a new crop of cysts that drop a few inches to the bottom sediments, where they will faithfully wait for weeks or decades for the next time the desert transforms into water.[22]

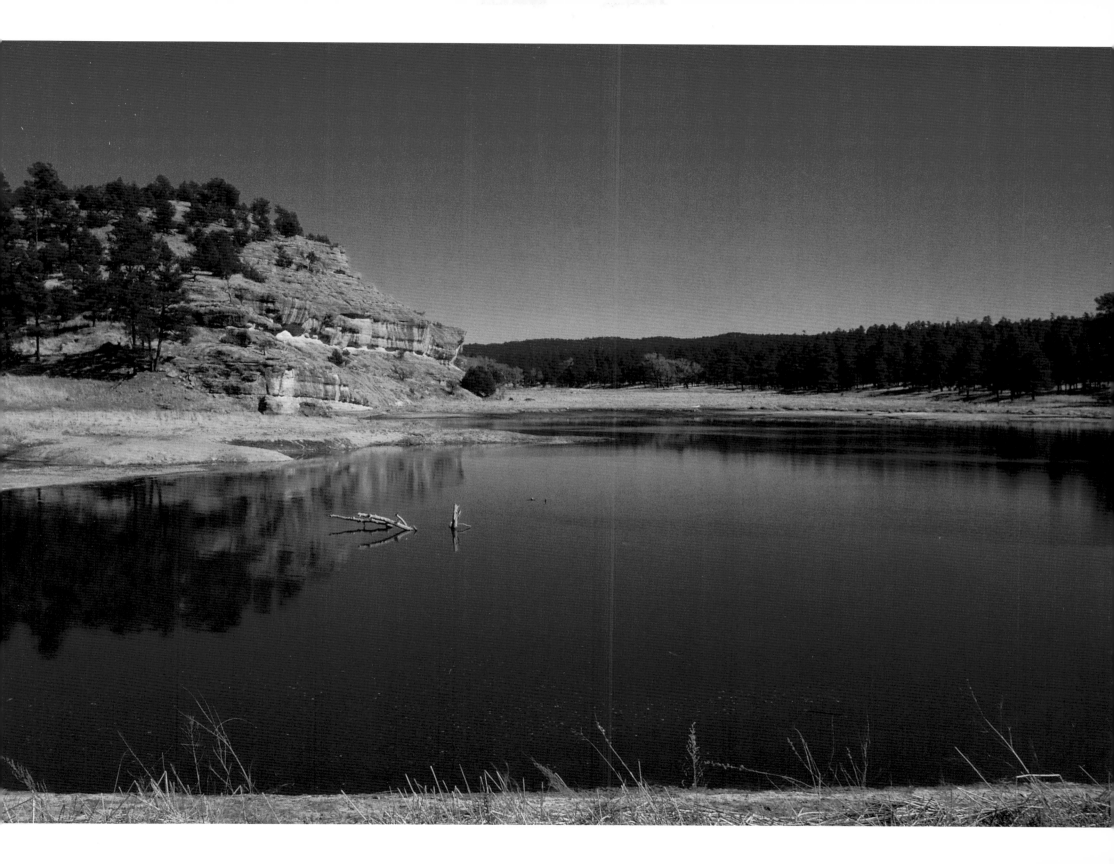

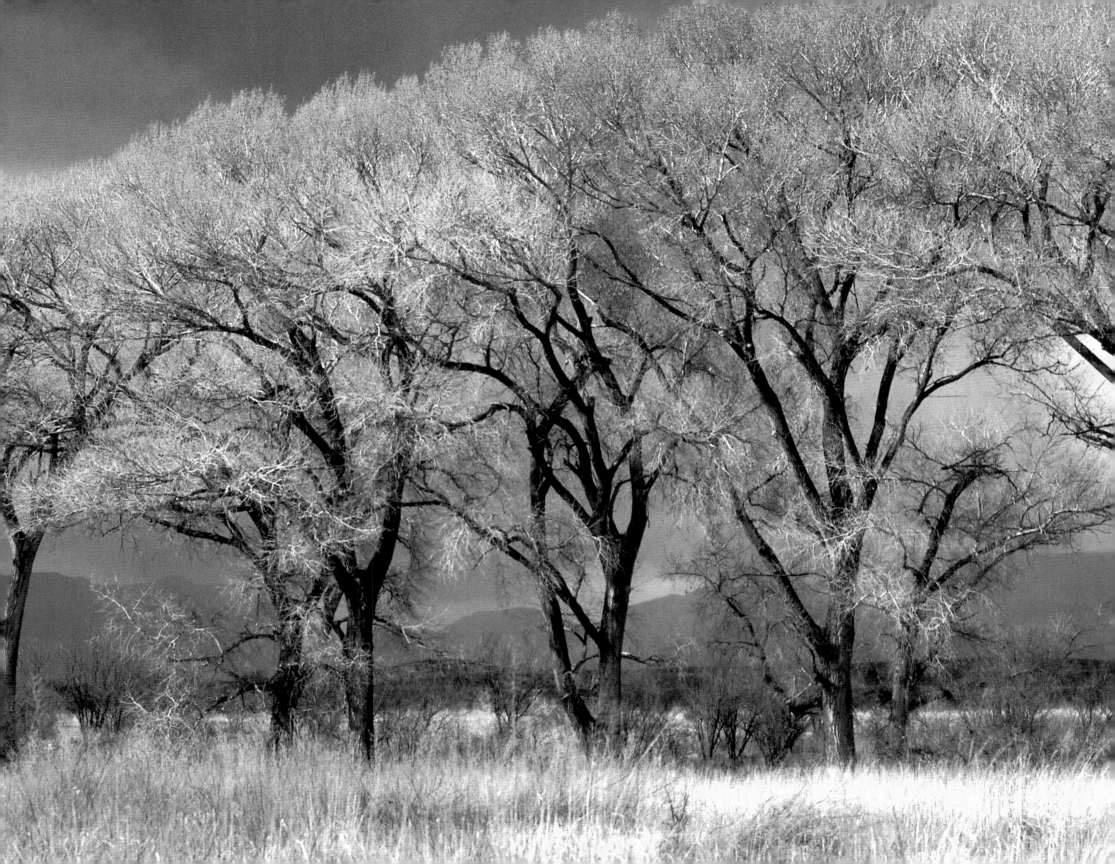

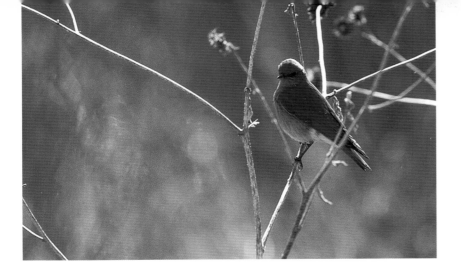

Above: Western bluebird (*Sialia mexicana*) in the Bosque del Apache National Wildlife Refuge, New Mexico.

Opposite: Cottonwoods greening up along the San Pedro River in southern Arizona.

4. The Human Touch

CARRYING WATER

Morning sun glints on the waters of the Infiernillo channel across which we've just come in the open fishing skiff. This Seri Indian man with erect dignity and a deeply creased face tells me of his ancestors who lived here centuries ago, who made the pots that now lie shattered at our feet. I pick up a ceramic fragment and turn it in my hand; I feel the determination of those who carried water here in these jugs from the spring hidden in the far hills, where we prepare to hike this January morning. My companion lived here himself until he was about the age of my *hijo*—he gestures toward my son who stands nearby, alert, shyly watching.

For uncounted centuries these people lived on this island, where desert encounters sea. To do so successfully required a joyous spirit—still much in evidence—and a deepening knowledge of the plants and animals that share this homeland. The Seri have named over four hundred types of plants and incorporated a quarter of these species into their diets.[23] Their intimate knowledge of animals from both desert and sea is no less impressive. But above all else living here necessitated a proper relationship with the most limited and crucial resource of all—water. This island, the largest in México, has two entire mountain ranges and over a hundred miles of shoreline, but freshwater exists in only a few small springs tucked into the mountains' folds. All water had to be toted several miles

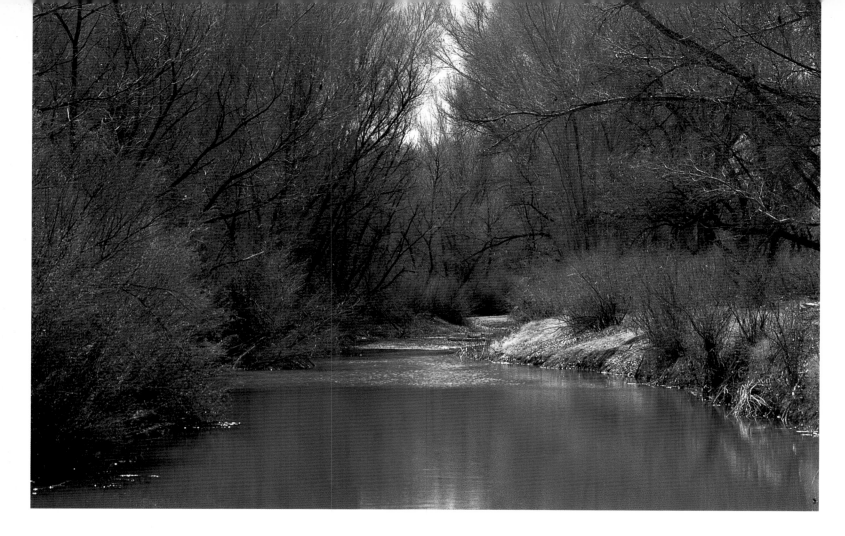

Left: San Pedro River in southern Arizona is a critical north–south wildlife corridor.

Opposite: Whooping cranes (*Grus americana*) in the Aransas National Wildlife Refuge, Texas. Just over 200 survive in the wild.

from those springs back to the village on the shoreline, at the site where we now stand. I ask my friend how often he made that journey when he was a boy; he shrugs and says two, three times a week.

We turn away from the glittering sea and head toward the mountains, where the fresh water lays hidden. People have walked this path for a thousand years, yet there *is* no path, no trampled ground. We hike through the open desert and tuck under the thorny trees along washes as midday approaches. Finally, as we wind our way into the occasional shade of the dry hills and draw closer to the spring, palo blanco trees, with their slender white trunks and grass-like leaves, grace the hillsides.

After three hours of walking we turn a corner in a dark-walled canyon and find the carrizo—reeds twice as tall as me emerging from damp soil. The last time I was here, in a wetter winter, water gurgled in a real stream. Today, though, dampness is enough—the only surface water for many miles. We relax in the cool shade before heading back towards our boat.

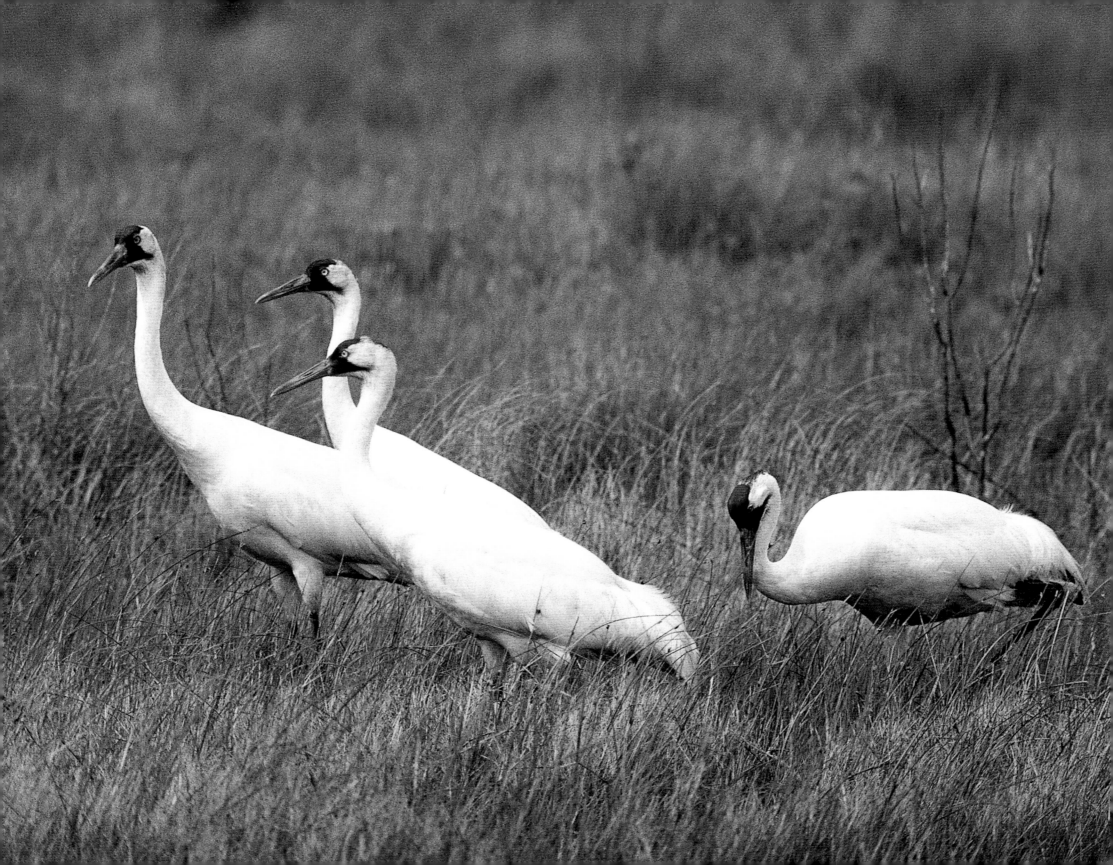

Rio Guadalupe, north of Gilman in the Jemez Mountains, flows into the Jemez River, then to the Rio Grande, New Mexico.

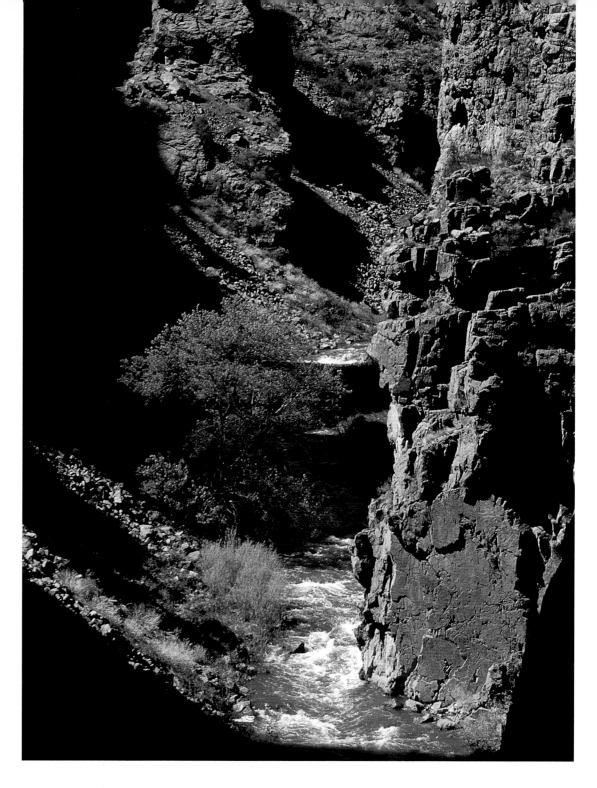

Unlike past generations, we fill no jugs, heft no burdens to our backs for this return trek. I cannot but think, though—how might it be to live in a desert culture that so viscerally understood what a gift water represented? How might our relationship to water and all the life it supports differ if we carried each drop in our hands or in a basket on our back?

This modest emergence of water, most precious of desert substances, has sustained this people for many hundreds of years. Without this great liquid gift, there would be no Seri language, no Seri baskets; we would lack this profound indigenous understanding of the plants of this desert coastline. We in the United States have been bestowed greater gifts of water but

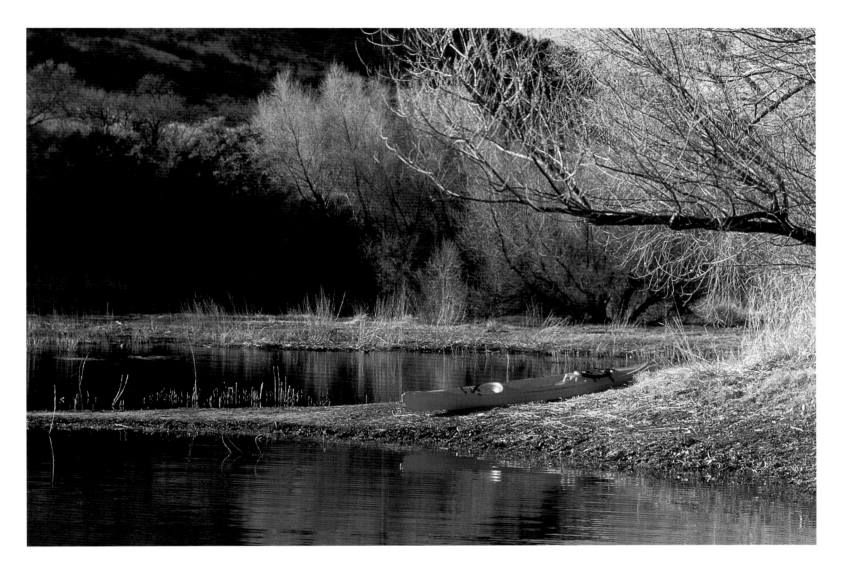

A kayak at Arivaca Lake, Arizona.

have squandered them more rashly. We, too, must learn that we have no greater treasure than water that arises in the middle of the desert.

The vision of the blessed afterlife for the Chiricahua Apache was "a beautiful place beneath the ground, where a nice stream of water flows between banks that are lined with cottonwood trees, and everything is green."[24] This indigenous view—that a healthy riparian ecosystem essentially represents heaven on earth—conflicts dramatically with our standard treatment of desert wetlands during the past century. Rather than seeing wetlands as ideal and

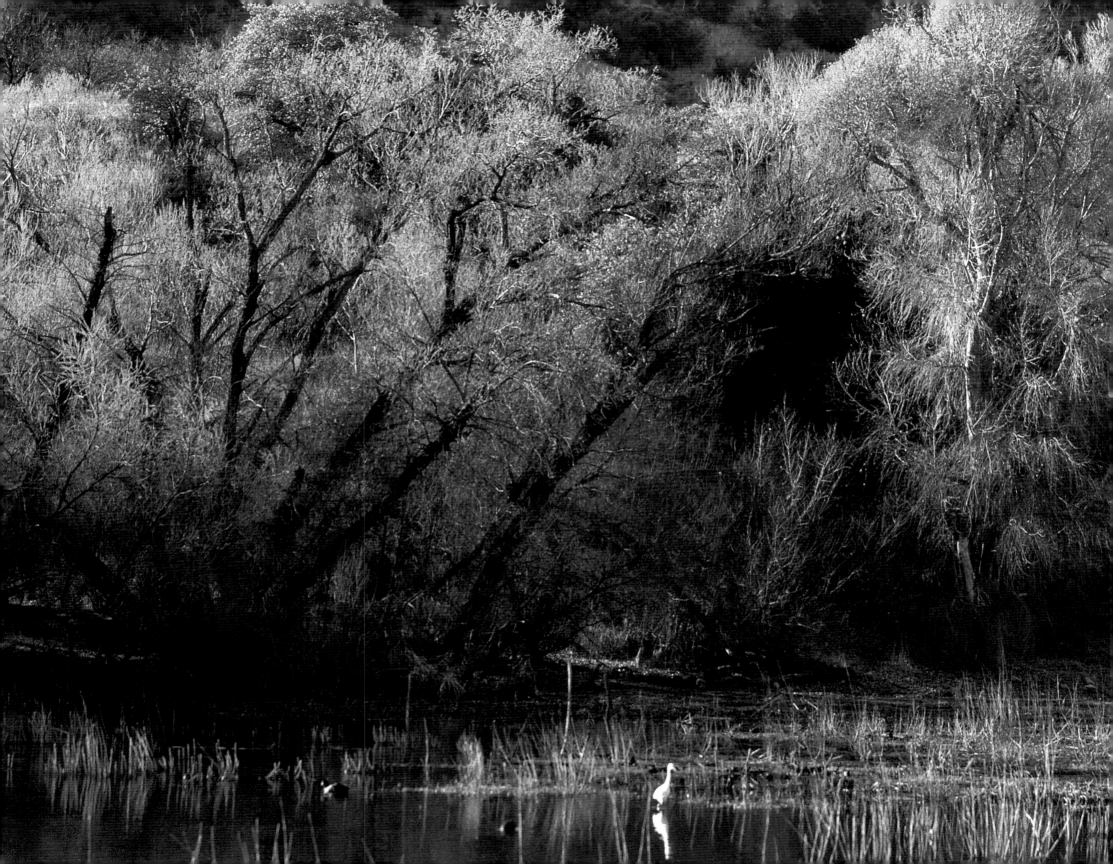

Top left: Once considered for our national bird, turkeys (*Meleagris gallopavo*) abound in the Bosque del Apache National Wildlife Refuge, New Mexico.

Top right: A stream to feed the desert surrounding the Zuni Mountains, New Mexico.

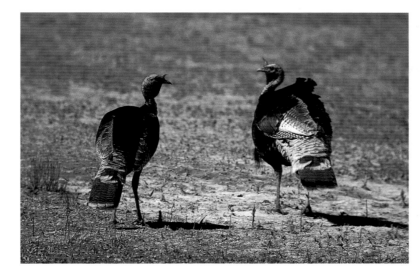

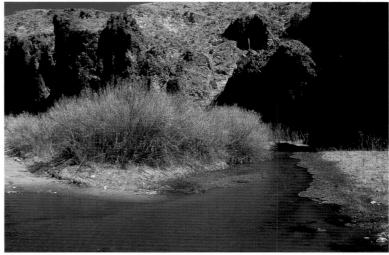

Right: Arivaca Lake, Arizona.

Opposite: Great egret (*Casmerodius albus*) at Arivaca Lake, Arizona.

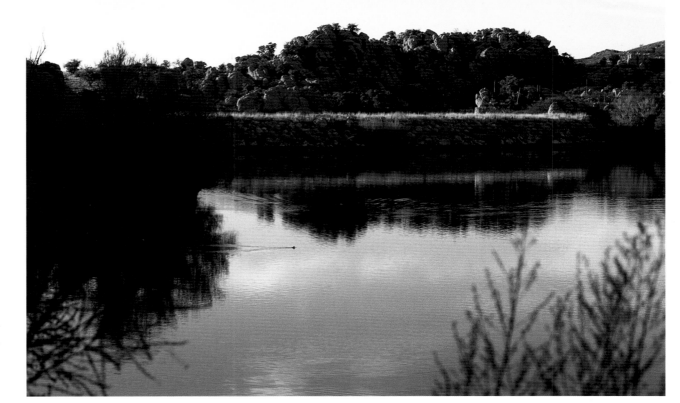

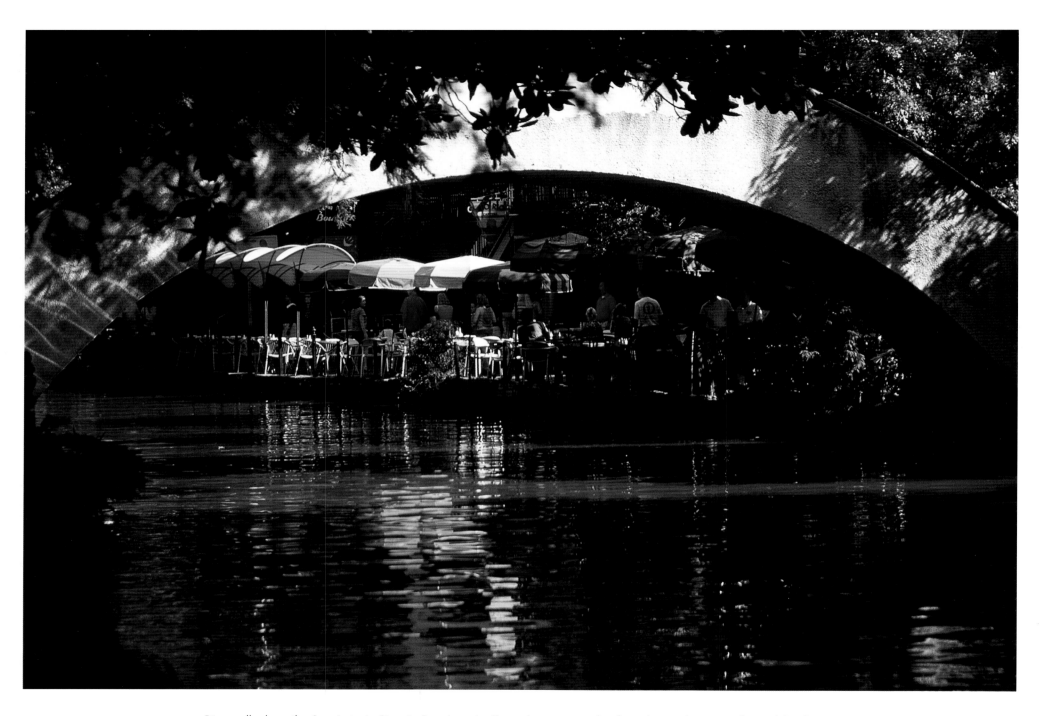

Riverwalk along the San Antonio River in San Antonio, Texas, is one example of man's use of water in the arid Southwest.

White-faced ibis (*Plegadis chihi*) on Pond Loop, Bosque del Apache National Wildlife Refuge, New Mexico.

Arivaca Ciénega and Creek (Arizona)

One of the most accessible remaining ciénega habitats (and the westernmost) is the Arivaca Ciénega, just outside the town of Arivaca, Arizona, roughly an hour south of Tucson. The ciénega, and Arivaca Creek that flows from it, are both part of the Buenos Aires National Wildlife Refuge, the majority of which is comprised of extensive desert grassland, habitat for the reintroduction of the masked bobwhite quail. What makes this portion of the Altar Valley special is that it is one of the largest grasslands free of grazing in the United States. Even more unusual, fire—a natural ecological feature in most grasslands—has been reintroduced as livestock have been eliminated. The wetlands of Arivaca Ciénega and Creek, then, provide a lush counterpoint to the dry, open country that makes up most of the refuge. The Fish and Wildlife Service has constructed a two-mile trail (a boardwalk in places) that weaves past the seven springs, pond, and seasonal wetlands of Arivaca Ciénega. Open country of sedges and grasses is interspersed with patches of rich cottonwood-willow riparian forest. This ecological interfingering provides bountiful habitat for birds and butterflies. Vermilion flycatchers, gray hawks, and many other borderland specialities are commonly seen here. A few miles downstream from the ciénega area there is also easy public access to the canopy of giant cottonwoods along Arivaca Creek.

For more information contact the U.S. Fish and Wildlife Service, Buenos Aires National Wildlife Refuge, P.O. Box 109, Sasabe, AZ 85633.

Vermillion flycatcher (*Pyrocephalus rubinus*), San Pedro River, Arizona.

inviolable, Euro-American settlement of the Southwest proceeded by treating water as a tool and wetlands as irrelevant at best. Ciénegas were drained; riparian trees were cut down and streambanks trampled to dust by huge herds of livestock; dams plugged stream after stream, killing living rivers with impoundments; pumping and irrigation canals caused groundwater levels to plunge deeper and deeper below the surface, allowing so many wetlands to wither and die. In short, heaven, too often, turned into ecological hell.

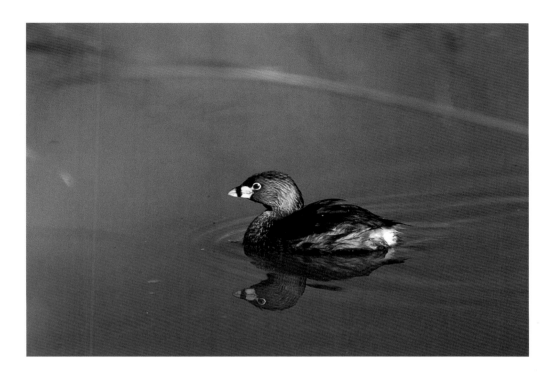

Pied-billed grebe (*Podilymbus podiceps*), Bosque del Apache National Wildlife Refuge, New Mexico.

FORSAKING HEAVEN

Close to half a century ago eminent fisheries biologist Robert Rush Miller lamented what had befallen aquatic ecosystems of the Southwest: a great shift from clear, dependable streams to deeply gouged channels that flowed only intermittently. These new streams were more vulnerable to flash floods and their heavy loads of silt. The surviving water—when there was any—tended to be warmer due to the overall loss of volume and the destruction of adjacent vegetation. Smaller creeks, springs, marshes, and lagoons, he reported, had largely disappeared, due at least in part to the lowering of the water table. Stories of individual rivers bore out this story. When Anglos arrived in the region, the Gila River was a permanent stream with clear to "sea-green" water rushing in a narrow channel, flanked by abundant cottonwoods, willows, and reeds so dense that approach was rendered difficult. A myriad of lagoons and extensive marshlands, full of geese, ducks, deer, and beaver, accompanied the course of the river. By 1920 these once-rich areas had become "desolate wastes of sand and silt." The upper Rio Grande once was a large enough river to support fishes such as the sturgeon caught near Albuquerque in the 1870s. By the beginning of the twentieth century, however, it often went dry, flowing only after storms. The once mighty Colorado River was tamed behind a series of dams, completely changing character from a silty, warm river with wildly fluctuating flows (records just upstream from its delta before the construction of Hoover Dam varied from sixteen to a quarter-million

cubic feet per second) to a series of chilly, sediment-free reservoirs stocked with non-native trout. The river itself rarely reaches the sea anymore.[25] Freshwater life is imperiled—though often ignored—throughout many parts of North America, but freshwater ecosystems of the bi-national Southwest are among the most critically threatened on the continent. After amphibians, freshwater fishes represent the most threatened group of vertebrate animals in the world.[26]

We could go on and on with these tales of degradation. But rather than drag our hearts through the dust, let's try to understand what caused these changes.

Three main types of human activities have proven to be less than benign and led to the dramatic changes we've just discussed: shifting patterns of water distribution with

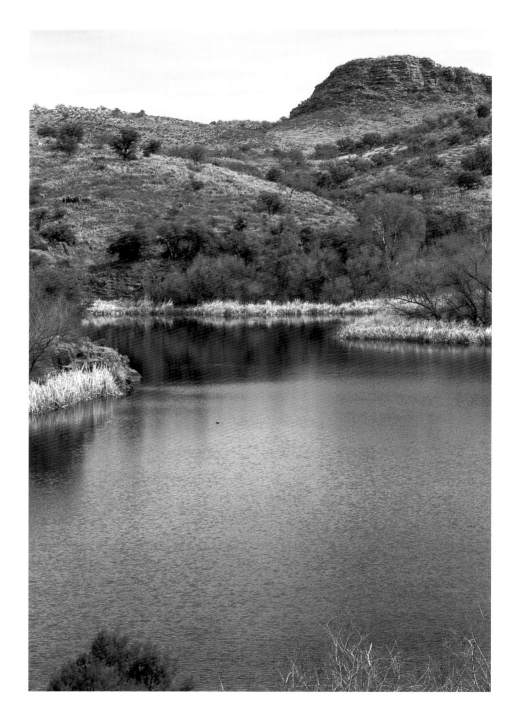

Pena Blanca Lake, Arizona.

dams, diversions, and pumping; disruption of watershed processes by livestock grazing; and introduction of exotic (non-native) species into both aquatic and adjacent terrestrial habitats.

Water has been diverted to new tasks throughout the Southwest as long as humans have lived here, but the technology has grown more and more sophisticated. In present-day Phoenix one can still find traces of an immense system of irrigation canals constructed by the Hohokam a millennium ago. Until the past century such developments remained relatively rare and localized. During the twentieth century, however, the situation changed dramatically. With the rush of Euro-Americans into the Sun Belt, population densities soared, intensifying demands on water resources. Technological innovations

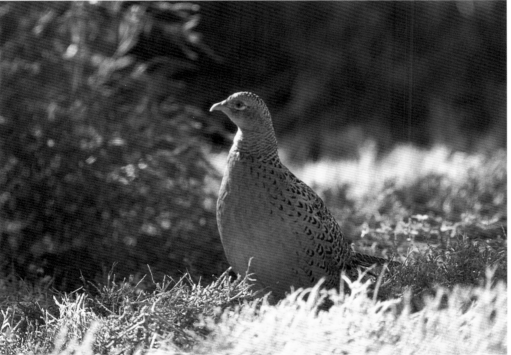

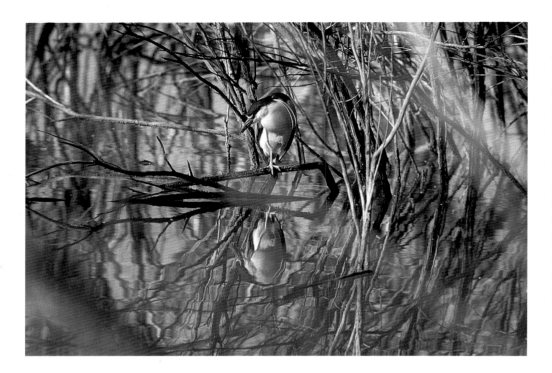

Left: Black-crowned night heron (*Nycticorax nycticorax*) on Pond Loop in the Bosque del Apache National Wildlife Refuge, New Mexico.

Opposite: Snow geese (*Chen caerulescens*) migrate from the Arctic, arriving in November and departing for the north in March, Bosque del Apache National Wildlife Refuge, New Mexico.

allowed sweeping changes in patterns of water distribution unimaginable to those, such as the Hohokam, who had to dig every irrigation trench by hand. New earth-moving machines, powered by new fossil fuels, enabled dams to control the flow of the majority of rivers in the Southwest. The even newer technology of pumping groundwater to the surface constituted an agricultural miracle. Within a few decades, few aquatic habitats in the Southwest escaped human manipulation, as dams and diversion channels bled water from streams, and springs, ciénegas,

and other isolated wetlands dried up and disappeared as groundwater pumping caused the water table to plummet.

Dams and water diversions are so common in the Southwest that we sometimes have trouble remembering what a fundamental change we have imposed upon the landscapes of this region. Tens of thousands of cars race across freeway bridges in Phoenix every day, seemingly oblivious to the startling sight below: the "river" seen is made of concrete, while the real Salt River is more full of tire tracks than water.

From the perspective of riparian plants, dams and diversions present two problems. In a great many cases riparian forests wither and die because so much water is drained away that it is simply too dry. But even when enough water remains, cottonwoods and their kin can die off. The problem is that in regulated rivers, floods come at the wrong time for seeds to germinate or are of the wrong intensity. Cottonwood groves have often declined after their rivers have been dammed. This becomes alarming when one realizes that Utah's

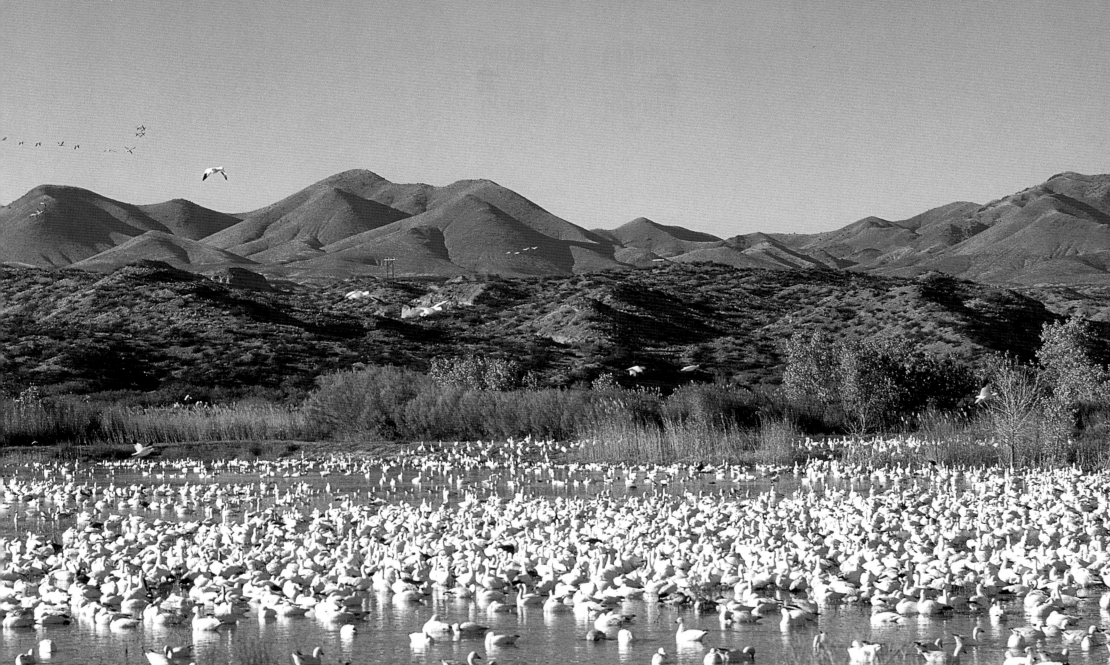

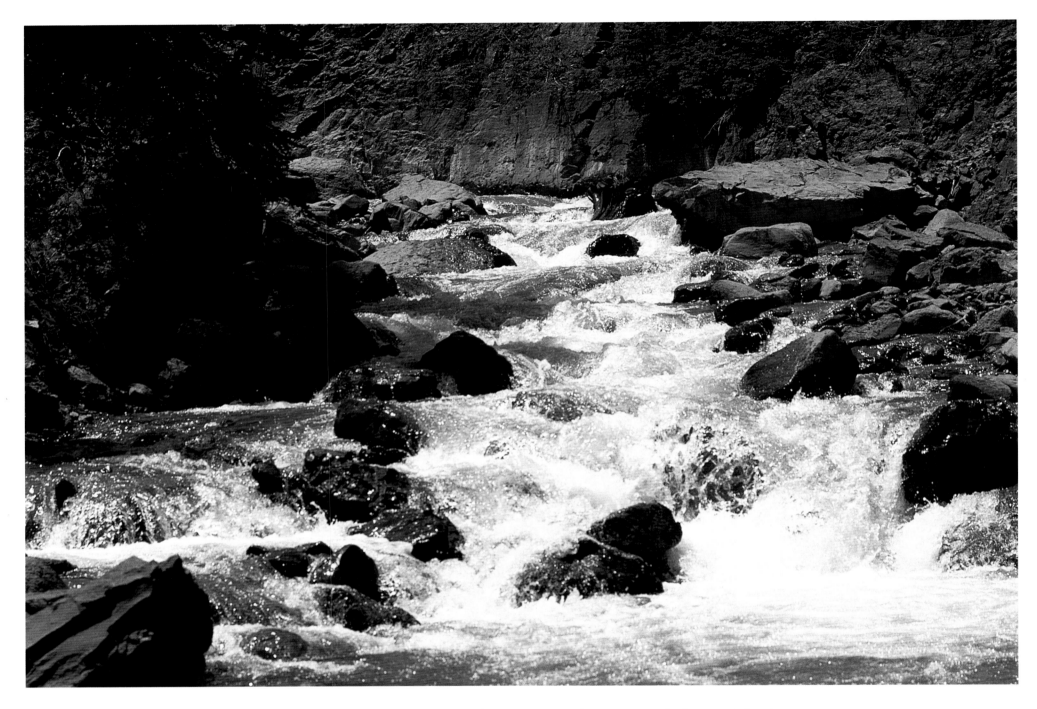

Water rushing from the snowpack carves the steep Uncompahgre Gorge south of Ouray, Colorado.

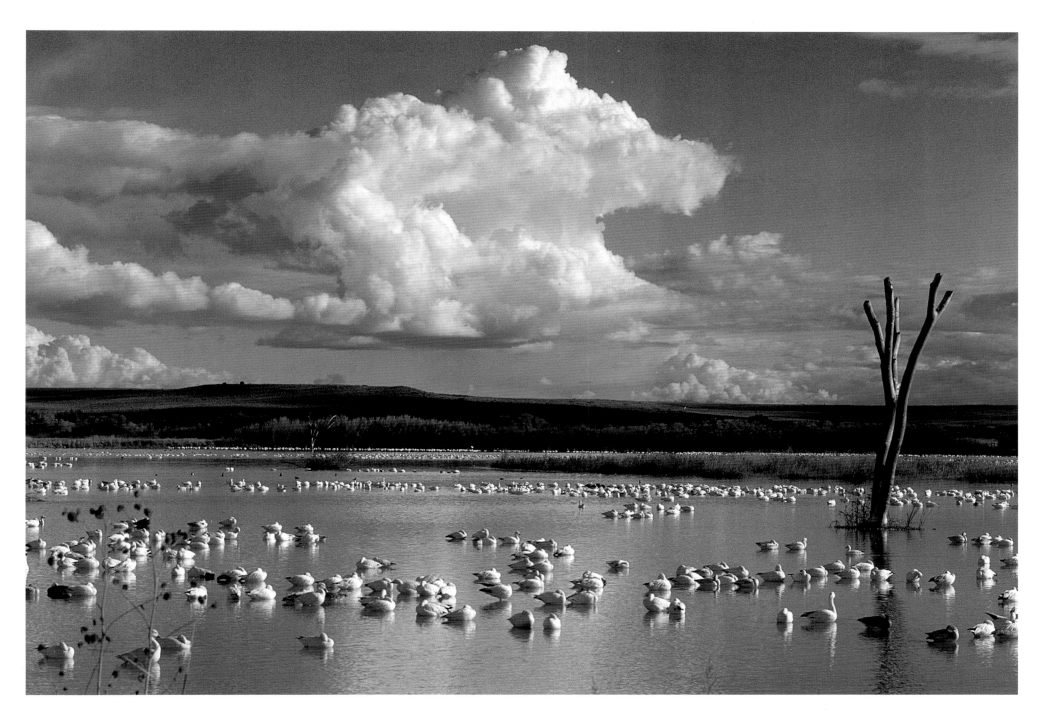

Snow geese (*Chen caerulescens*) with a big sky in the Bosque del Apache National Wildlife Refuge, New Mexico.

Escalante and Arizona's San Pedro and Verde are the only major undammed rivers left in the Southwest.

Grazing by domestic livestock—mostly cattle—is the most ubiquitous influence on native ecosystems of western North America. No other form of land use even comes close: approximately 70 percent of the eleven western-most states is grazed. Cattle are not terribly intelligent, but they are not as dumb as we sometimes think—they prefer riparian areas for the same reasons we humans do: shade, cooler temperatures, and water, not to mention more abundant food. While public lands grazing allotments may stretch over thousands of acres, livestock spend a disproportionate amount of their time in riparian zones. Riparian habitats are not only biologically rich, as discussed earlier, but also easily damaged. The U.S. Environmental Protection Agency recently concluded that riparian conditions throughout the West are the worst in American history. Over 90 percent of Arizona's original riparian habitat is gone; cottonwoods along the Rio Grande in New Mexico are being replaced by exotic shrubs. A few years back a committee of biologists from several government agencies quietly concluded that grazing was the most important factor degrading wildlife and fisheries habitat in the West. Such conditions led three major scientific societies—the American Fisheries Society, the Society for Conservation Biology, and The Wildlife Society—to call for a major overhaul of grazing practices in the West.

The Smithsonian Migratory Bird Center recently stated that grazing "remains the single most destructive force that can be practically and significantly reduced" to benefit Neotropical migrant birds. A recent synthesis of research in seven riparian ecosystems in five western states concurred: protecting more riparian areas and "reducing cattle grazing is likely to produce the greatest benefits for bird species dependent on western deciduous riparian habitats."[27]

So how do cows cause so much trouble? Livestock alter riparian communities in several ways. Their heavy-bodied trampling compacts soil, turning it into something more akin to pavement—rainfall runs off rather than soaking in where it can be used by plants. By munching green leaves and

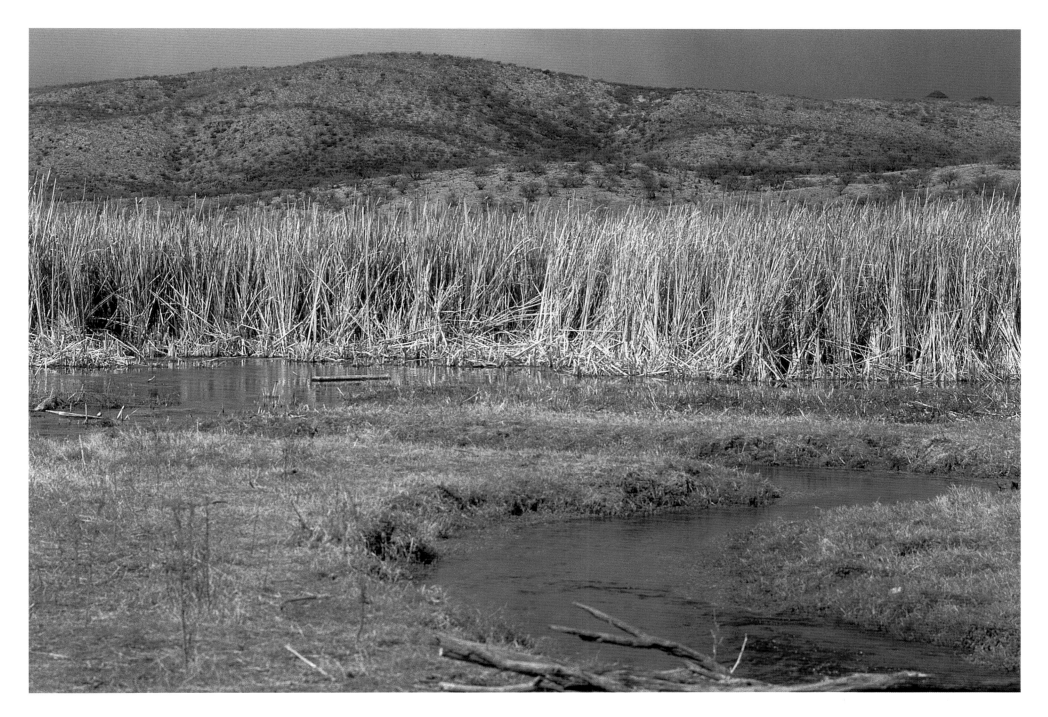

Patagonia Lake State Park, Arizona.

Left: Long-billed curlew (*Numenius americanus*) in the Laguna Atascosa National Wildlife Refuge in Texas.

Oppostie: Rio Chama River in Abiquiu, New Mexico.

stems livestock remove much of what shelters the ground from intense solar radiation; as a result, evaporation rates increase, and the riparian habitat becomes distinctly more desert-like. Livestock can bring cottonwood regeneration to a screeching halt—cattle selectively eat the tender saplings, leaving none to become adults. They physically damage vegetation by rubbing, trampling, and browsing, and they can alter the growth form of plants by removing terminal buds, which stimulates lateral branching—a sort of bovine bonsai project. Cattle activities

especially damaging to native fishes are the removal of vegetative cover and the trampling of overhanging streambanks. Without shade, stream temperatures rise; without overhanging banks, native fishes lack cover from predators. Livestock, in essence, create entirely new aquatic ecosystems by changing water chemistry (via feces) and temperature of streams, disturbing streamside vegetation, trampling streambanks, and changing the shape of the water column.[28]

The visionary ecologist Aldo Leopold once wrote, "To be an ecologist is to live

alone in a world of wounds."[29] Perhaps the wounds least visible to the general public, but painfully evident to ecologists, are those inflicted by exotic (nonnative) species, because they may be the least fixable. The fate of a new plant or animal introduced into an area, whether by intention or accident, is most often to perish. But occasionally, through ecological coincidence, the newcomer is preadapted to flourish in its new habitat. Its good fortune always comes at the cost of native species and processes.[30]

Two exotic trees—tamarisk and Russian olive—are rapidly colonizing

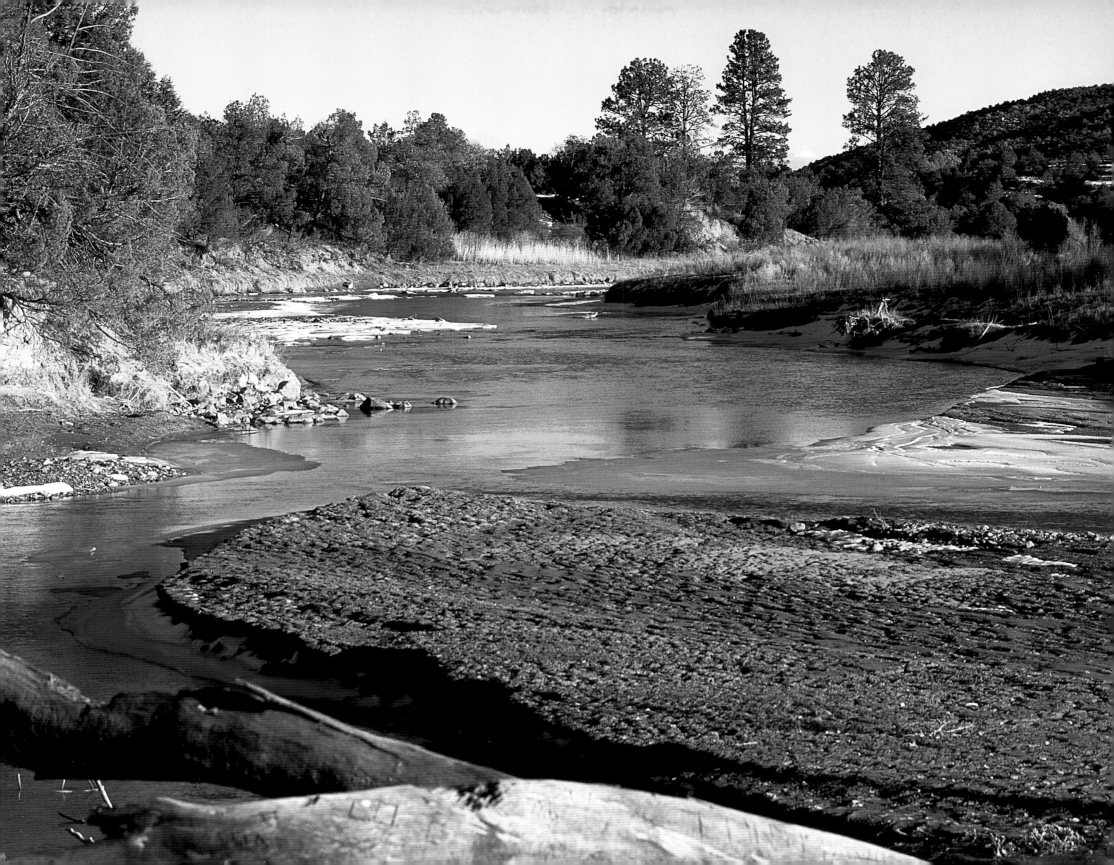

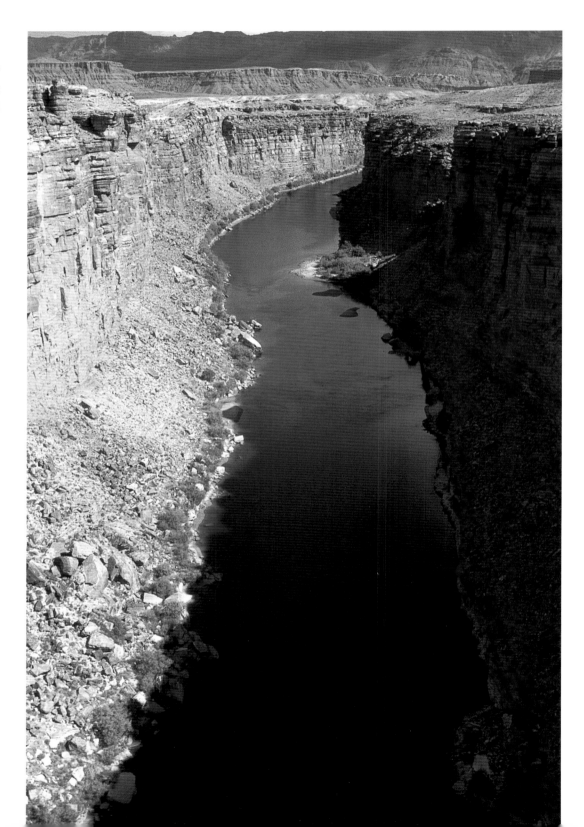

The Colorado River at Lee's Ferry leading toward the Grand Canyon, Arizona.

riparian zones throughout the Southwest at the expense of native cottonwoods and willows. Bird diversity is lower in riparian zones composed of these exotics than in the native forests. Tamarisk was intentionally introduced to North America from Eurasia in the late-eighteenth century but didn't start escaping cultivation in a big way until the early twentieth century, when it began to be planted more widely for erosion control. In Utah it spread especially rapidly from the mid-1930s to the mid-1950s, an unwitting beneficiary of Euro-American habits. Its seeds began to spread at the same time that native riparian communities were being cut down for firewood, roof-beams, pasture, and cropland. Even though tamarisk seedlings actually grow more slowly than many native riparian trees

The Colorado River

One of the great rivers of North America, the Colorado drains portions of seven states in the United States and two in México, a watershed area of almost a quarter-million square miles. It has been called "the single most unifying geographical and political factor in the West." From its headwaters in the Wind River Range of Wyoming, the river journeys 1,700 miles to its delta at the head of the Gulf of California. In actuality, though, the river rarely reaches the sea anymore. A series of dams and extensive diversions allows each drop of water to be used, on average, three times before it gets to the lowest reaches of the river. As author Philip Fradkin said, the Colorado is "the most used, the most dramatic, and the most highly litigated and politicized river in this country, if not the world."

Originally, this was a warm, silt-laden river, with dramatic, seasonal variations in flow, dependent on snowmelt and rain storm patterns. The Colorado once carried one of the heaviest silt loads of all the world's rivers; it was calculated that 160 million tons of suspended sediments floated past Yuma, Arizona each year—more than all the railroad cars ever made could carry. It used to be said that Colorado River water was "too thick to drink but too thin to plow." But, beginning in 1936, a series of dams—Hoover, Davis, Glen Canyon, and many others—have choked the river's flow. As described elsewhere in this book, dams profoundly alter aquatic and adjacent wetland and terrestrial habitats by lowering water temperature, disrupting flood cycles and thus the natural movement of beach-forming sediments, and encouraging the spread of exotic plant species. The Colorado River is a poster child for the disastrous ecological consequences of dams and diversions. The river system was home to a number of endemic fish species, all adapted to life in turbid, fast-flowing streams. Now that the river has largely been converted to a series of cold, still impoundments, all its endemic fish species are imperiled. More than fifty exotic fish species have been introduced to the river system, while exotic plants, such as tamarisk, displace native riparian forests. Riverside beaches shrink as sediments are trapped behind dams. Native cottonwood-willow habitat, vital to a large portion of the region's bird life, is much diminished due to elimination of natural flood regimes. Studies along the lower Colorado River valley confirm that tamarisk habitat supports far fewer bird species than the native cottonwood-willow stands it has replaced. These researchers were clear: if we care about wildlife along this river, restoration of cottonwood-willow habitat is essential. Even such a grim story has its different sides, however, because ecological change can move in many directions. It turns out that new marsh habitats created behind dams support large numbers of birds, and that the open water habitat of the lower river supports more waterbirds than it did before dams regulated flow. For the present, though, contested politics, not ecology, too often dominates discussion of the Colorado River's future.

For more information see Abell et al. 2000, Carothers and Brown 1991, Fradkin 1981, Rosenberg et al. 1991, and Worster 1985.

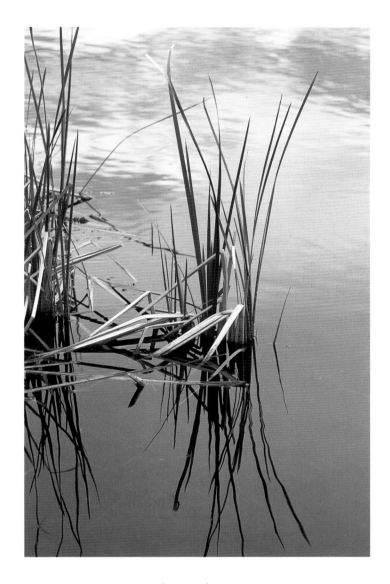

Pena Blanca Lake, Arizona.

Left: Morning frost, Pond Loop in the Bosque del Apache National Wildlife Refuge, New Mexico.

Opposite: A mountain bog in the Sangre de Cristo Mountains in southern Colorado.

(including cottonwood), they have an edge in other ways. Their seeds can germinate within a day of being wet. And—unlike most native riparian species—they can survive indefinitely in unsaturated soil. Furthermore, whereas cottonwoods flower at one time in the spring, tamarisks bloom almost continuously for half the year, and thus can be producing seeds throughout that time. And salinity—which tends to increase over time on degraded floodplains— favors tamarisk because it discourages the germination of cottonwood seeds. Tamarisks, then, have tended to take over riparian sites which have been abused by livestock or where dams have altered flood regimes—which is to say, along most streams in the Southwest. Another introduced tree, the Russian olive, is also rapidly destabilizing Southwestern riparian habitats. Although it has been stud- ied much less than tamarisk, Russian olive is spreading swiftly throughout the entire West. Along some streams it is becoming established more extensively and quickly than tamarisk.[31]

Even less visible to most observers, the introduction of exotic fishes into streams and pools can spell disaster for natives. The native fish fauna of the Southwest is highly unusual—while overall diversity is low, many of the

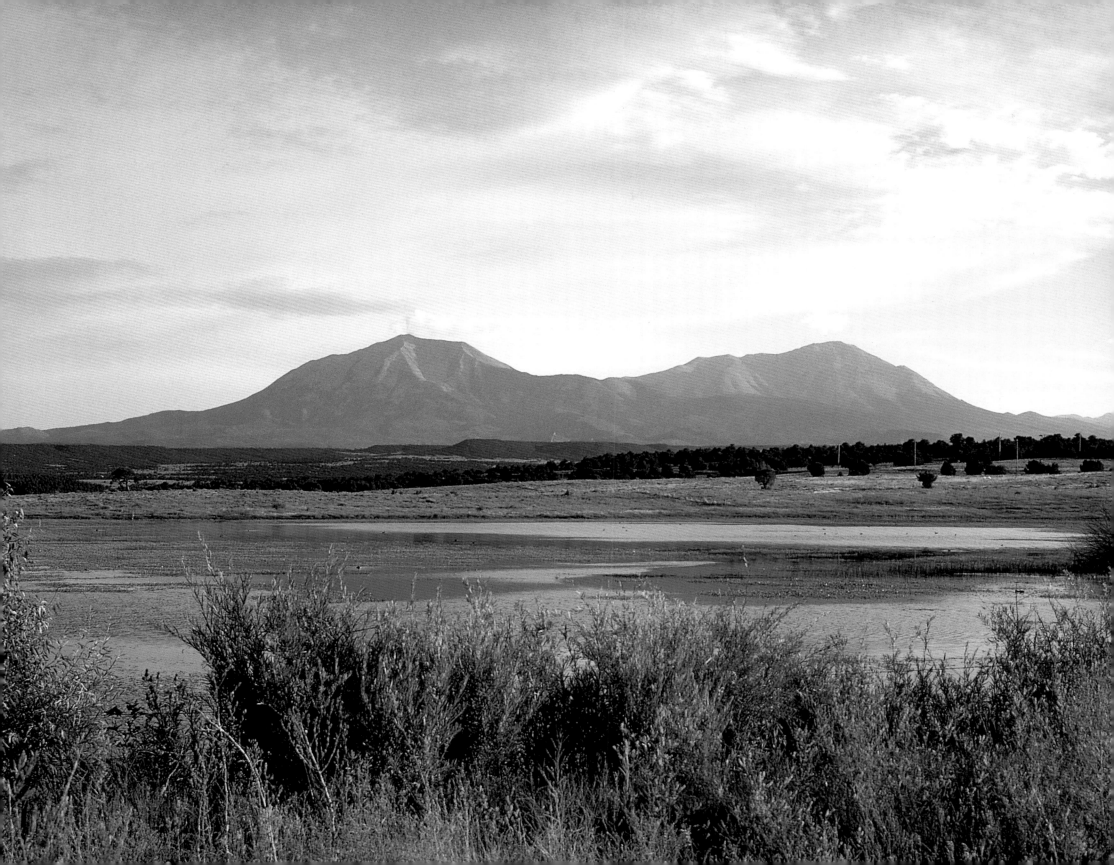

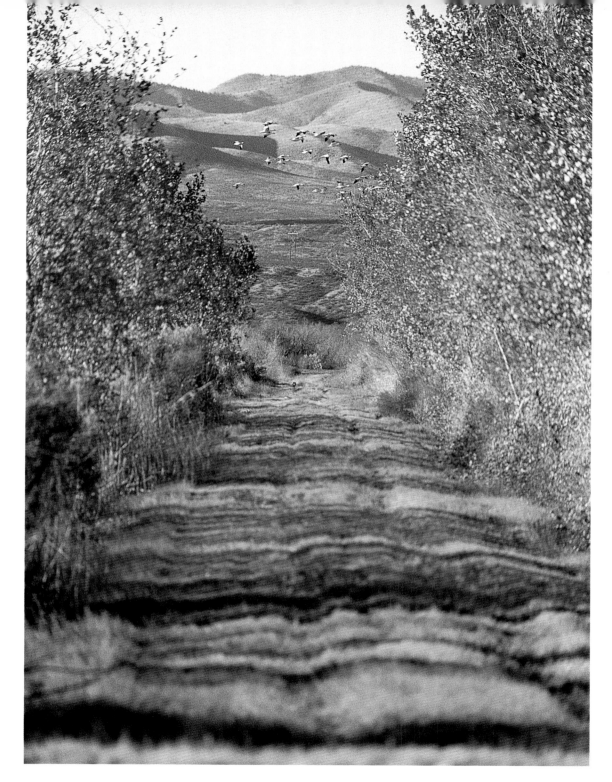

Fall in the Bosque del Apache National Wildlife Refuge, New Mexico.

species that exist here are relicts of earlier climatic regimes, are the only representatives of their taxonomic groups, or live in geographically tiny habitats. Having evolved with reduced competition and predation pressure, these native fishes lacked defense mechanisms and were particularly vulnerable to more aggressive exotic fishes. Well over half of the fishes on the Endangered Species list are found in the southwestern United States and adjacent México.[32]

As sobering as this may be, management of exotic fish species has progressed in the past few decades. Native fish species are still tremendously undervalued by many fisheries biologists—who have often been trained to supply trout for fishermen at all costs—and by the larger society, often unaccustomed

Juniper berries (*Juniperus osteosperma*) in the Grand Staircase-Escalante National Monument, Utah.

to considering fish as anything more than recreational subjects or culinary objects. But just four decades ago government biologists collaborated in a grand management scheme that seems—thankfully—unthinkable today. In 1962 more than one hundred people labored for three days to accomplish a management goal that was startling in its simplicity: to poison four hundred miles of the Green River system so that native fishes could be cleared out to make room for the non-native trout favored by the fishing public. For three days toxic levels of rotenone were dribbled into the river system at fifty-five different stations. Sure enough, the natives—some of which are now considered endangered—were vanquished. Although we still introduce exotic fish species for recreational purposes, it is much less common that we intentionally annihilate natives.

Nevertheless our neglect often leads to the same result. Several fish species that lived in localized springs went extinct in the face of the juggernaut of real estate development. As biologists sadly noted later, there was "little evidence to suggest that the fishes were

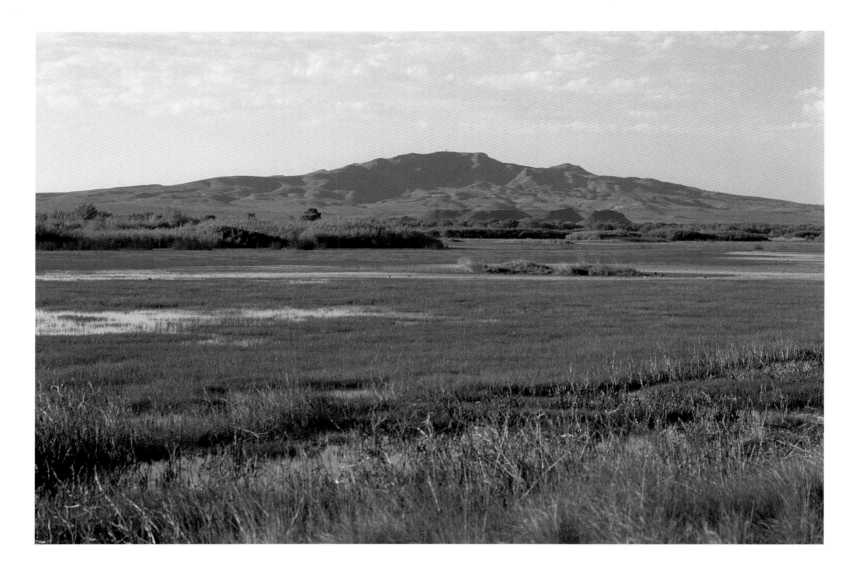

Pond Loop in the Bosque del Apache National Wildlife Refuge, New Mexico.

given more than a passing thought."[33] Managing exotic species does not always involve such ecologically clear rights and wrongs, however. Along a number of rivers, for example, the endangered Southwest Willow Flycatcher has begun nesting in tamarisk—which, as we have seen, can be a great destabilizer of riparian communities. In such cases biologists are left with a confounding dilemma: which matters more, endangered species or endangered ecosystems?[34]

Different types of impact and disturbance often spiral together in a negative turbulence. Trampling and munching by cows can accelerate establishment of non-native plants. Destruction of overhanging streambanks by rumbling cattle

Ramsey Canyon stream in southern Arizona beneath the Huachuca Mountains.

eliminates shady hideouts for native fishes—as a result, water temperature rises and fishes are more vulnerable to predation. When dams harness stream flows, cottonwoods cannot successfully reproduce and must yield to tamarisks, which are better adapted to drier conditions. Yet another example: while fires are a natural disturbance factor in many plant communities, wildfire was rare in riparian communities dominated by native cottonwoods, willow, and mesquites. Fire remains rare in riparian communities where tamarisk has not yet arrived. However, fire has become more common in riparian habitats where tamarisk has gained a foothold. In the aftermath of fire, with dried-out soils and altered soil chemistry, tamarisk fares better than the native trees.[35]

The negative effects of land use can persist for longer than we might guess. A study of an eastern riparian habitat found that the current fauna of fish and invertebrates correlated more closely with land use several decades earlier than with more benign management of the past decade. This "ghost of land use past"[36] could serve as a cautionary tale, reminding us that it is easier to take ecosystems apart than to reassemble them.

THE CONVICTION TO CARE

Unfortunately, in the intervening years since Robert Rush Miller's report, most of the demoralizing trends he noted have only continued to worsen. But the exceptions to the rule shine a light upon a more hopeful path, showing that we *do* have the capacity to do things right.

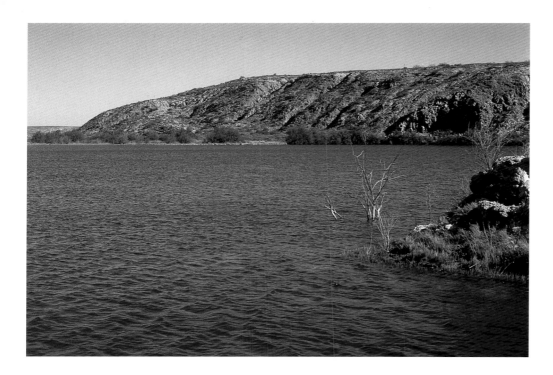

Left: Bottomless Lakes
State Park, New Mexico.

Opposite: A sandhill crane
(*Grus canadensis*) foraging
for food, Bosque del
Apache National Wildlife
Refuge, New Mexico.

Miller's 1961 account of southern Arizona's San Pedro River was largely a requiem for lost fish species. I first visited the river in 1989 but must confess I hardly remember it—just one more bridge over one more blown out Southwest river. Unbeknownst to me, however, profound and heartening changes were afoot in this watershed. Just a few months earlier Congress had passed the Arizona-Idaho Conservation Act, which created a new legal entity: the San Pedro Riparian National Conservation Area. The new reserve was to be managed by the Bureau of Land Management (BLM) who, with the help of The Nature Conservancy, had successfully cobbled together over 56,000 acres along forty miles of river and riparian corridor through land exchanges or purchases from willing private landowners. Although changes were not yet evident on the ground that afternoon I crossed the river in 1989, they soon took shape. With its new management plan for the area BLM took a bold stand for biodiversity. In spite of vocal political pressure to the contrary, livestock and off-road vehicles were excluded from the new conservation zone.

Today the San Pedro is justly held up as a model of successful conservation and collaboration. The area has one of the highest bird diversities for its size of anywhere in North America: close to four hundred species have been seen in the upper San Pedro River valley—almost half the species found on the continent! Its geographic location near the Rocky Mountains, its north-south orientation, and—especially—the rarity of healthy riparian habitat have all contributed to its

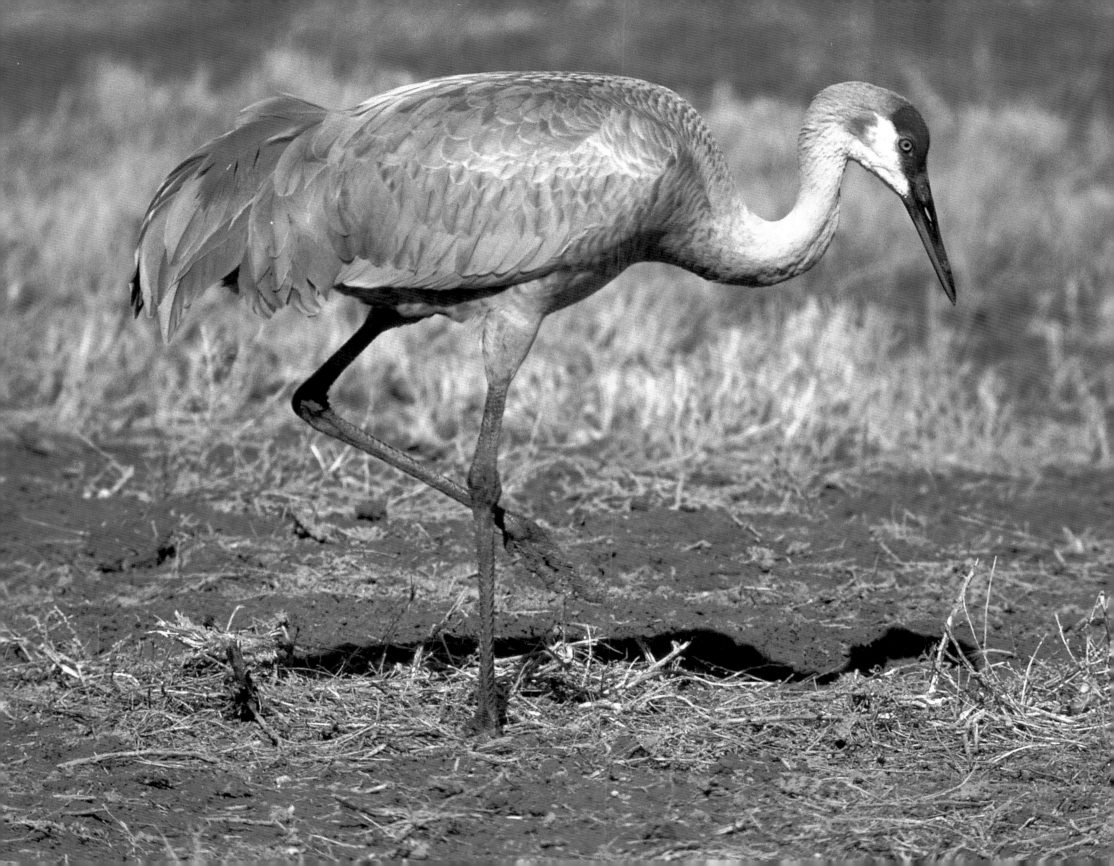

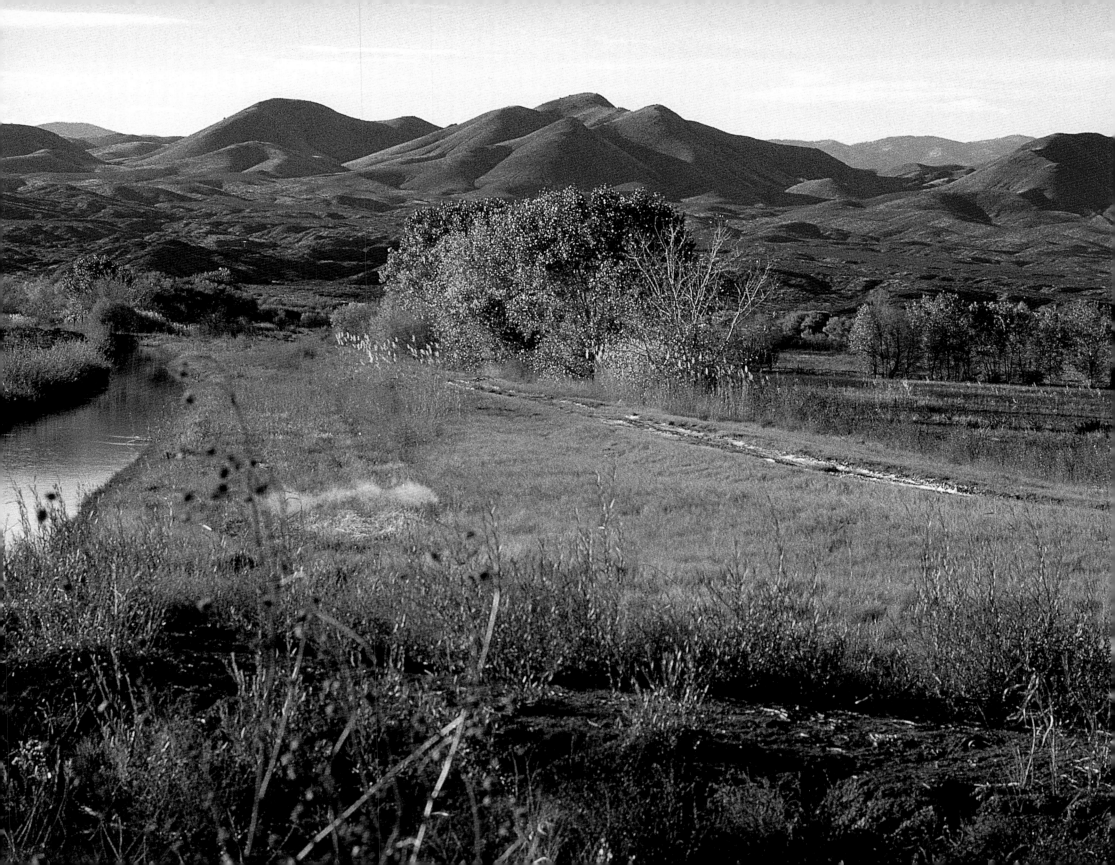

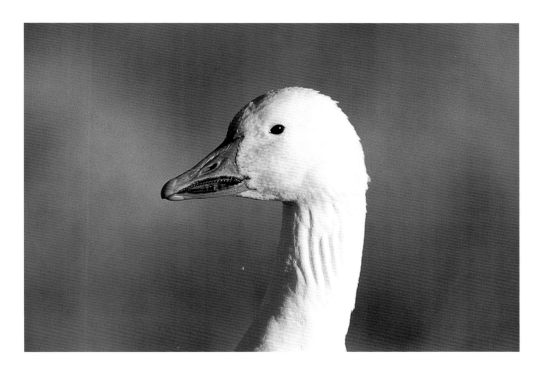

Right: Snow goose (*Chen caerulescens*) on Farm Loop in the Bosque del Apache National Wildlife Refuge, New Mexico.

Opposite: Farm Loop at Bosque del Apache National Wildlife Refuge, New Mexico.

importance as a key corridor for Neo-tropical migrant songbirds. Between one and four million individuals of fifty different songbird species migrate through this riparian corridor each year. In 1995 the American Bird Conservancy designated the San Pedro as the first Globally Important Bird Area in North America, and The Nature Conservancy listed it among its "Last Great Places." The San Pedro also hosts one of the richest assemblages of mammals in the world, as well as harboring endangered species such as the Southwest Willow Flycatcher and Yellow-billed Cuckoo, and three threatened plant communities.

Riparian habitats are remarkably forgiving and, unlike arid uplands, have the capacity to heal, at least partially, rather quickly. Protection from damage by cattle and dune buggies gave the San Pedro riparian corridor a fighting chance for recovery, and it responded by becoming one of the premier wildlife habitats in the United States. In spite of this encouraging recent history, however, the San Pedro remains at risk. The lifeblood of any wetland—water—is in great demand as the nearby city of Sierra Vista grows by leaps and bounds, and along with the Army's Fort Huachuca, uses more and more of the basin's groundwater. If the lowering of the water table doesn't halt soon, the river at the center of this emerald ribbon of biological diversity could simply dry up. Recent ecological studies confirm that access to groundwater is the most important factor determining the structure of vegetation along the San Pedro.

Because the San Pedro River remains undammed, a natural flood

disturbance regime still prevails, which helps keep native plant communities intact, thus discouraging invasion by exotic species. Only a few other rivers in the desert Southwest run free—notably, the Verde in central Arizona and the Escalante in southern Utah. The Escalante River—the most remote undammed river in the Lower 48—offers a story of hope not unlike the San Pedro's. In contrast to the San Pedro, the Escalante was shielded from human impacts along much of its length due to its remoteness (in fact, it was the last discovered river in the contiguous United States). One great exception cracked this shield, however: livestock grazing impacted virtually every square foot of the cottonwood-willow riparian habitat tucked away

inside deep canyons. When the river gained National Park Service protection in the early 1970s, grazing practices were unchanged. As recreational use increased in the 1980s and 1990s, though, hikers' incessant complaints about cattle devastation widened the dialogue on grazing and led to some reforms. Restoration of native riparian habitat directly followed the removal of cows from canyon after canyon along the Escalante. Recently, the nonprofit Grand Canyon Trust helped broker an agreement between ranchers and the government to remove cattle from much of the Escalante's riparian habitat.[37]

Both the San Pedro and the Escalante rivers, then, present hope—and lessons. First, that healing can be accomplished so much more easily

along rivers that lack dams. Along these free-flowing watercourses, natural floods can continue their essential work, which deters the establishment of exotic species. And without impoundment, draining and diversion of water from a stream are less likely. Even regulated rivers, however, can do a better job of maintaining native riparian vegetation by mimicking natural flood regimes.[38] Second, removal of livestock from riparian habitats—simple logistically, if not politically—allows ecological recovery to commence immediately. This requires no great investment of technology or cash, just an exertion of political will. And third, exotic species make non-negotiable demands on any ecosystem they enter. The best strategy against this accelerating menace is to attempt to

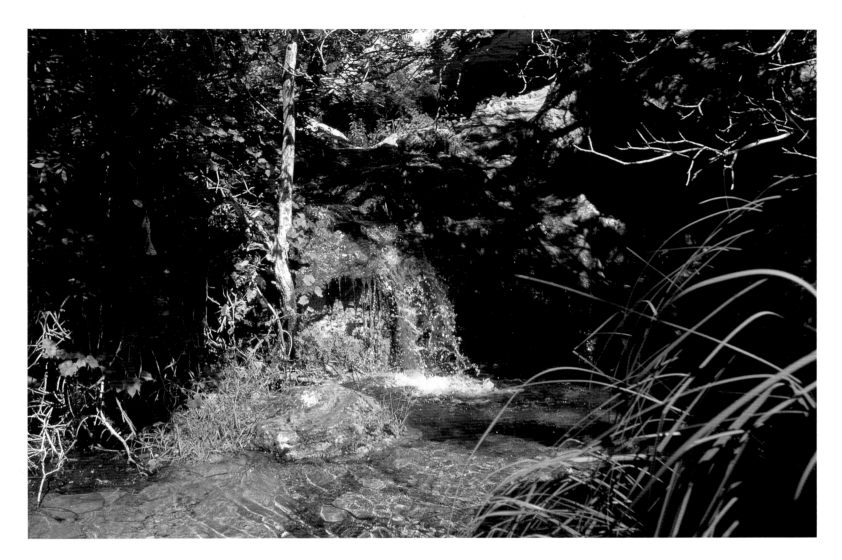

Sitting Bull Falls, an oasis in southern New Mexico near the Guadalupe Mountains.

keep them from gaining an initial foothold in any given watershed. Admittedly, this is impossible to succeed at completely, but maintaining natural conditions—with native floods and without exotic grazers—goes a long way. Finally, and perhaps most importantly, we can learn this simple lesson: we *can* manage desert wetlands wisely.

More generally, a number of laws and federal regulations have been asserted in defense of wetland ecosystems. For well over a century the policy of the United States towards wetlands was to drain them, and by the mid-1970s over half the wetlands in the Lower 48 states had, indeed, been drained. About this time,

Pond at Inscription Rock,
El Morro National
Monument, New Mexico.

though, public consciousness about the importance of wetland habitats grew, as scientists began to recognize and articulate their ecological value. In 1977 President Carter issued two Executive Orders that together established protection of wetland and riparian ecosystems as the official policy of the federal government. Earlier that decade, the Clean Water Act had become law. Its

Section 404 required anyone dredging or filling "waters of the United States" to obtain a permit from the Army Corps of Engineers. Initially, the Corps interpreted this law narrowly to refer only to navigable waters. However, a pair of court cases in the mid-1970s clarified that the law also applied to wetlands.

Following these legal developments, conservationists, real estate developers,

and landowners shared at least one concern: how to determine what was and wasn't a wetland? In 1987 the Army Corps published a technical manual to address this question of wetland "delineation," which specified three mandatory criteria—hydrology, soils, and vegetation—for a piece of land to be declared a wetland in the legal sense. Two years later the four federal agencies involved

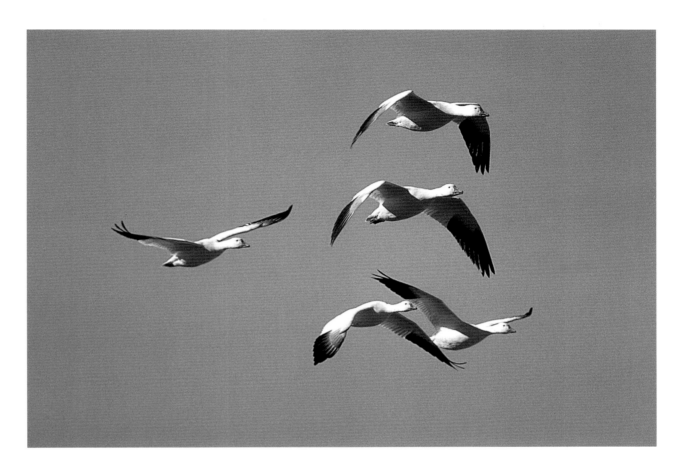

Snow geese (*Chen caerulescens*) flying at the Bosque del Apache National Wildlife Refuge, New Mexico.

in wetland management co-published a unified, revised version of this manual. This new version still insisted upon the same three mandatory criteria for wetlands, but allowed one criterion to infer another—saturated soils, for example, could be taken as strong evidence of wetland hydrology (how else could the soils become saturated, after all?). This seemed too lenient to commercial interests in real estate, agriculture, and

industry, who had been fighting all along to limit the legal scope of wetland delineation. They intensified their lobbying efforts and were rewarded by the Bush Administration in 1991 with a substantially weakened wetland delineation manual. It was soundly and immediately denounced, however, for its lack of scientific credibility and was abandoned the following year. Since that time the original 1987 manual has

again been used to resolve questions about what was or wasn't a wetland. (In the early 1990s the National Academy of Sciences affirmed that this had scientific merit.)

The 1970s also begat an international thrust toward wetland conservation. A conference in Ramsar, Iran, in 1971 provided a framework for the international protection of wetlands. Since that time 117 nations have signed on to

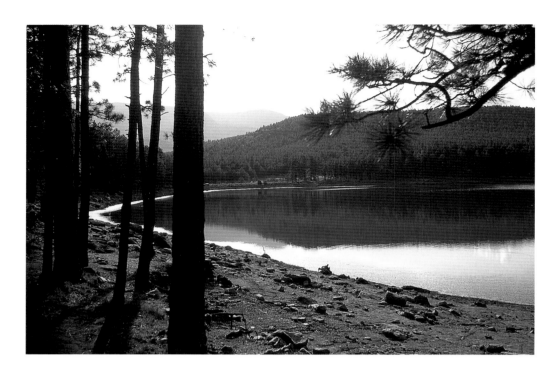

Top: Morphy Lake State Park in New Mexico.

Bottom: Lesser yellowlegs (*Tringa flavipes*) on Pond Loop in the Bosque del Apache National Wildlife Refuge, New Mexico.

the agreement, and a permanent secretariat has been established, associated with the International Union for the Conservation of Nature, in Switzerland.

Laws and treaties for wetland conservation, as reflections of public will, have been great steps in the right direction. But, depending on the gusting of political winds, laws can be undermined. For example, instream flow rights are granted for fish and wildlife habitat in most western states, but these rights often have lower legal precedence than others. (Instream flow rights simply refer to the legal right for water to stay in a stream—the fact that this is a contested area of law speaks volumes about our relationship to water in this part of the world!)[39]

As I write, the Southwest withers. This is the driest year in recorded

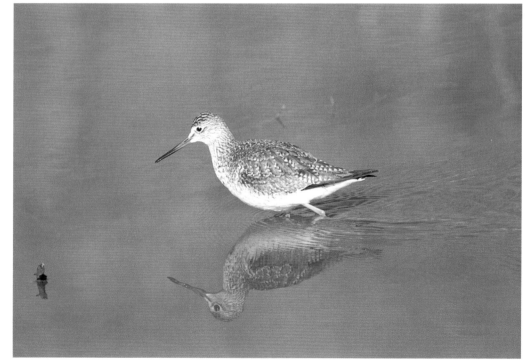

A frosty, misty morning in Bosque del Apache National Wildlife Refuge, New Mexico.

history, yet we continue to take our remaining desert wetlands for granted. Ultimately, then, saving these precious habitats will require more than laws. The needed changes lie deeper—in the realm of ethics and social values. Perhaps we need to once again see wetlands in the desert as a piece of heaven.

Homo sapiens wounds the world with greater ferocity than any other being. Yet at the heart of our nature dwells a psyche with two capacities. We are wired not just for destruction, but for healing, grace, and compassion. From this deeply rooted potential, then—evident in the tenderness of a parent for child, the offering of food to the homeless, or the inclination to stare into the throat of a wildflower for the simple sensation of beauty—we can take heart and justly feel hope. Remembering that our bodies are built of clear water, borrowed from the fluid of earth, is a place to start.

Ethics, by its very nature, involves choosing to *not* do what we *can* do. An ethical relationship with water in the arid Southwest would entail leaving some in the ground even though we have the know-how to suck aquifers dry. It demands leaving remaining wetland ecosystems intact even though we can desiccate them without blinking. Do we have the courage to look at water as we would if we carried every drop on our backs beneath the desert sun? Can we summon the wisdom to acknowledge this planet's primary truth: that life is mostly made of water?

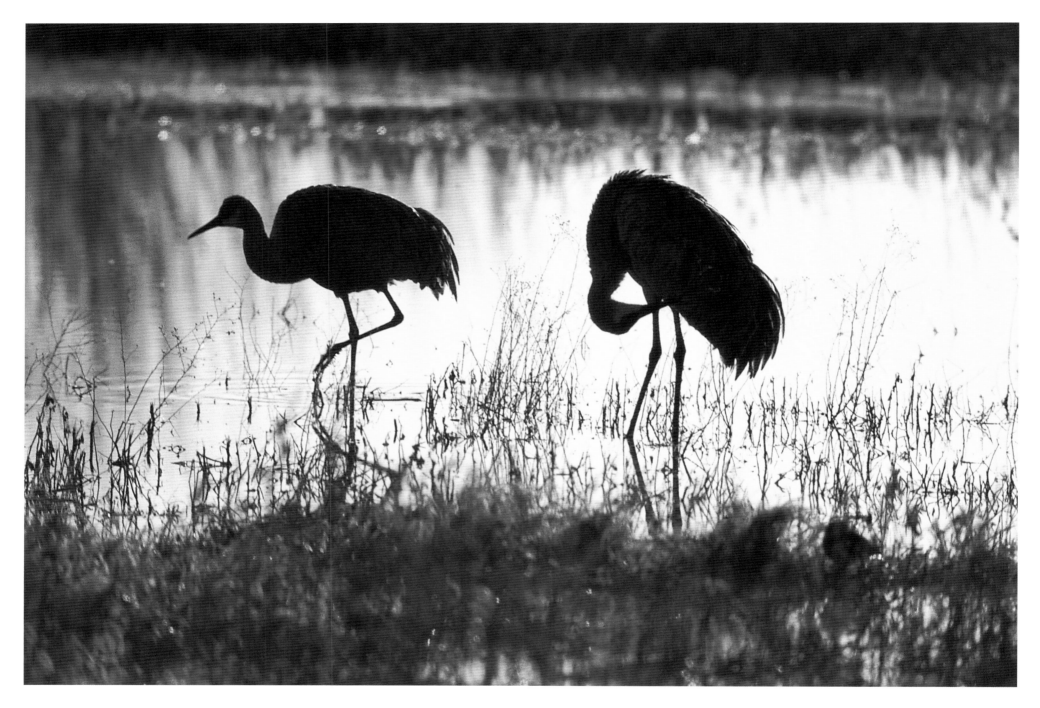

Sandhill cranes (*Grus canadensis*) in evening twilight, Bosque del Apache National Wildlife Refuge, New Mexico.

Taxonomy of Species Mentioned in the Text

This section is included for those readers who desire more detailed information on the specific plants and animals used as examples in the text. Be forewarned that biologists have not always reached consensus on the appropriate name for a given species. Thus, you may find a few of these species with a slightly different scientific name elsewhere. Generally, this sort of uncertainty revolves around whether a particular organism should be considered a subspecies or a fully separate species (for example, Rio Grande Cottonwood, which some specialists consider its own species), but in a few cases the confusion exists at the much broader level of family (for example, Agaves are sometimes placed in their own family). I have tried, using a number of different sources, to provide the most current and accurate information. The plants and animals, of course, really don't care what we call them, as long as we respect them.

Plants

FERNS

Maidenhair	*Adiantum capillus-veneris*	Pteridaceae (brake family)

DICOTS

Sagebrush	*Artemisia tridentata*	Asteraceae (sunflower family)
Seepwillow	*Baccharis salicifolia*	Asteraceae (sunflower family)
Arrowweed	*Pluchea sericea*	Asteraceae (sunflower family)
Alder	*Alnus oblongifolia*	Betulaceae (birch family)
Fiddleneck	*Amsinckia sp.*	Boraginaceae (borage family)
Saguaro	*Carnegiea gigantea*	Cactaceae (cactus family)
Cardón	*Pachycereus pringlei*	Cactaceae (cactus family)
Organ Pipe	*Stenocereus thurberi*	Cactaceae (cactus family)
Saltbush	*Atriplex spp.*	Chenopodiaceae (goosefoot family)
Acacia	*Acacia spp.*	Fabaceae (legume family)
Palo Blanco	*Acacia willardiana*	Fabaceae (legume family)
Palo Verde	*Cercidium microphyllum*	Fabaceae (legume family)
Ironwood	*Olneya tesota*	Fabaceae (legume family)
Mesquite	*Prosopis glandulosa, P. velutina*	Fabaceae (legume family)
Russian Olive	*Elaeagnus angustifolia*	Elaeagnaceae (oleaster family)
Phacelia	*Phacelia sp.*	Hydrophyllaceae (waterleaf family)
Walnut	*Juglans major*	Juglandaceae (walnut family)

Agave	*Agave spp.*	Liliaceae (lily family)
Joshua Tree	*Yucca brevifolia*	Liliaceae (lily family)
Ash	*Fraxinus velutina*	Oleaceae (olive family)
Sycamore	*Platanus wrightii*	Platanaceae (sycamore family)
Columbine	*Aquilegia chrysantha, A. micrantha*	Ranunculaceae (buttercup family)
Blackbrush	*Coleogyne ramosissima*	Rosaceae (rose family)
Fremont Cottonwood	*Populus fremontii*	Salicaceae (willow family)
Rio Grande Cottonwood	*Populus wislizenii*	Salicaceae (willow family)
Coyote Willow	*Salix exigua*	Salicaceae (willow family)
Goodding Willow	*Salix gooddingii*	Salicaceae (willow family)
Tamarisk	*Tamarix chinensis*	Tamaricaceae (tamarisk family)

MONOCOTS

California Fan Palm	*Washingtonia filifera*	Arecaceae (palm family)
Blue Fan Palm	*Erythea armata*	Arecaceae (palm family)
Sedge	*Carex spp.*	Cyperaceae (sedge family)
Spikerush	*Eleocharis spp.*	Cyperaceae (sedge family)
Bulrush, Three-square	*Scirpus spp.*	Cyperaceae (sedge family)
Rush	*Juncus spp.*	Juncaceae (rush family)
Carrizo, Reed	*Phragmites australis, Arundo donax*	Poaceae (grass family)
Cattail	*Typha spp.*	Typhaceae (cattail family)

Animals

CRUSTACEANS

Fairy Shrimp	*Branchinecta mackini*	Order Anostraca
Tadpole Shrimp	*Triops longicaudatus*	Order Notostraca

FISHES

Moapa Dace	*Moapa coriacea*	Cyprinidae (minnow family)
Springfish	*Crenichthys baileyi, C. nevadae*	Goodeidae (Mex. livebearer fam.)

BIRDS

Sandhill Crane	*Grus canadensis*	Family Gruidae
Willow Flycatcher	*Empidonax traillii*	Family Tyrannidae
Yellow-billed Cuckoo	*Coccyzus americanus*	Family Cuculidae

Notes

I have included this information on primary sources for those readers who wish to delve more deeply into the subject. The list of references is not intended to be comprehensive—if such a thing could exist it would take a great many pages. What follows, however, should provide a solid starting point for further research. For readers seeking good overviews, I would suggest Abell et al. 2000, Mitsch and Gosselink 2000, and Richardson 2000 for wetlands in general, and Minckley and Brown 1994 and Ohmart and Anderson 1982 for Southwest wetlands.

1. The recent definition of desert is from Dimmitt 2000. There are many resources on the ecology and geography of North American deserts; I drew particularly from Phillips and Comus 2000 and Sowell 2001.
2. The simple definition of wetlands is from Minckley and Brown 1994. The formal definition is from Cowardin et al. 1979; see Mitsch and Gosselink 2000 and Richardson 2000 for discussion of this definition.
3. Richardson 2000 discusses the high productivity of cattail marshes and nutrient cycling in wetlands.
4. Ibid.
5. The relationship between wetlands and endangered species is discussed in Niering 1988 and Mitsch and Gosselink 2000.
6. Thorp and Covich 1991 provide a good summary of this terminology associated with classification of wetlands; Bruns and Minckley 1980 present a Southwest example where interstitial hyporheic habitat is important.
7. Richardson 2000 discusses the loss of wetlands between 1780–1980.
8. Minckley and Brown 1994 discuss the original prevalence of lotic habitats and the scarcity of lentic habitats in the Southwest.

9. Minckley and Brown 1994; Brown 1985.
10. For definitions and descriptions of riparian habitats, see Arizona Riparian Council 1994; Fleischner 1999a, 1999b; Johnson et al. 1977; Johnson 1989; Ohmart and Anderson 1982; Reichenbacher 1984; Richardson 2000.
11. Szaro 1989 describes twenty-eight riparian plant communities in Arizona and New Mexico; Minckley and Brown 1994 lump many of these into the two broad categories of cottonwood-willow and mixed broadleaf.
12. Minckley and Brown 1994 and Szaro 1989, 1990 discuss the evolutionary history of riparian forest tree species since the end of the Pleistocene.
13. The comment on floods as "the principal driving force" is from Junk et al. 1989; for insight on floods and riparian ecosystem dynamics in the Southwest see Collins et al. 1981, Everitt 1968, 1995, Fisher and Minckley 1978, Minckley and Brown 1994, Patten 1998, Richardson 2000, Stromberg 1997, Stromberg et al. 1991, Stromberg et al. 1993, Szaro 1990, Warren and Turner 1975.
14. Stromberg 1997 discusses germination and seed dispersal of cottonwood, willow, and tamarisk in relation to floods.

15. Fisher and Minckley 1978 describe the physical and chemical effects of floods, while Collins et al. 1981 describe effects on biological populations.
16. On the importance of riparian areas to biodiversity and wildlife, see Fleischner 1994, 1999a, Knopf et al. 1988, Johnson 1989, Johnson et al. 1977, Johnson and Haight 1984, Stevens et al. 1977, Thomas et al. 1979. The highest breeding bird density, reported by Carothers et al. 1974, was along the Verde River, Arizona. The study site was adjacent to an alfalfa field, so insect densities related to agriculture may have inflated bird density. Ohmart and Anderson 1982 speculate on the reasons for avian diversity in cottonwood-willow forests, while Strong and Bock 1990 documented greater avian usage of this habitat than any other riparian habitat in southern Arizona.
17. Minckley and Brown 1994 comment on the relationship of physiological adaptation and resistance to invasion by exotic fish species. For more on desert fishes, see Miller 1961, Minckley and Deacon 1991, Pister 1974, 1981.
18. Brown 1985 and Minckley and Brown 1994 discuss the prevalence of human-built wetlands such as cattle tanks and stock ponds.

19. The outstanding work on ciénegas is Hendrickson and Minckley 1984.

20. Minckley and Brown 1994 briefly describe palm oases; Malanson 1980 describes hanging gardens; Minckley and Unmack 2000 succinctly summarize the importance of desert springs for biodiversity.

21. Smith and Miller 1986 discuss the evolutionary history of playas in relation to climate change.

22. For perspective on temporary pools and playas see Belk and Cole 1975; Brown and Carpelan 1971; and Dodson 1987.

23. Felger and Moser 1985, the key source on Seri plant use, is an ethnobotanical classic.

24. The Apache view of the afterlife is from Opler 1996.

25. Robert Rush Miller's seminal report, written in the late 1950s, is Miller 1961.

26. On the imperilment of freshwater biodiversity, see Allan and Flecker 1993, Ricciardi et al. 1999, Richter et al. 1997; Saunders et al. 2002; and Abell et al. 2000.

27. The EPA conclusion on the state of riparian habitats is in Chaney et al. 1990; estimates of Arizona riparian habitat loss are in Arizona Riparian Council 1994 and Johnson 1989, while Rio Grande information is from Howe and Knopf 1991; the committee of biologists was the Oregon-Washington Interagency Wildlife Committee 1979; the statements of the three scientific societies are Armour et al. 1991, Fleischner et al. 1994, and The Wildlife Society 1996; the comment of the Smithsonian Migratory Bird Center is in its Fact Sheet No. 5. The synthesis of seven riparian ecosystem studies is Tewksbury et al. 2002.

28. For an overview of the effects of livestock grazing on biodiversity, see Fleischner 1994; for overviews of grazing impacts on riparian zones see Belsky et al. 1999; Fleischner 1994, 1999a, 1999b; Kauffman and Krueger 1984; Ohmart 1996; Szaro 1989. Effects on fishes is from Behnke and Zarn 1976—see also many references in the overview articles.

29. The quote, "To be an ecologist . . ." is from Leopold 1953.

30. See Coblentz 1990 for an overview of the ecological effects of exotic species.

31. The ecology of tamarisk and its interactions with native cottonwoods has been much studied—see Busch and Smith 1993, 1995; Everitt 1980, 1995; Horton 1972, 1977; Horton et al. 1960; Horton and Campell 1974; Shafroth et al. 1995; and Warren and Turner 1975. For perspective on the geographic spread of tamarisk see Christensen 1962, Everitt 1998, and Graf 1982. For perspective on Russian olive see Howe and Knopf 1991, Knopf and Olsen 1984.

32. For perspective on the biology and endangerment of Southwest fishes, see, especially, Minckley and Deacon 1991, as well as Meffe et al. 1983; Miller 1961; Pister 1974, 1981; and Rinne and Minckley 1991.

33. Holden 1991 discusses the Green River fiasco in great detail; the quote from the biologists retarding the loss of fish species from localized springs is from Deacon and Minckley 1991.

34. Brown and Trosset 1989 documents willow flycatcher usage of tamarisk in the Grand Canyon.

35. See Busch and Smith 1993 for perspectives on the ecology of fire in riparian areas and Bahre 1985 for historical perspectives on fire in southern Arizona.

36. The "ghost of land use past" is from Harding et al. 1998.

37. For perspective on the Escalante River see Fleischner 1999b.

38. Stromberg 1997 discusses ways that regulated rivers could mimic natural flow regimes for the benefit of native plant communities.

39. Mitsch and Gosselink 2000 do a fine job of summarizing wetland laws in general; for insight into legal issues more specific to the desert Southwest, see Feller 1998, Glennon and Maddock 1994, and Lamb and Lord 1992. Navid 1989 discusses the Ramsar Convention.

Abell, R. A. and ten co-editors. 2000. *Freshwater Ecoregions of North America: A Conservation Assessment.* World Wildlife Fund-US/Island Press, Washington, D.C.

Allan, J. D. and A. S. Flecker. 1993. Biodiversity conservation in running waters: identifying the major factors that threaten destruction of riverine species and ecosystems. *BioScience* 43: 33–43.

Arizona Riparian Council. 1994. Fact Sheet No. 1. Arizona Riparian Council, Center for Environmental Studies, Arizona State University, Tempe, AZ.

Armour, C. L., D. A. Duff, and W. Elmore. 1991. The effects of livestock grazing on riparian and stream ecosystems. *Fisheries* 16: 7–11.

Bahre, C. J. 1985. Wildfire in southeastern Arizona between 1859 and 1890. *Desert Plants* 7: 190–94.

Behnke, R. J. and M. Zarn. 1976. Biology and management of threatened and endangered western trouts. General Technical Report RM-28, Rocky Mountain Forest and Range Experiment Station, U.S. Forest Service, Fort Collins, Colorado.

Belk, D. and G. A. Cole. 1975. Adaptational biology of desert temporary-pond inhabitants. Pages 207–26 in N. F. Hadley, ed. *Environmental Physiology of Desert Organisms.* Dowden, Hutchinson, and Ross, Stroudsburg, PA.

Belsky, A. J., A. Matzke, and S. Uselman. 1999. Survey of livestock influences on stream and riparian ecosystems in the western United States. *Journal of Soil and Water Conservation* 54: 419–31.

Biological Interagency Team. 1993. Middle Rio Grande Ecosystem: Bosque Biological Management Plan. Biological Interagency Team, U.S. Fish and Wildlife Service, Albuquerque, NM.

Brown, B. T. and M. W. Trosset. 1989. Nesting-habitat relationships of riparian birds along the Colorado River in Grand Canyon, Arizona. *Southwestern Naturalist* 34: 260–70.

Brown, D. E. 1985. *Arizona Wetlands and Waterfowl.* University of Arizona Press, Tucson.

Brown, L. R. and L. H. Carpelan. 1971. Egg hatching and life history of a fairy shrimp Branchinecta mackini Dexter (Crustacea: Anostraca) in a Mohave Desert playa (Rabbit Dry Lake). *Ecology* 52: 41–54.

Bruns, D. A. and W. L. Minckley. 1980. Distribution and abundance of benthic invertebrates in a Sonoran Desert stream. Journal of Arid Environments 3: 117–31.

Busch, D. E. and S. D. Smith. 1993. Effects of fire on water and salinity relations of riparian woody taxa. *Oecologia* 94: 186–94.

Busch, D. E. and S. D. Smith. 1995. Mechanisms associated with decline of woody species in riparian ecosystems of the southwestern U.S. *Ecological Monographs* 65: 347–70.

Carothers, S. W. and B. T. Brown. 1991. *The Colorado River through Grand Canyon: Natural History and Human Change.* University of Arizona Press, Tucson.

Carothers, S. W., R. R. Johnson, and S. W. Aitchison. 1974. Population structure and social organization of Southwestern riparian birds. *American Zoologist* 14: 97–108.

Chaney, E., W. Elmore, and W. S. Platts. 1990. Livestock grazing on western riparian areas. U.S. Environmental Protection Agency, Region 8, Denver, Colorado.

Christensen, E. M. 1962. The rate of naturalization of Tamarix in Utah. *American Midland Naturalist* 68: 51–57.

Coblentz, B. E. 1990. Exotic organisms: a dilemma for conservation biology. *Conservation Biology* 4: 261–65.

Collins, J. P., C. Young, J. Howell, and W. L. Minckley. 1981. Impact of flooding in a Sonoran Desert stream, including elimination of an endangered fish population (*Poeciliopsis o. occidentalis;* Poeciliidae). *Southwestern Naturalist* 27: 415–23.

Commission for Environmental Cooperation. 1999. Ribbon of life: an agenda for preserving transboundary migratory bird habitat on the upper San Pedro River. Commission for Environmental Cooperation, Montreal, Canada.

Contreras-Balderas, S. 2000. The valley of Cuatro Cienegas, Coahuila: its biota and its future. Pages 94–96 in R. A. Abell et al., editors. *Freshwater Ecoregions of North America: A Conservation Assessment.* World Wildlife Fund—US/ Island Press, Washington, DC.

Cowardin, L. M., V. Carter, F. C. Golet, E. T. LaRoe. 1979. Classification of wetlands and deepwater habitats of the United States. U.S. Fish and Wildlife Service, Publication FWS/OBS-79/31, Washington, D.C.

Deacon, J. E. and W. L. Minckley. 1991. Western fishes and the real world: the enigma of "endangered species" revisited. Pages 405–13 in W. L. Minckley and J. E. Deacon, eds. *Battle against Extinction: Native Fish Management in the American West.* University of Arizona Press, Tucson.

Dimmitt, M. A. 2000. Biomes and communities of the Sonoran Desert region. Pages 3–18 in S. J. Phillips and P. W. Comus, eds. *A Natural History of the Sonoran Desert*. Arizona-Sonora Desert Museum Press/University of California Press, Tucson/Berkeley.

Dodson, S. I. 1987. Animal assemblages in temporary desert rock pools: aspects of the ecology of *Dasyhelea sublettei* (Diptera: Ceratopogonidae). *Journal of the North American Benthological Society* 6: 65–71.

Everitt, B. L. 1968. Use of the cottonwood in an investigation of the recent history of a flood plain. *American Journal of Science* 266: 417–39.

———. 1980. Ecology of saltcedar—a plea for research. *Environmental Geology* 3: 77–84.

———. 1995. Hydrologic factors in regeneration of Fremont cottonwood along the Fremont River, Utah—natural and anthropogenic influences in fluvial geomorphology. *Geophysical Monographs* 89: 197–208.

———. 1998. Chronology of the spread of tamarisk in the central Rio Grande. *Wetlands* 18: 658–68.

Feller, J. M. 1998. Recent developments in the law affecting livestock grazing on western riparian areas. *Wetlands* 18: 646–57.

Felger, R. S. and M. B. Moser. 1985. *People of the Desert and Sea: Ethnobotany of the Seri Indians.* University of Arizona Press, Tucson.

Finch, D. M. and J. A. Tainter, technical editors. 1995. Ecology, diversity, and sustainability of the Middle Rio Grande Basin. General Technical Report RM-GTR-268, Rocky Mountain Forest and Range Experiment Station, USDA Forest Service, Fort Collins, CO.

Fisher, S. G. and W. L. Minckley. 1978. Chemical characteristics of a desert stream in flash flood. *Journal of Arid Environments* 1: 25–33.

Fleischner, T. L. 1994. Ecological costs of livestock grazing in western North America. *Conservation Biology* 8: 629–44.

———. 1999a. Keeping the cows off: conserving riparian areas in the American West. Pages 64–65 in T. Ricketts et al., eds. *Terrestrial Ecoregions of North America: A Conservation Assessment.* World Wildlife Fund-US/Island Press, Washington, D.C.

———. 1999b. *Singing Stone: A Natural History of the Escalante Canyons.* University of Utah Press, Salt Lake City.

Fleischner, T. L., D. E. Brown, A. Y. Cooperrider, W. B. Kessler, and E. L. Painter. 1994. Society for Conservation Biology Position Statement: livestock grazing on public lands of the United States of America. *Society for Conservation Biology Newsletter* 1(4): 2–3.

Fradkin, P. L. 1981. *A River No More: The Colorado River and the West.* Alfred A. Knopf, New York.

Glennon, R. J. and T. Maddock, III. 1994. In search of subflow: Arizona's futile attempt to separate groundwater from surface water. *Arizona Law Review* 36: 567–610.

Graf, W. L. 1982. Tamarisk and river-channel management. *Environmental Management* 6: 283–96.

Hanson, R. B. 2001. *The San Pedro River: A Discovery Guide.* University of Arizona Press, Tucson.

Harding, J. S., E. F. Benfield, P. V. Bolstad, G. S. Helfman, and E. B. D. Jones III. 1998. Stream biodiversity: The ghost of land use past. *Proceedings of the National Academy of Sciences (USA)* 95: 14843–47.

Hendrickson, D. A. and W. L. Minckley. 1985. Ciénegas—vanishing climax communities of the American Southwest. *Desert Plants* 6(3): 130–76.

Holden, P. B. 1991. Ghosts of the Green River: impacts of Green River poisoning on the management of native fishes. Pages 43–54 in W. L. Minckley and J.E. Deacon, eds. *Battle against Extinction: Native Fish Management in the American West.* University of Arizona Press, Tucson.

Horton, J. S. 1972. Management problems in phreatophyte and riparian zones. *Journal of Soil and Water Conservation* 27: 57–61.

Horton, J. S. 1977. The development and perpetuation of the permanent tamarisk type in the phreatophyte zone of the Southwest. Pages 124–27 in R. R. Johnson and D. A. Jones, eds. Importance, preservation and management of riparian habitat: A symposium. General Technical Report RM-43, U.S. Forest Service, Fort Collins, CO.

Horton, J. S. and C. J. Campbell. 1974. Management of phreatophyte and riparian vegetation for maximum multiple use values. Research Paper RM-117, Rocky Mountain Forest and Range Experiment Station, U.S. Forest Service, Fort Collins, Colorado.

Horton, J. S., F. C. Mounts, and J. M. Kraft. 1960. Seed germination and seedling establishment of phreatophyte species. Station Paper 48, Rocky Mountain Forest and Range Experiment Station, U.S. Forest Service, Fort Collins, Colorado.

Howe, W. H. and F. L. Knopf. 1991. On the imminent decline of Rio Grande cottonwoods in central New Mexico. *Southwestern Naturalist* 36: 218–24.

Johnson, A. S. 1989. The thin green line: Riparian corridors and endangered species in Arizona and New Mexico. Pages 35–46 in G. Mackintosh, ed. *In Defense of Wildlife: Preserving Communities and Corridors.* Defenders of Wildlife, Washington, D.C.

Johnson, R. R. and L. T. Haight. 1984. Riparian problems and initiatives in the American Southwest: a regional perspective. Pages 404–12 in R. E. Warner and K. M. Hendrix, eds. *California Riparian Systems: Ecology, Conservation, and Productive Management.* University of California Press, Berkeley.

Johnson, R. R., L. T. Haight, and J. M. Simpson. 1977. Endangered species vs. endangered habitats: A concept. Pages 68–79 in R. R. Johnson and D. A. Jones, eds. Importance, preservation and management of riparian habitat: A symposium. General Technical Report RM-43, U.S. Forest Service, Fort Collins, CO.

Junk, W. J., P. B. Bayley, and R. E. Sparks. 1989. The flood-pulse concept in river-floodplain systems. *Canadian Special Publications in Fisheries and Aquatic Sciences* 106: 110–27.

Kauffman, J. B. and W. C. Krueger. 1984. Livestock impacts on riparian ecosystems and streamside management implications: a review. *Journal of Range Management* 37: 430–37.

Knopf, F. L. and T. E. Olson. 1984. Naturalization of Russian-olive: implications to Rocky Mountain wildlife. *Wildlife Society Bulletin* 12: 289–98.

Knopf, F. L., R. R. Johnson, T. Rich, F. B. Samson, and R. C. Szaro. 1988. Conservation of riparian ecosystems in the United States. *Wilson Bulletin* 100: 272–84.

Lamb, B. L. and E. Lord. 1992. Legal mechanisms for protecting riparian resource values. *Water Resources Research* 28: 965–77.

Leopold, A. 1953. *Round River.* Oxford University Press, New York.

Malanson, G. P. 1980. Habitat and plant distributions in hanging gardens of the Narrows, Zion National Park, Utah. *Great Basin Naturalist* 40: 178–82.

Marsh, P. C. 1984. Biota of Cuatro Cienegas, Coahuila, Mexico: proceedings of a special symposium. Preface. *Journal of the Arizona-Nevada Academy of Sciences* 19(1): 1–2.

Meffe, G. K., D. A. Hendrickson, and W. L. Minckley. 1983. Factors resulting in decline of the endangered Sonoran topminnow *Poeciliopsis occidentalis* (Atheriniformes: Poeciliidae) in the United States. *Biological Conservation* 25: 135–59.

Miller, R. R. 1961. Man and the changing fish fauna of the American Southwest. *Papers of the Michigan Academy of Science, Arts, and Letters* 46: 365–404.

Minckley, W. L. 1969. Environments of the bolson of Cuatro Cienegas, Coahuila, Mexico. *University of Texas at El Paso Science Series 2:* 1–65.

———. 1992. Three decades near Cuatro Cienegas, Mexico: photographic documentation and a plea for area conservation. Pages 81–110 in M. R. Sommerfield and D. M. Kubly, eds. Limnology and aquatic biology of the Southwest: Proceedings of a special symposium to honor Professor Gerald Ainsworth Cole. Thirty-fourth annual meeting of the Arizona-Nevada Academy of Science, Tempe, Arizona, 21 April 1990. *Journal of the Arizona-Nevada Academy of Science* 26(2).

Minckley, W. L. and D. E. Brown. 1994. Wetlands. Pages 223–87 in D. E. Brown, ed. *Biotic Communities: Southwestern United States and Northwestern Mexico.* University of Utah Press, Salt Lake City.

Minckley, W. L. and J. E. Deacon, eds. 1991. *Battle against Extinction: Native Fish Management in the American West.* University of Arizona Press, Tucson.

Minckley, W. L. and P. J. Unmack. 2000. Western springs: their faunas and threats to their existence. Pages 52–53 in R. A. Abell et al., eds. *Freshwater Ecoregions of North America: A Conservation Assessment.* World Wildlife Fund-US/Island Press, Washington, D.C.

Mitsch, W. J. and J. G. Gosselink. 2000. *Wetlands, third ed.* John Wiley and Sons, New York.

Navid, D. 1989. The international law of migratory species: the Ramsar Convention. *Natural Resources Journal* 29: 1001–16.

Niering, W. A. 1988. Endangered, threatened, and rare wetland plants and animals of the continental United States. Pages 227–38 in D. D. Hook et al., eds. *The Ecology and Management of Wetlands, Vol. 1: Ecology of Wetlands.* Timber Press, Portland, Oregon.

Ohmart, R. D. 1996. Historical and present impacts of livestock grazing on fish and wildlife riparian habitats. Pages 245–79 in P. Krausman, ed. *Rangeland wildlife.* Society for Range Management, Denver, Colorado.

Ohmart, R. D. and B. W. Anderson. 1982. North American desert riparian ecosystems. Pages 433–79 in G. L. Bender, ed. *Reference Handbook on the Deserts of North America.* Greenwood Press, Westport, Connecticut.

Opler, M. E. 1996. *An Apache Lifeway: The Economic, Social, and Religious Institutions of the Chiricahua Indians.* University of Nebraska Press, Lincoln. (Originally published in 1941 by the University of Chicago Press).

Oregon-Washington Interagency Wildlife Committee. 1979. Managing riparian ecosystems for fish and wildlife in eastern Oregon and eastern Washington. Available from Washington State Library, Olympia.

Patten, D. T. 1998. Riparian ecosystems of semi-arid North America: diversity and human impacts. *Wetlands* 18: 498–512.

Phillips, S. J. and P. W. Comus, eds. 2000. *A Natural History of the Sonoran Desert.* Arizona-Sonora Desert Museum Press/University of California Press, Berkeley.

Pister, E. P. 1974. Desert fishes and their habitats. *Transactions of the American Fisheries Society* 103: 531–40.

———. The conservation of desert fishes. Pages 411–45 in R. J. Naiman and D. L. Soltz, eds. *Fishes in North American Deserts.* John Wiley, New York.

Reichenbacher, F. W. 1984. Ecology and evolution of Southwestern riparian plant communities. *Desert Plants* 6: 15–22, 14.

Ricciardi, A., R. J. Neves, and J. B. Rasmussen. 1999. Extinction rates of North American freshwater fauna. *Conservation Biology* 13: 1–3.

Richardson, C. J. 2000. Freshwater wetlands. Pages 449–99 in M.G. Barbour and W.D. Billings, eds. *North American Terrestrial Vegetation, second edition.* Cambridge University Press, New York.

Richter, B. D., D. P. Braun, M. A. Mendelson, and L. L. Master. 1997. Threats to imperiled freshwater fauna. *Conservation Biology* 11: 1081–93.

Rinne, J. N. and W. L. Minckley. 1991. Native fishes of arid lands: a dwindling resource of the desert Southwest. General Technical Report RM-206, Rocky Mountain Forest and Range Experiment Station, USDA-Forest Service, Fort Collins, CO.

Rosenberg, K. V., R. D. Ohmart, W. C. Hunter, and B. W. Anderson. 1991. *Birds of the Lower Colorado River Valley.* University of Arizona Press, Tucson.

Saunders, D. L., J. J. Meuwig, and A. C. J. Vincent. 2002. Freshwater protected areas: strategies for conservation. *Conservation Biology* 16: 30–41.

Shafroth, P. B., J. M. Friedman, and L. S. Ischinger. 1995. Effects of salinity on establishment of *Populus fremontii* (cottonwood) and *Tamarix ramosissima* (saltcedar) in southwestern United States. *Great Basin Naturalist* 55: 58–65.

Smith, M. L. and R. R. Miller. 1986. The evolution of the Rio Grande Basin as inferred from its fish fauna. Pages 457–86 in C. H. Hocutt and E. O. Wiley, eds. *Zoogeography of North American Freshwater Fishes.* Wiley and Sons, New York.

Sowell, J. 2001. *Desert Ecology: An Introduction to Life in the Arid Southwest.* University of Utah Press, Salt Lake City.

Stevens, L. E., B. T. Brown, J. M. Simpson, and R. R. Johnson. 1977. The importance of riparian habitat to migrating birds. Pages 156–64 in R. R. Johnson and D. A. Jones, eds. Importance, preservation and management of riparian habitat: A symposium. General Technical Report RM-43, U.S. Forest Service, Fort Collins, CO.

Stromberg, J. C. 1997. Growth and survivorship of Fremont cottonwood, Goodding willow, and saltcedar seedlings after large floods in central Arizona. *Great Basin Naturalist* 57: 198–208.

Stromberg, J. C., D. T. Patten, and B. D. Richter. 1991. Flood flows and dynamics of Sonoran riparian forests. *Rivers* 2: 221–35.

Stromberg, J. C., B. D. Richter, D. T. Patten, and L. G. Wolden. 1993. Response of a Sonoran riparian forest to a 10-year return flood. *Great Basin Naturalist* 53: 118–30.

Stromberg, J. C., R. Tiller, and B. Richter. 1996. Effects of groundwater decline on riparian vegetation of semiarid regions: the San Pedro, Arizona. *Ecological Applications* 6: 113–31.

Strong, T. R. and C. E. Bock. 1990. Bird species distribution patterns in riparian habitats in southeastern Arizona. *Condor* 92: 866–85.

Szaro, R. C. 1989. Riparian forest and scrubland community types of Arizona and New Mexico. *Desert Plants* 9 (3–4): 70–138.

Szaro, R. C. 1990. Southwestern riparian plant communities: site characteristics, tree species distributions, and size-class structures. *Forest Ecology and Management* 33/34: 315–34.

Tewksbury, J. J., A. E. Black, N. Nur, V. A. Saab, B. D. Logan, and D. S. Dobkin. 2002. Effects of anthropogenic fragmentation and livestock grazing on western riparian bird communities. *Studies in Avian Biology* 25: 158–202.

Thomas, J. W., C. Maser, and J. E. Rodiek. 1979. Riparian zones in managed rangelands—their importance to wildlife. Pages 21–31 in O. B. Cope, ed. *Proceedings of the Forum—Grazing and Riparian/Stream Ecosystems.* Trout Unlimited, Denver, Colorado.

Thorp, J. H. and A. P. Covich. 1991. An overview of freshwater habitats. Pages 17–36 in J. H. Thorp and A. P. Covich, eds. *Ecology and Classification of North American Freshwater Invertebrates.* Academic Press, San Diego.

Warren, D. K. and R. M. Turner. 1975. Saltcedar (*Tamarix chinensis*) seed production, seedling establishment, and response to inundation. *Journal of the Arizona Academy of Science* 10: 135–44.

Wildlife Society, The. 1996. The Wildlife Society position statement on livestock grazing on federal rangelands in the western United States. *Wildlifer,* January–February 1996, p. 10–13.

Worster, D. 1985. *Rivers of Empire: Water, Aridity, and the Growth of the American West.* Oxford University Press, Oxford.

Yuncevich, G. M. 1993. The San Pedro Riparian National Conservation Area. General Technical Report RM-226, Rocky Mountain Forest and Range Experiment Station, U.S. Forest Service, Fort Collins, Colorado.